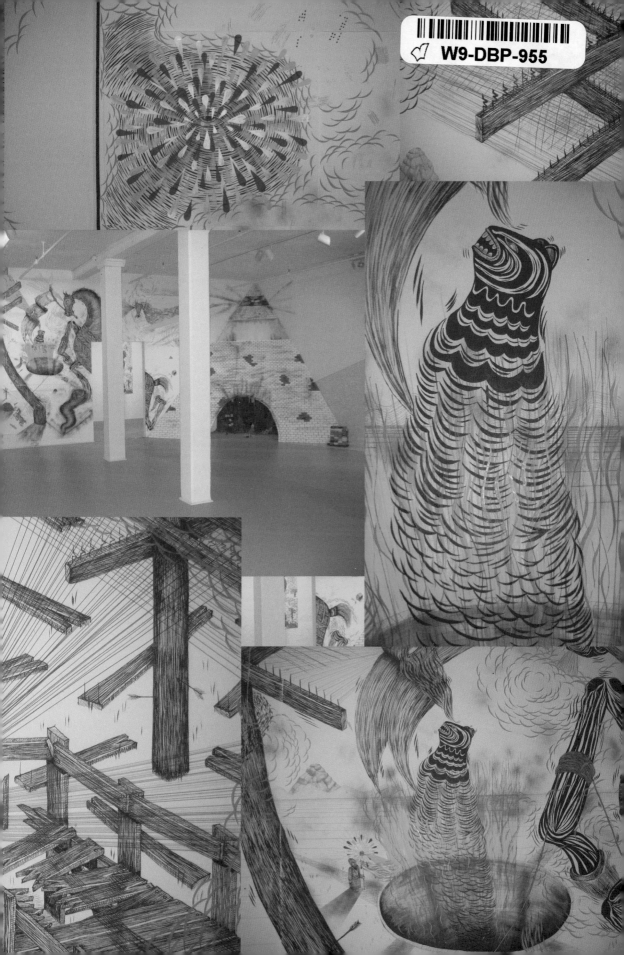

Ulysses: Departures, Journeys, & Returns.
The Artwork of Andrew Schoultz

For Information:
Paper Museum Press
220 Clement St
San Francisco, CA 94118
www.paper-museum.net

First Edition

Art Direction: Andrew Schoultz
Graphic Design: Mark Pearsall
Copy Editor: Kevin B. Chen

ISBN: 978-0-9788739-0-5
ISBN: 0-9788739-0-4

Printed in China

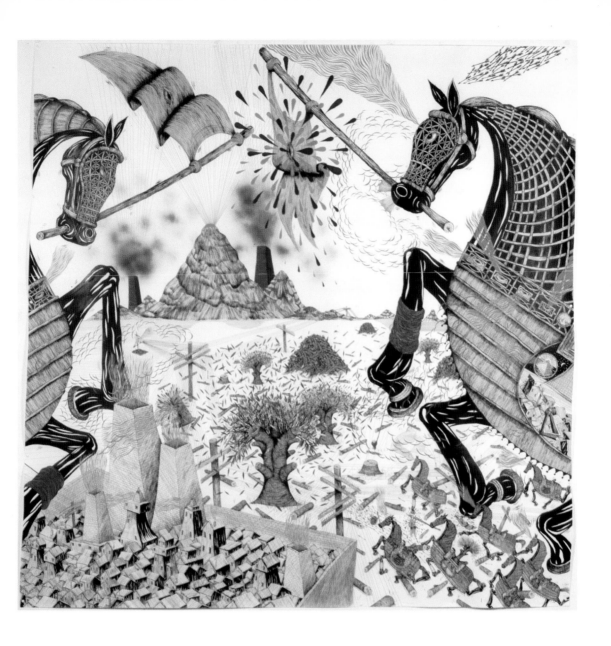

Ulysses: Departures, Journeys, & Returns.

The Artwork of Andrew Schoultz

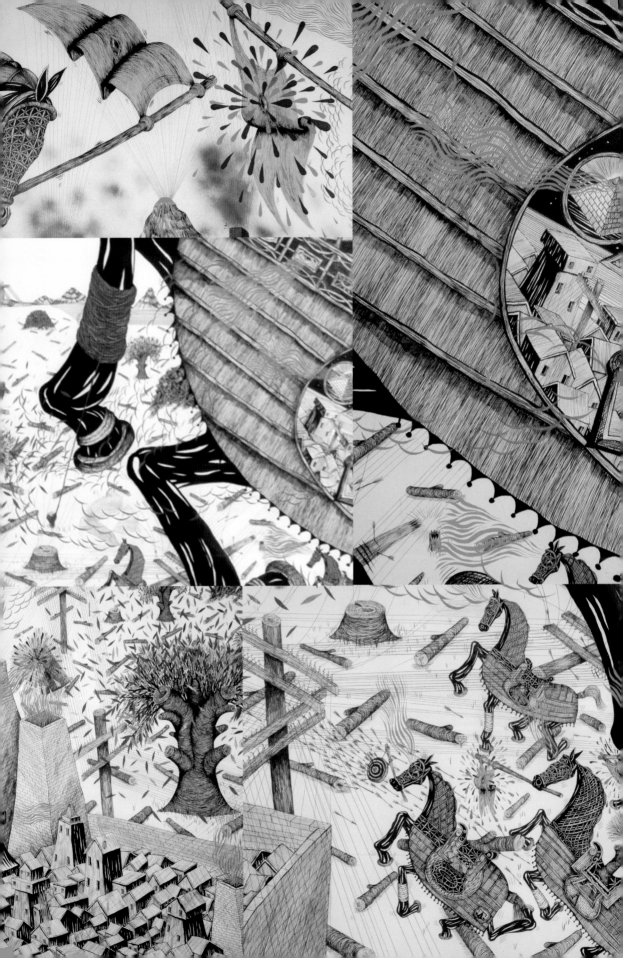

Dedication

This book is dedicated to my family.
My parents Mary & Bill, who have consistently put my
interests in front of their own, my entire life. Without them,
I would not be the person I am. My wife Madeline for
her unconditional love and support through it all, including
very doubtful times. And also, my brother Tim, his wife
Sue, & my beautiful niece Emma.

Foreword

The following 180 pages represent what I have been doing
for the past 10 years of my life. I have engulfed myself
in the lifestyle of creating things, and honestly cannot imag-
ine doing anything else with my life. When I started
thinking about putting together a book of my work, I came
to the conclusion that it would be very important to have
content, as well as compelling images. I invited a couple of
friends/peers to write something for this. I left it up
to each person, to decide what they wanted to write and
inserted these pieces accordingly, where I thought
they were most relevant.

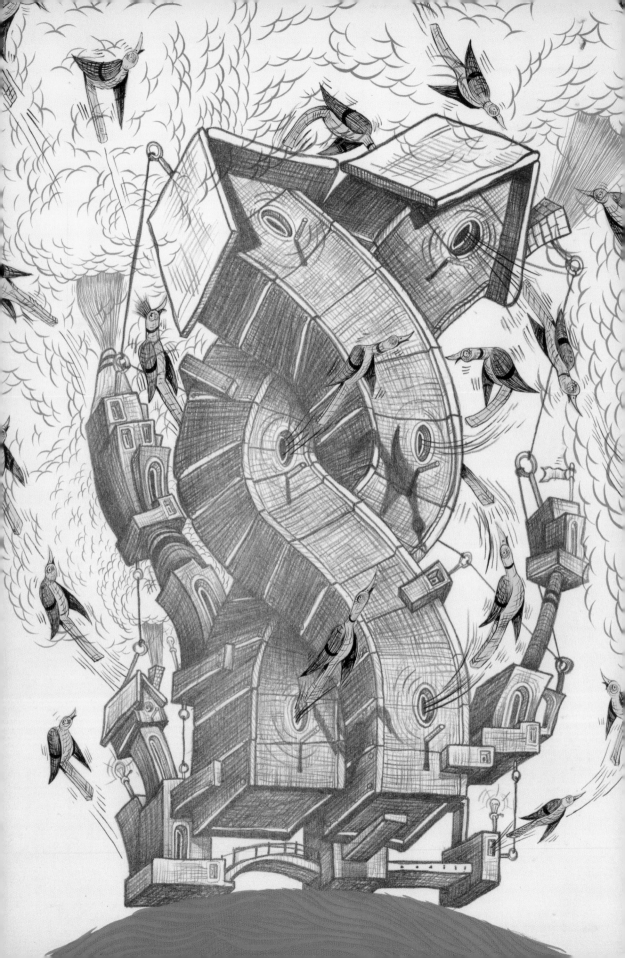

Introduction
What Happened When I Met Andy Schoultz

Six years ago Andy Schoultz found me on Clarion Alley in San Francisco where I had been getting fully sick of the community mural project some of us had started eight years before. He said he wanted to paint. I put him off with the standard response—get us some kind of proposal, we'll review it at the next curatorial meeting—and figured that would get rid of him. He was back the next day with an intricate drawing on several sheets of paper taped together, a dense progression of birds coming out of bottles, morphing into money and skulls and weird chunky elephants across six upper story panels. I had never seen anything quite like it. It looked like the hip-hop child of Dr. Suess and M.C. Escher. It looked like several weeks of painting. It took me a week or two to round up the unanimous votes for his design, and Andy was like a bull waiting for the gate. He kept putting notes and design revisions through my mail slot and called me every few days, sounding like he wasn't allowed to take a deep breath until he got the go-ahead. I called him finally to say yes, of course you can paint the mural, and he was there the next morning to start, and there every morning until it was done, and then he pitched in on the Clarion Alley block party and brought a bunch of new artists to the alley, and organized a retrospective of Ray Patlan's work at Gallery Balazo and taught classes at Precita Eyes and generally made himself indispensable to the mural community while generating a huge and rapidly evolving body of outdoor and gallery work.

Being a recent arrival to San Francisco, Andy had an exaggerated sense of the importance of the Clarion Alley Mural Project, which he had seen a picture of in some graf rag back in Milwaukee. This must have carried over to an unwarranted respect for me, because after he finished his amazing mural on Clarion he invited me to go out and do some illegal wall painting with him. I don't know what he thought I was going to paint, not being any kind of tagger myself, but, as luck would have it, I actually had an idea. I had just done my first painting based on collaged comic-book fragments for a warehouse show that Bill Daniel got me into. If Andy hadn't shown up to kick my ass I might still be waiting for some curator to give me a second show. We went out on a weekend with ladders, traffic cones and drop-cloths, trying to look entirely legit, and put up a couple of medium size pieces off Harrison Street with no problem and much encouragement from the halfway house residents across the street. I made the mistake of going back on Monday to finish up, got caught by the owner and had to buff my whole piece out, but Andy's ran for months

right next to it. Then we found a crumbling block-long retaining wall in China Basin slated for eventual demolition, and started going down there every chance we got. We didn't start out planning to do the whole wall—that would have seemed unthinkable. But time went on, nobody stopped us, the cops accepted our semi-bullshit stories, the restaurant staff across the street fed us fancy chocolate truffles, and we were on fire, refining our styles, free-styling, leapfrogging each other down the wall. I basically got my whole thing together on China Basin, how I mix my colors, how I use the pearlescent acrylic, how the color relates to the line. Andy's work was more developed already, but it seems to me in retrospect that it was on that long wall that his spatial sense started to open up, the first step toward the complex, quasi-Asian spaces of his current paintings. We were totally full of ourselves, we were convinced the wall would be legendary. It was respected anyway, until it got demolished six or eight months later.

Andy never told me he had been a semi-pro skateboarder before he turned his ridiculously single-minded focus to tagging and then drawing—I read it in a magazine. Last year I did a piece in a skate-park in Oregon and the whole graf-skate connection started to make sense to me. I relate to skating as balance and serenity—the moment of weightlessness—but with respect to Andrew I think its more about practice and flow and the conquest of urban space. After all, Andy isn't really balanced; he's obsessive and profuse. He's the hardest working artist in San Francisco. When we start a wall it goes this way: I like to show up and putter around for an hour or so, sipping coffee & squinting at the space from various angles, holding my design up, lining up my paints and brushes, then maybe getting another cup of coffee. Andy just walks up to any part of the wall and starts slamming fill color on it with some random brush or roller that materialized in his hand that second. He'll have paint on the wall before the back wheel of his bike stops spinning. He seems to compose big sections on the fly. Birds and buildings and elephants loop and spiral around the wall as though Andy had discovered the second-and-a-half dimension. I'm certain that during the long hours on the ladder, painting thousands of hairline strokes while his fingers chill and his wrist stiffens and his lower back gets sore and the balls of his feet start aching on the narrow aluminum rung: I'm certain that some part of Andy's mind is skating that wall.

Aaron Noble

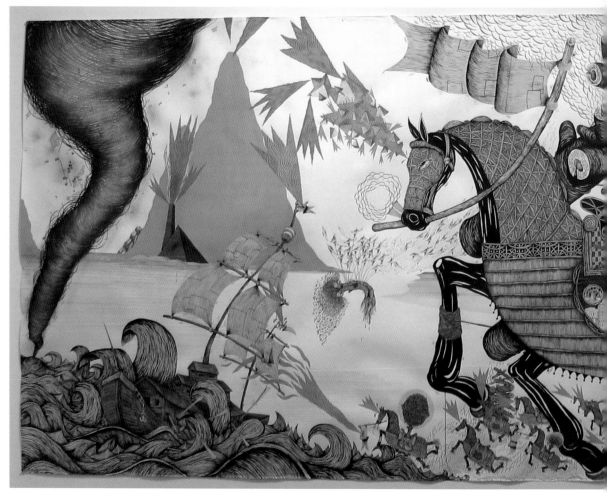

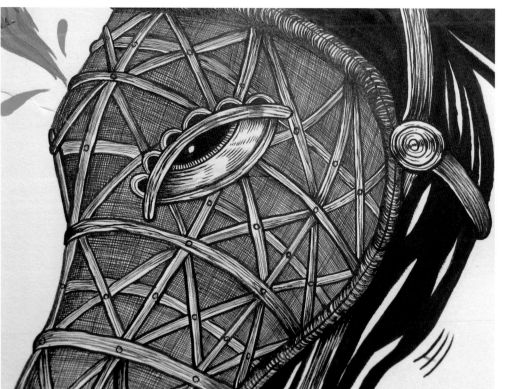

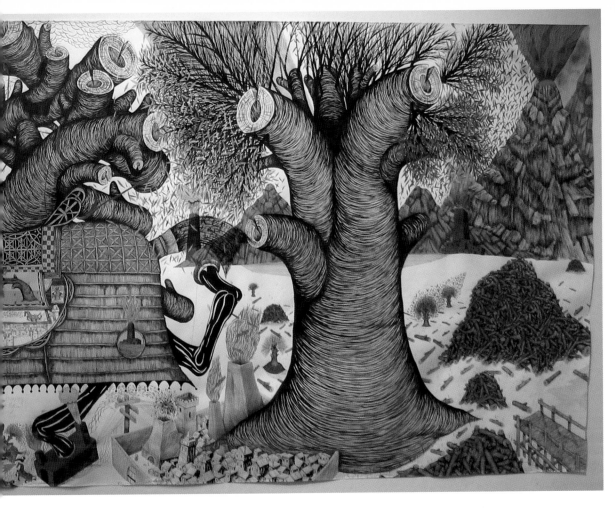

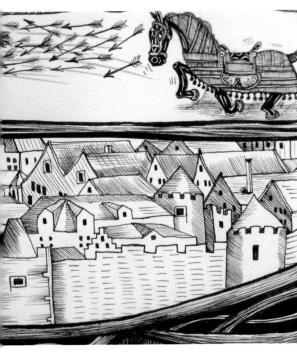

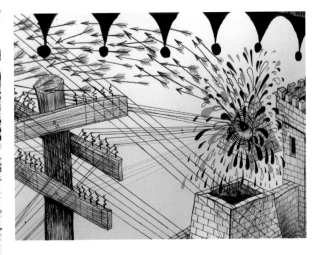

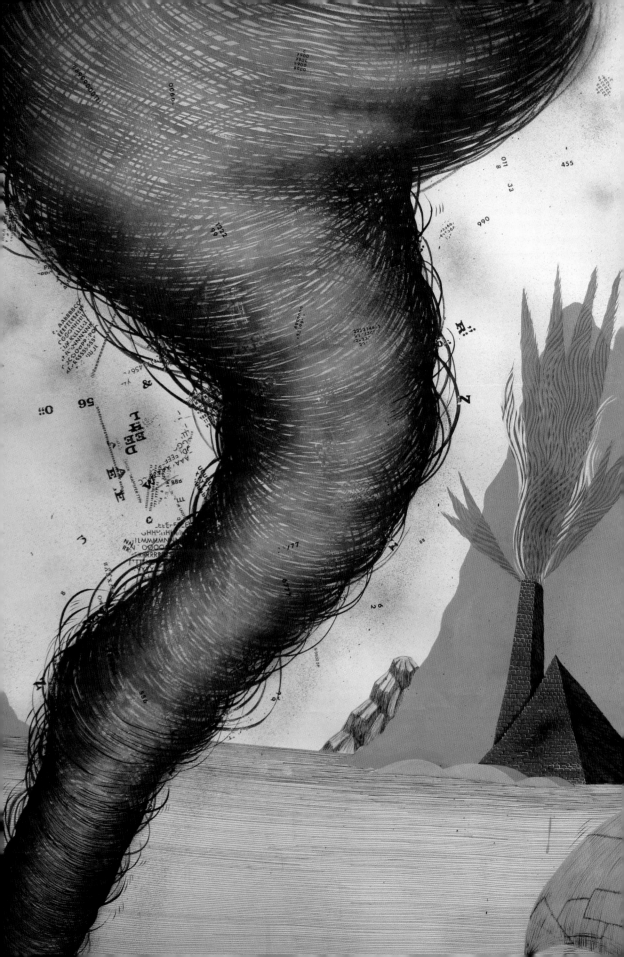

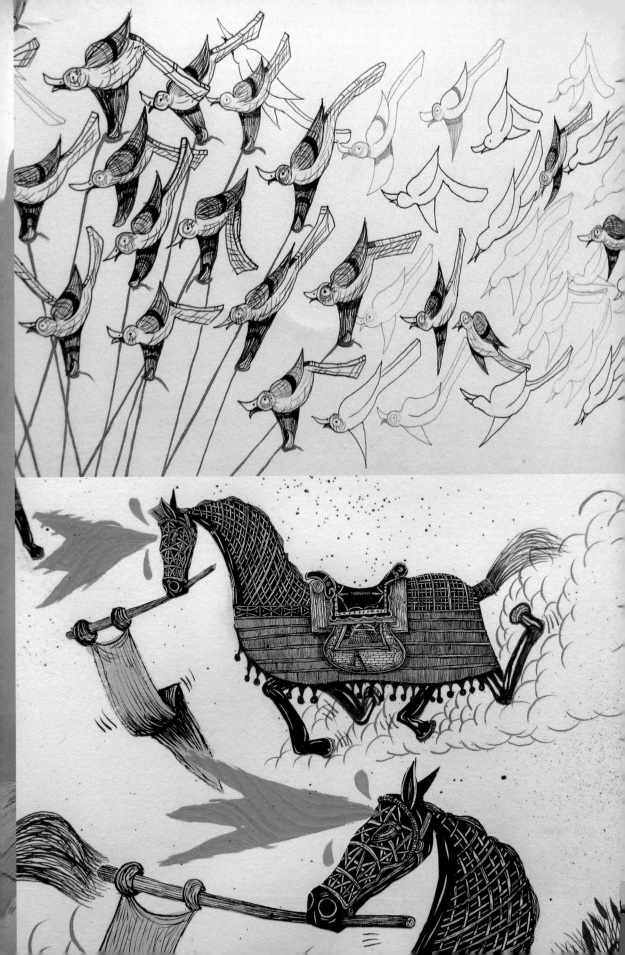

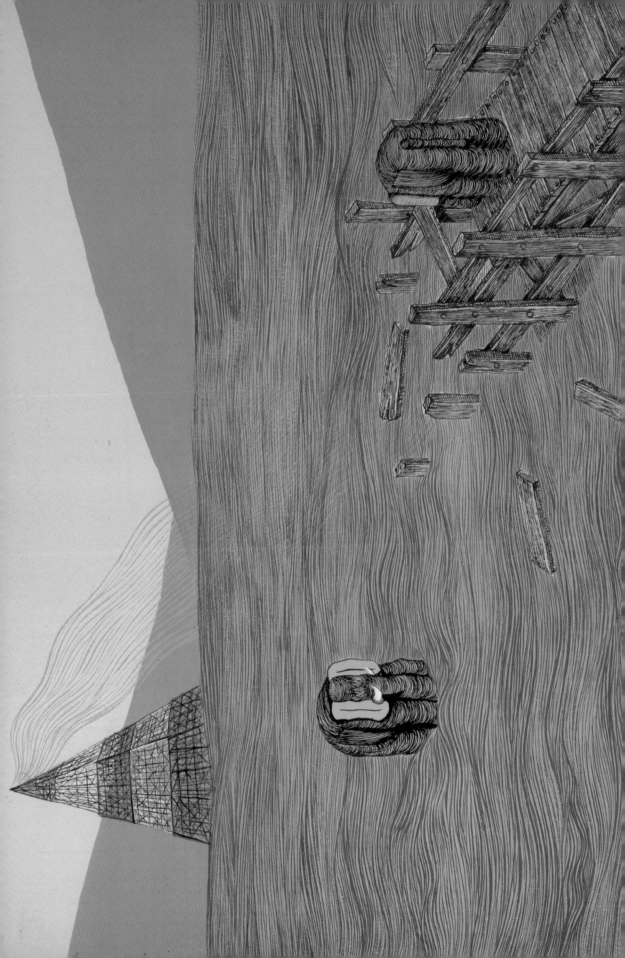

Excerpt from
Arrow Magazine #3

My work is filled with symbolism and yes, there are different connotations to consumerism and its disposable culture present in it. However, I don't think it would be impossible for a viewer to draw other conclusions. I am effected by and tend to paint what I see everyday to a degree, and unfortunately in today's world there are unlimited signs of the aftermath of consumerism everywhere. You would have to be blind not to see it. Although I am critical of consumerism, I am a lot more critical of "blind" consumerism. This "feeding frenzy of convenience" mentality that is so prevalent in today's society is neither responsible, nor is it sustainable. I am not going to sit here on a pedestal, and act like I am not participating and benefiting from it, to a degree. If you live in America, whether you like it or not, you are part of it. My depictions of such things to an extent, are an effort to establish a period of time in my work, which is the present, or now. This is not to say that there are not critical motivations behind these depictions. It is very important for people to be informed and conscious in their decision-making in regards to all of this. This is all I feel like I can really hope for. Our fast paced society doesn't make it very easy to do so

though. With informed decision making there is at least some sense of responsibility added to the equation, even if it is ignored. For example-if you want to shop at Wal-mart, go for it. But at least have the consciousness to know that by shopping there, you are supporting the greedy, rich, exploitative, soul-less, corporation that they are. It is not so easy to ignore when it is put in such honest terms. The problem is that most people are not making informed decisions. I guess it is convenient, easier, and cheaper in the short term, to ignore things like this. I must also acknowledge that some people do not live in a financial situation that allows them the privilege to even make such decisions, and what makes it even worse is that this is all part of the master plan of corporate America. It is sad.

In terms of messages in my work, there definitely are, however in the recent past I have avoided telling viewers what they are. That would defeat the purpose of painting them to begin with. My intention with my work is not to be definitive. Generally speaking, people are not stupid. They will be able to draw their own conclusions and I want to allow them to do so. Their conclusions may

be different than my intent, but that is fine with me. An artist's intent is no more significant or important than what a viewer sees or gets from a work of art. A viewer may get something similar, or they may get something completely different than what I intended, and that should be welcomed in all art. Sometimes people see things in my work that I never thought of. It's always interesting what different viewers decide to put emphasis on in a piece. It is all non-verbal communication, and it is that for a reason. If it was easier to put things into words or another medium, I would not be spending so much time painting and drawing. nor do I think they would accurately translate into any other form. It doesn't feel that necessary to try to explain my work in any other terms. This is not to say that "meaning" in art, is not both important and necessary.

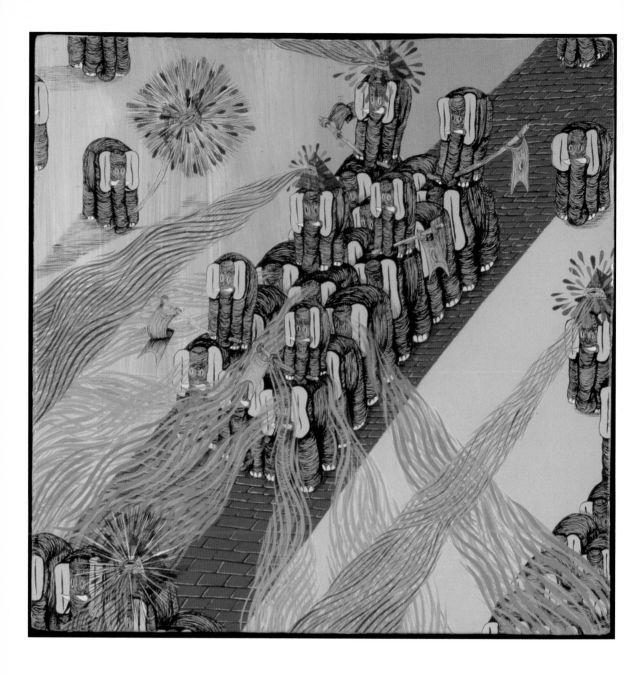

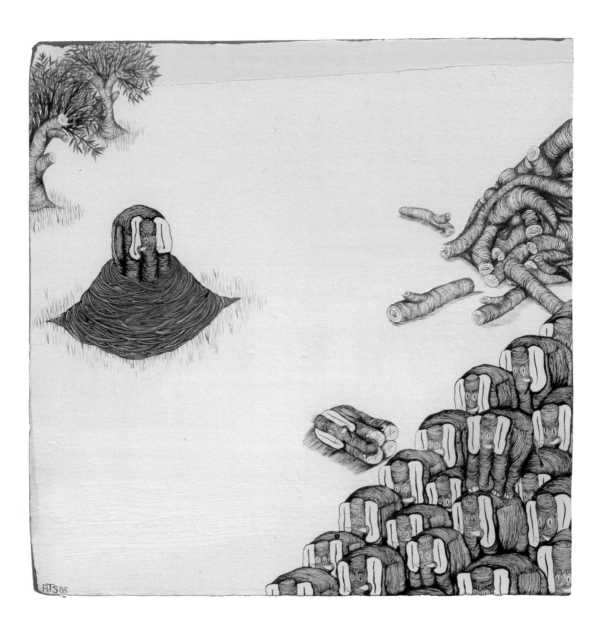

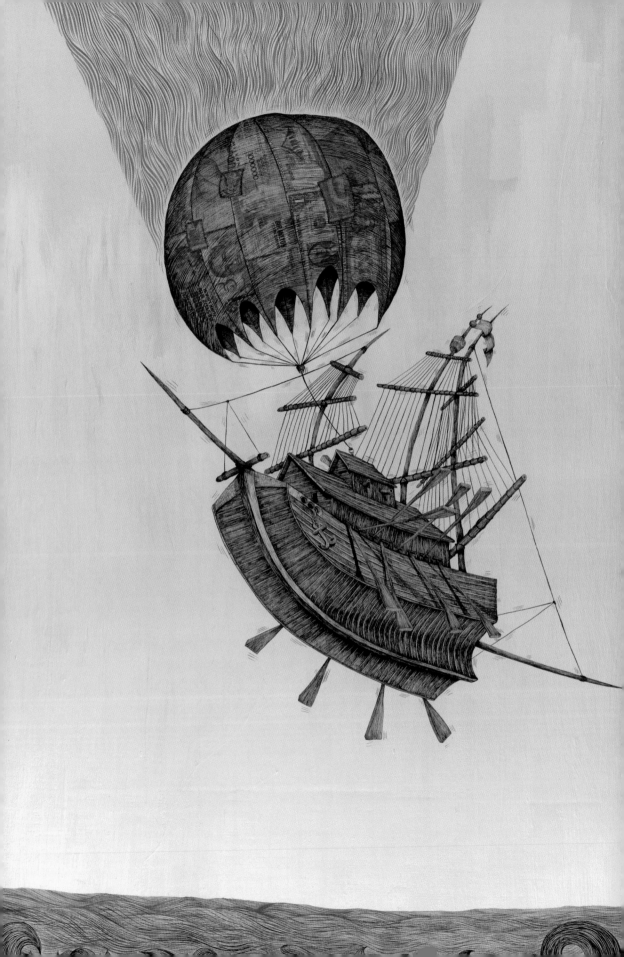

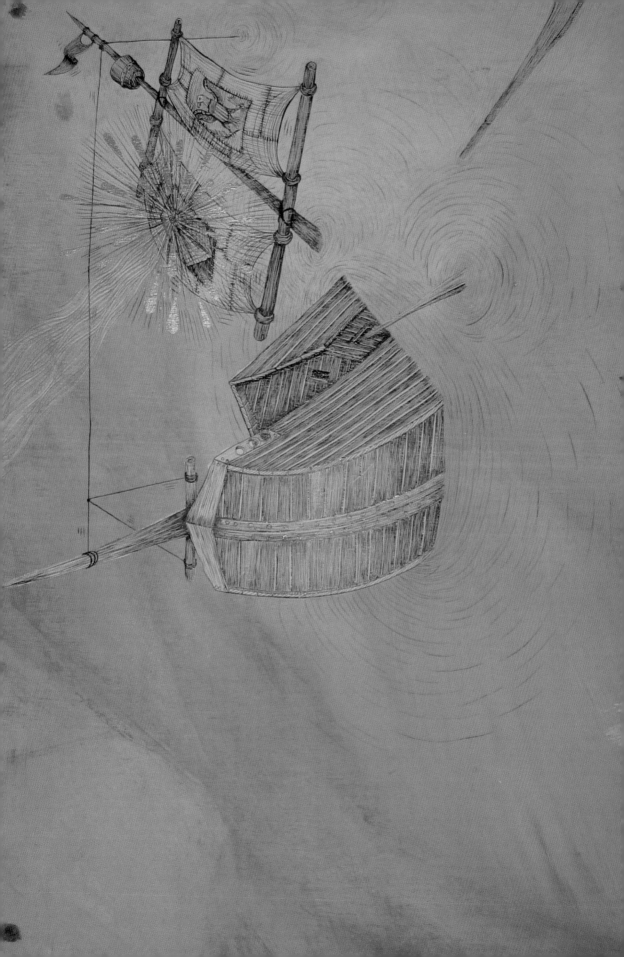

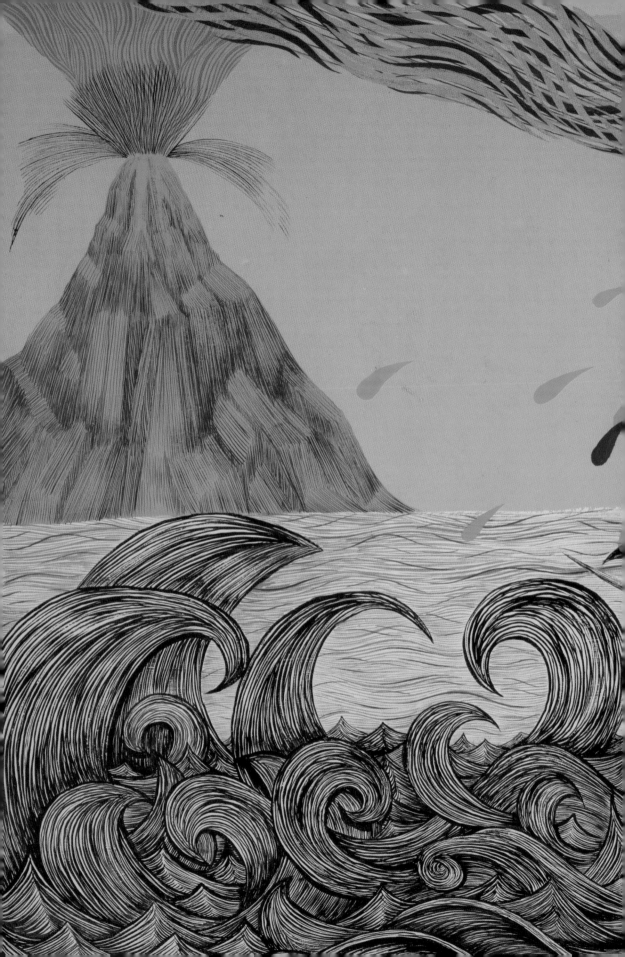

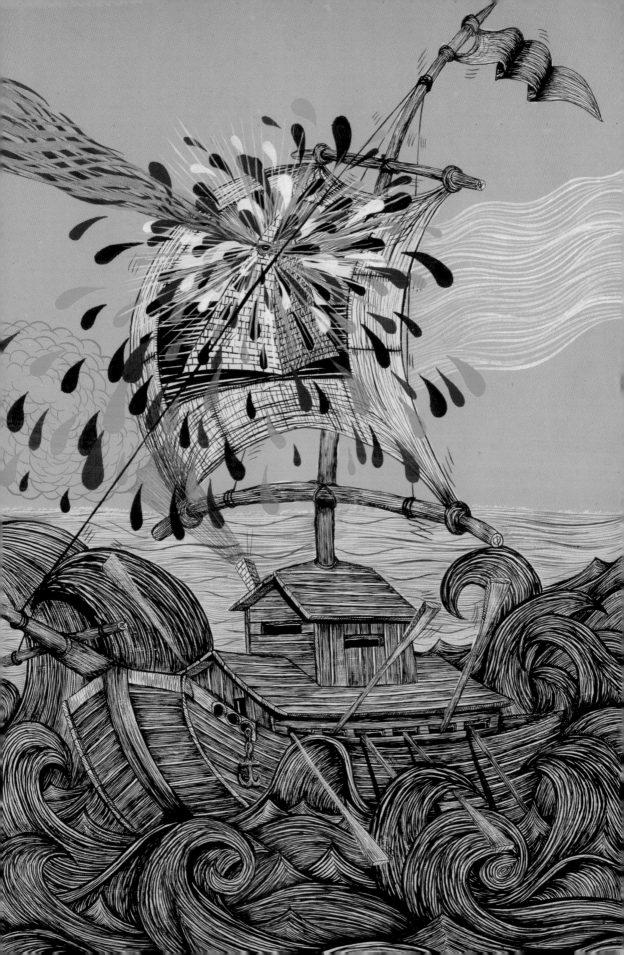

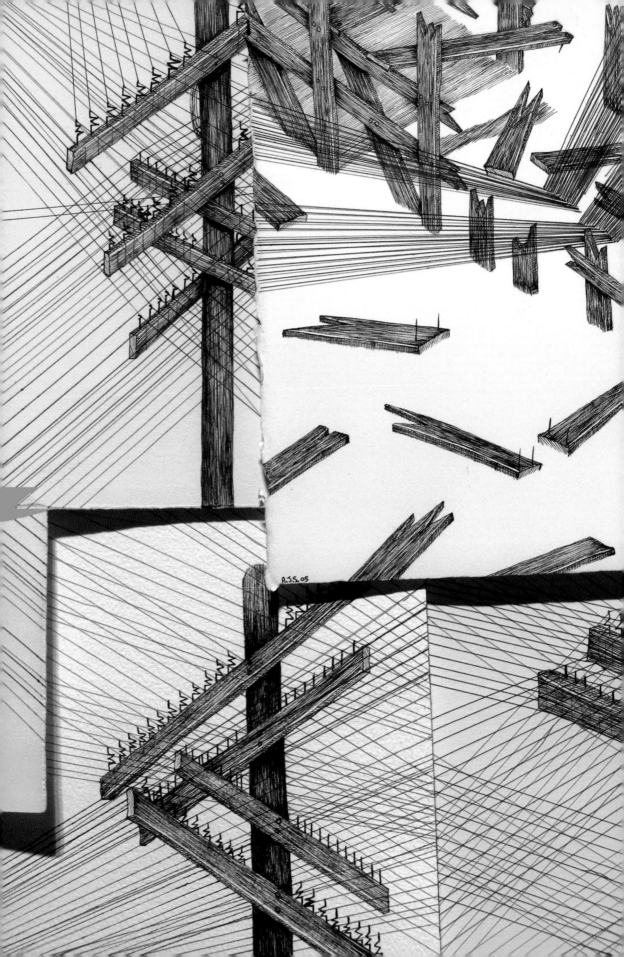

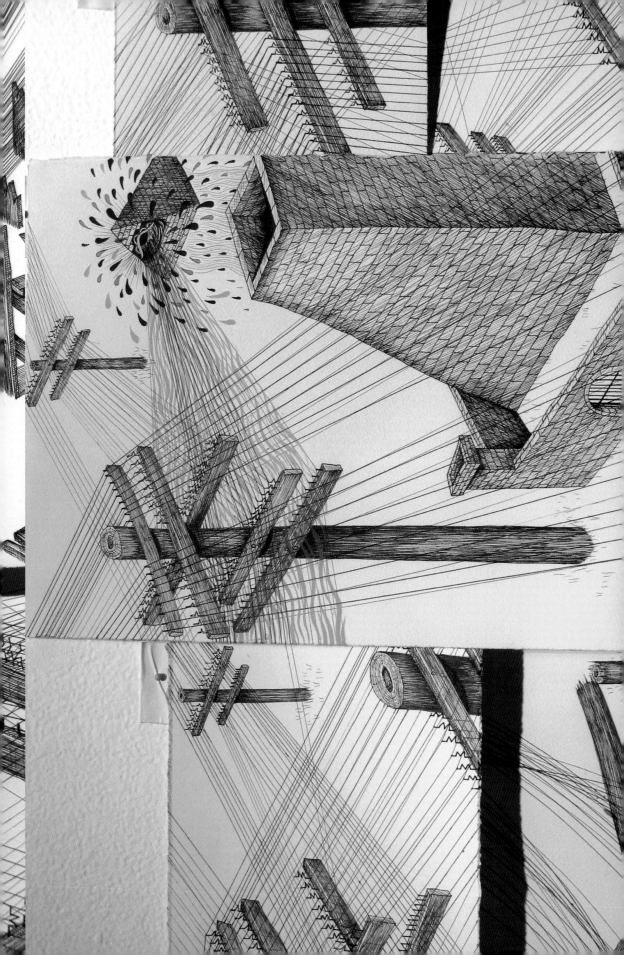

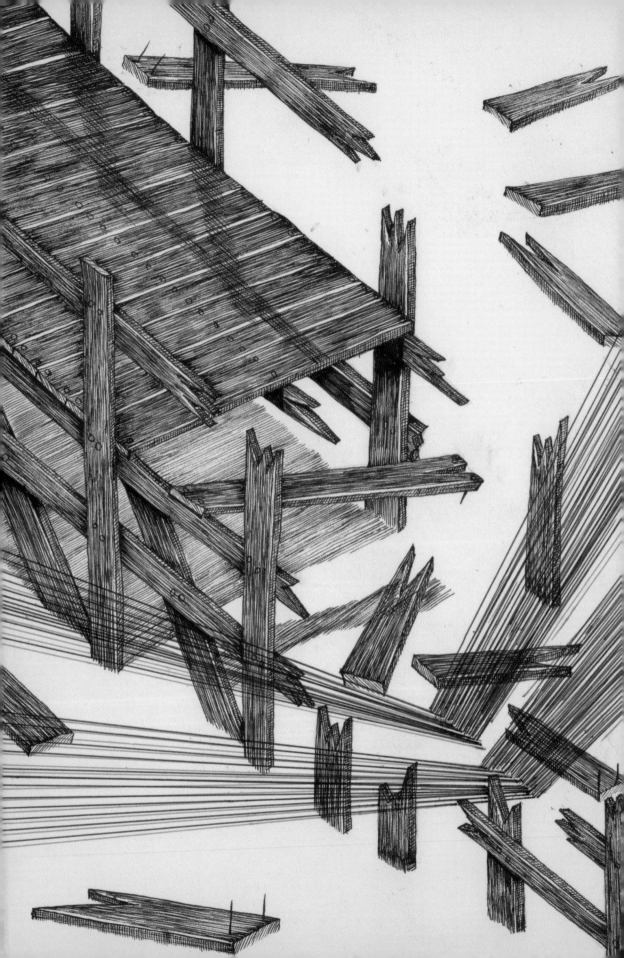

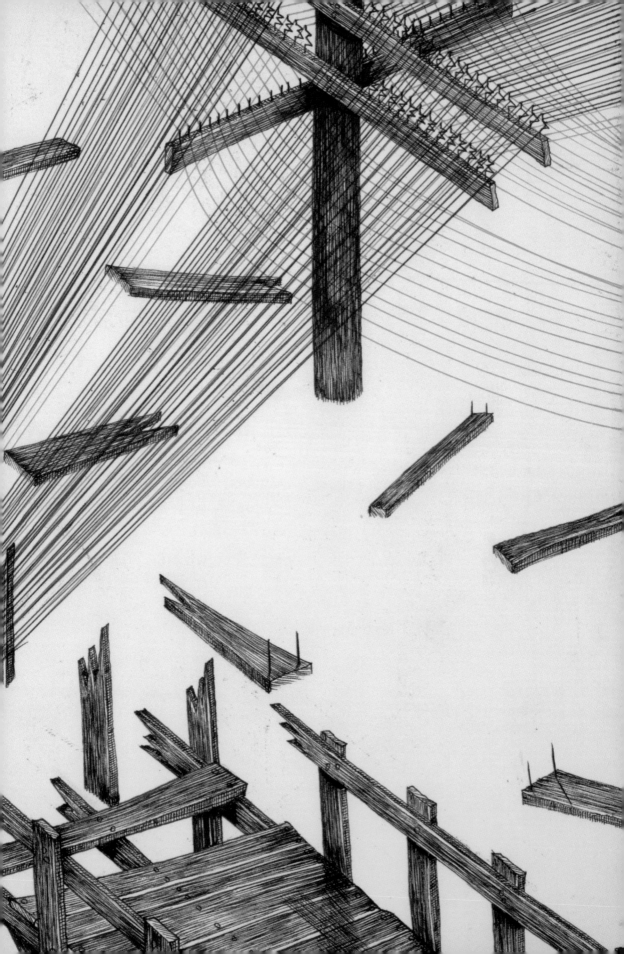

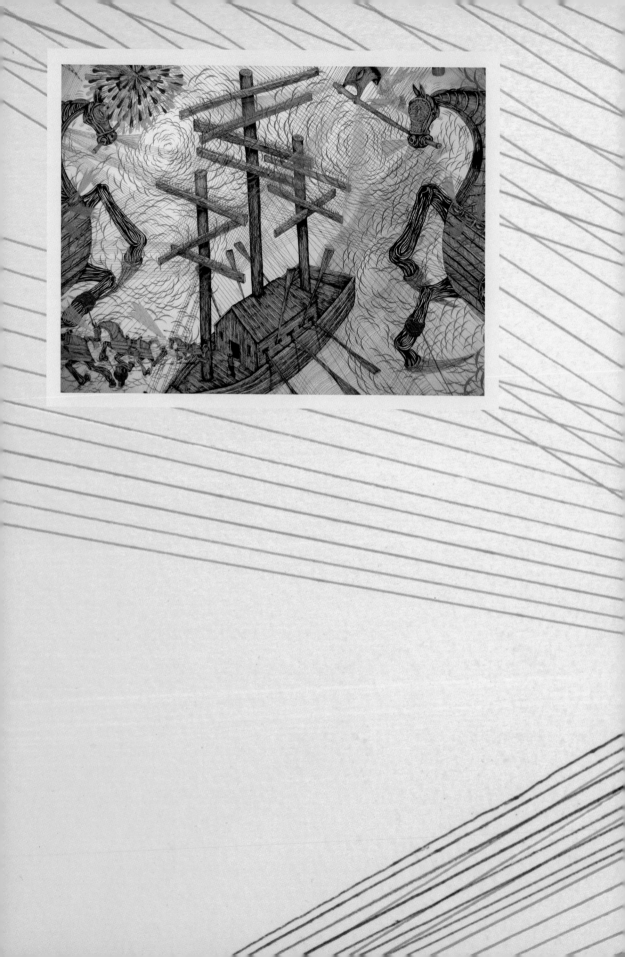

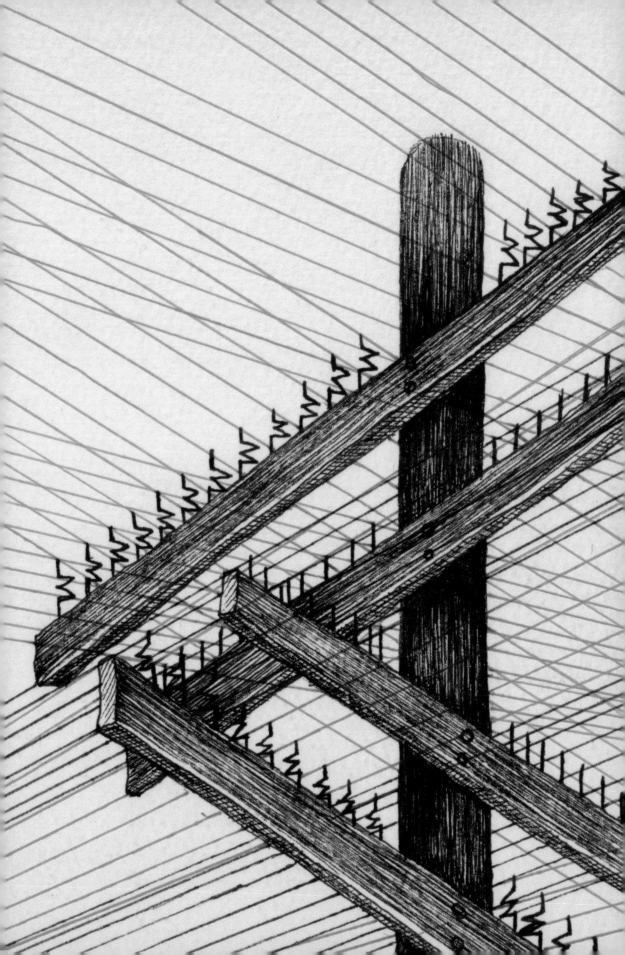

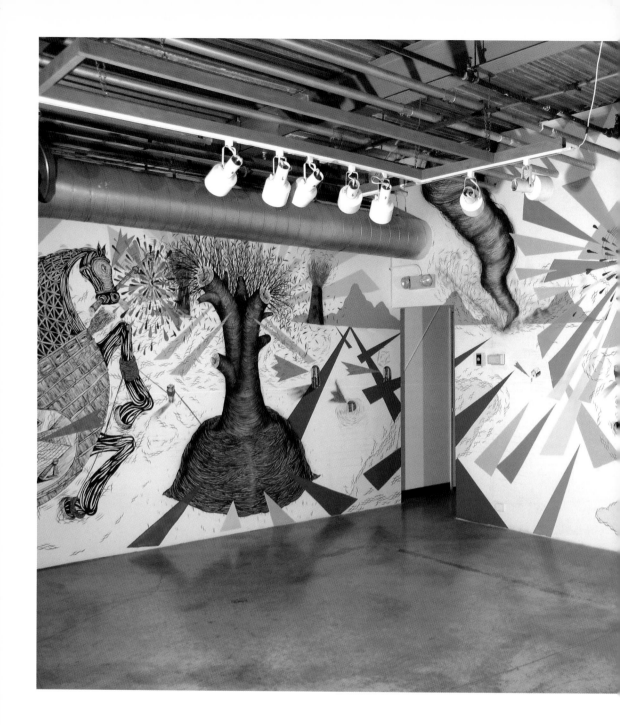

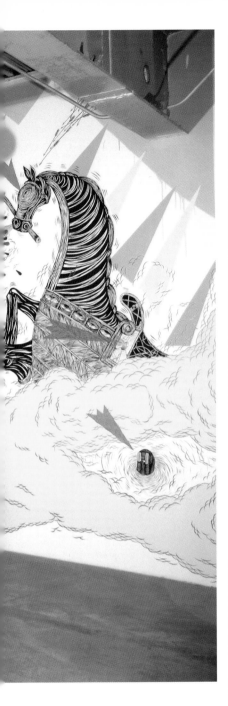
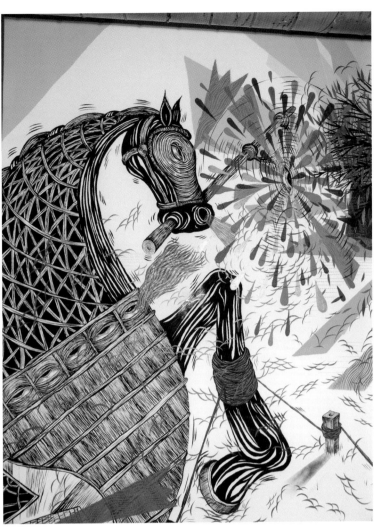
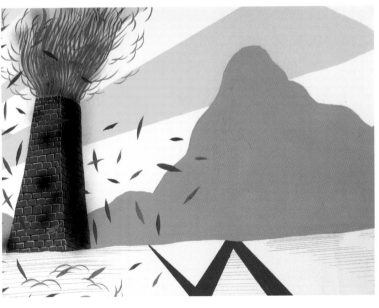

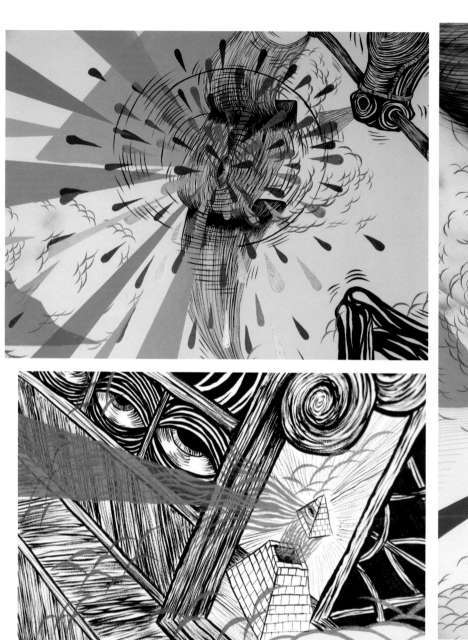
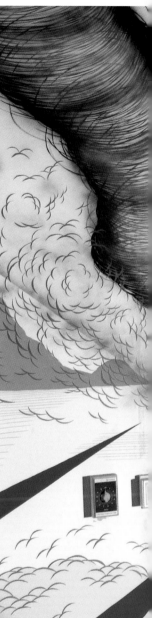

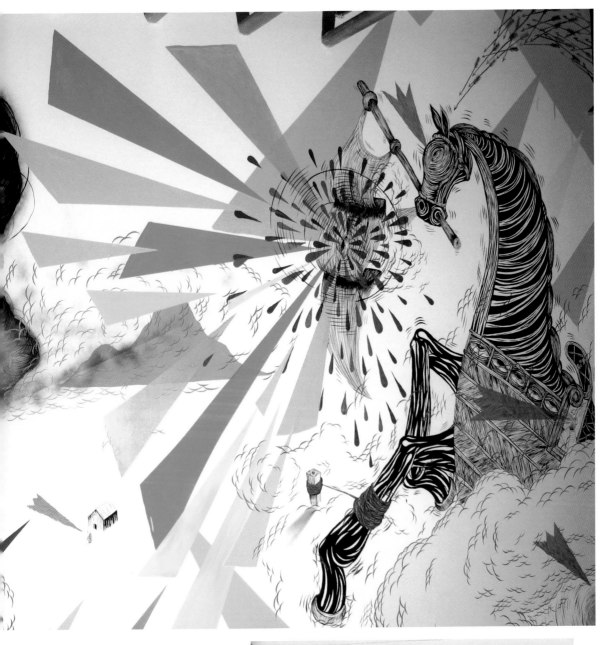
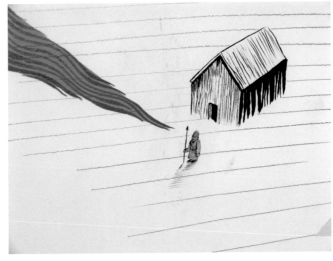

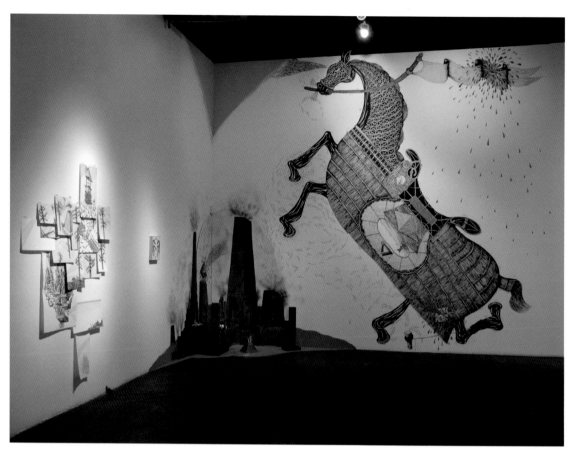

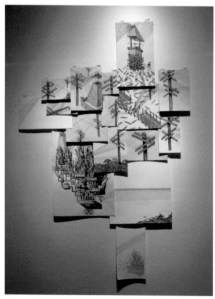

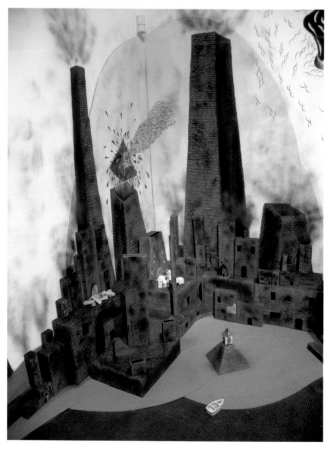

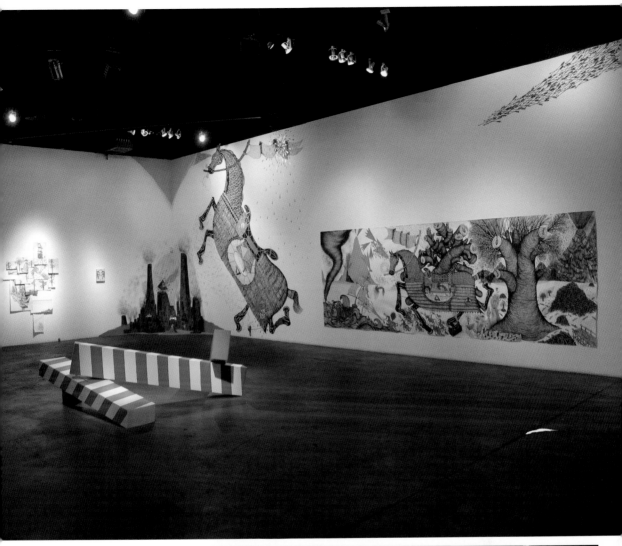

Foreground Sculpture by Craig Costello.

OTHER POSSIBILITIES:

CRAIG COSTELLO
GREG LAMARCHE
ALICIA McCARTHY
ANDREW SCHOULTZ

Track 16 Gallery, Santa Monica, CA, September 2005.

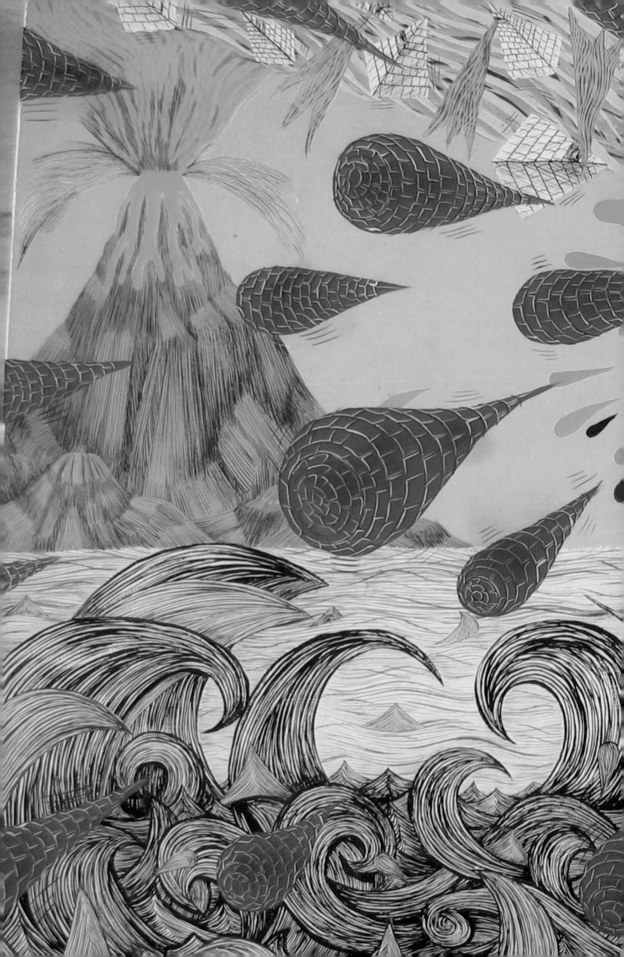

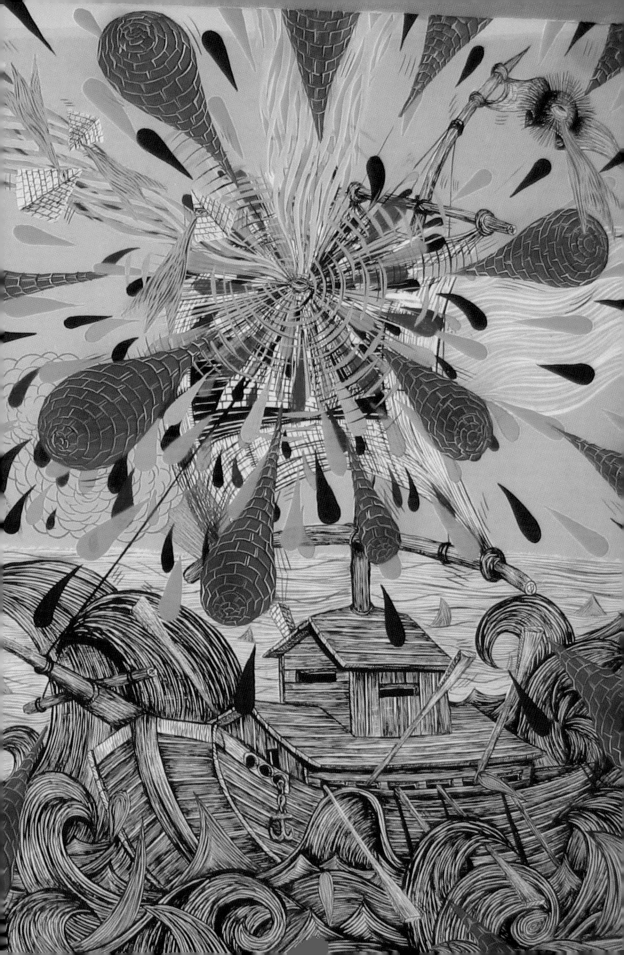

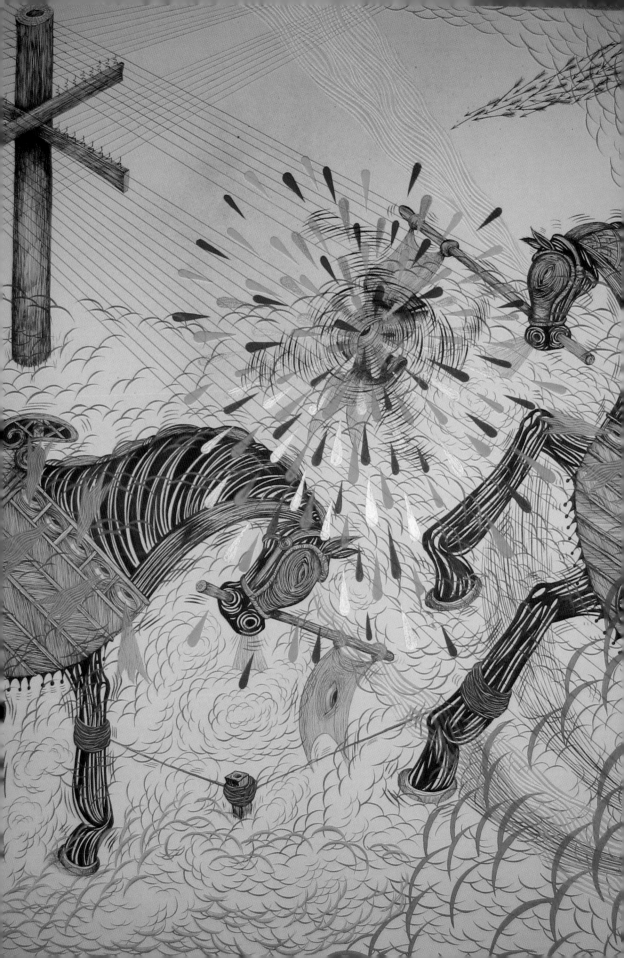

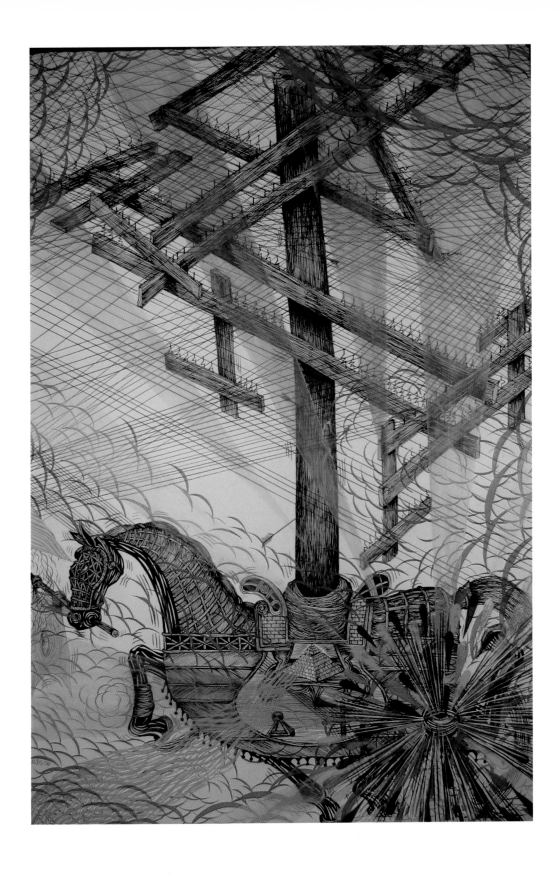

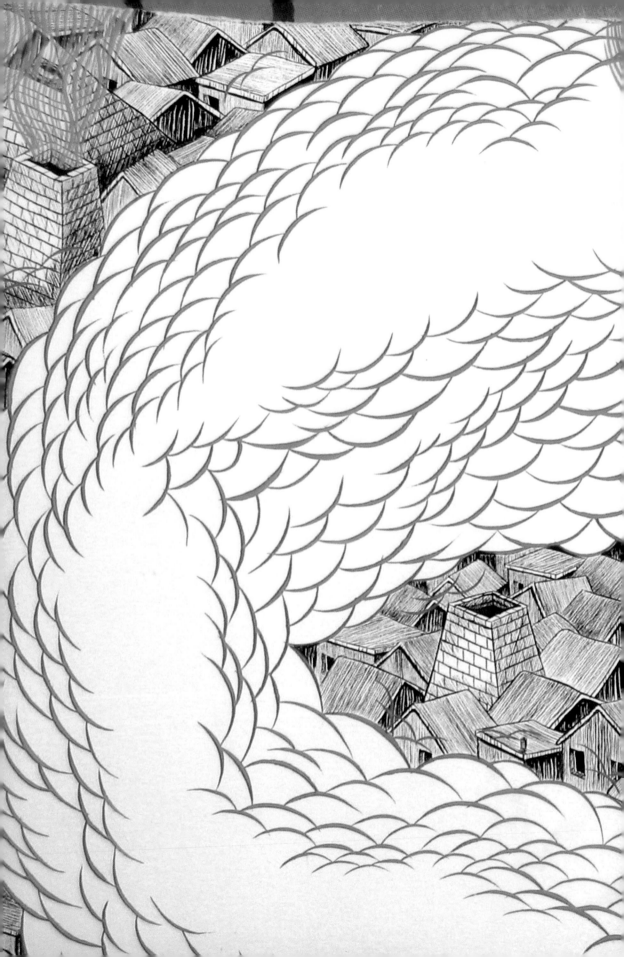

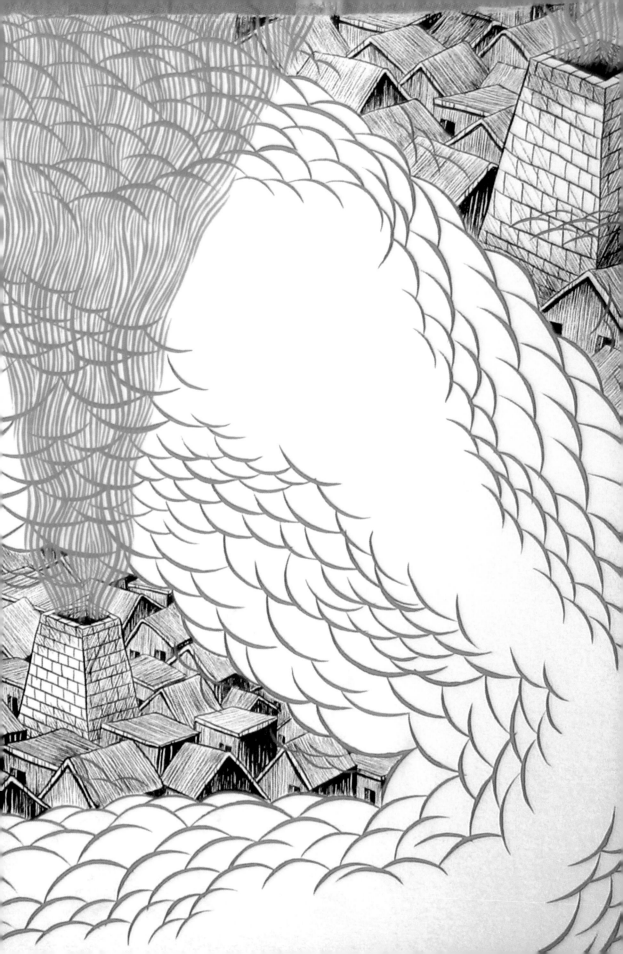

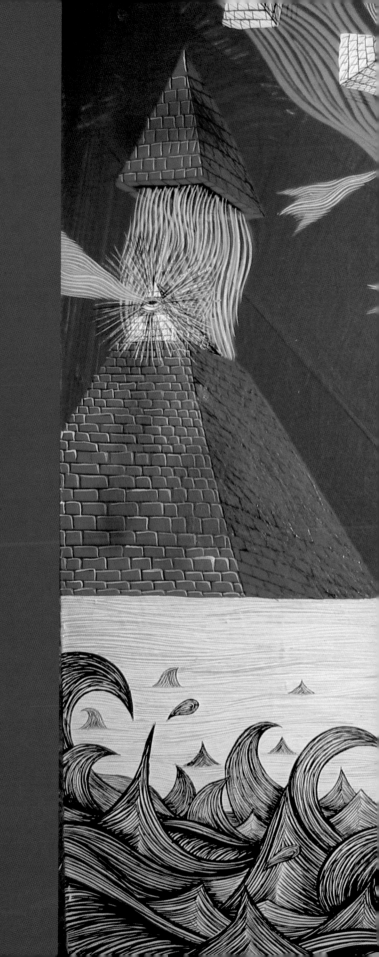

"It is admirable and respectable to cheer for
things that are both righteous and unrecognizable
in today's society".

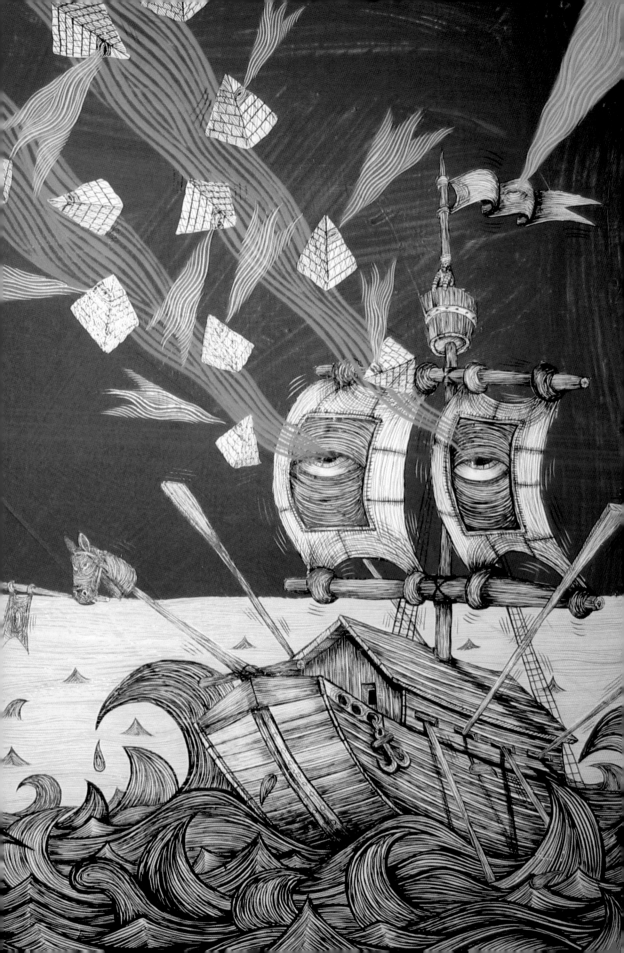

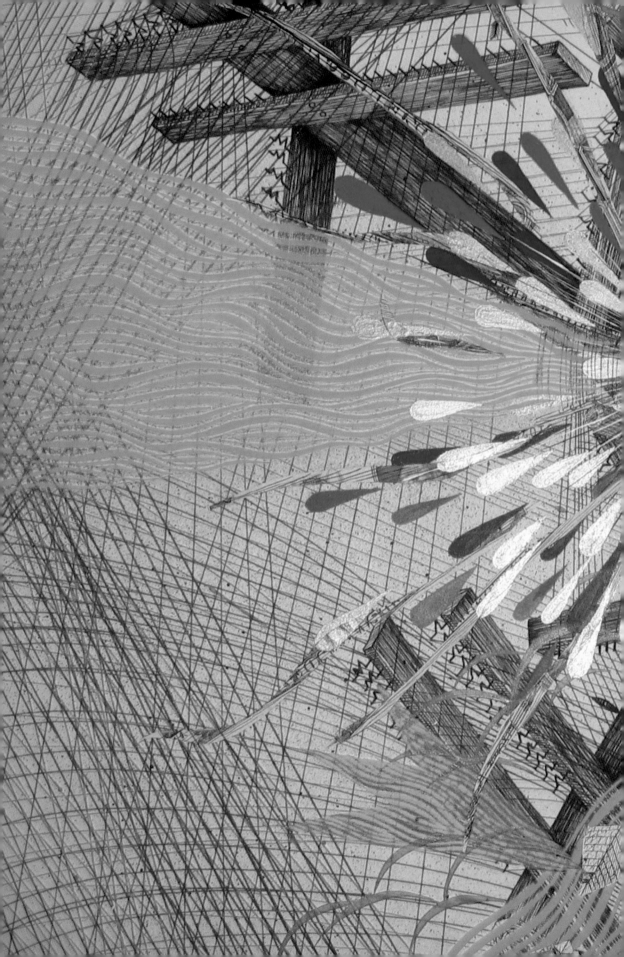

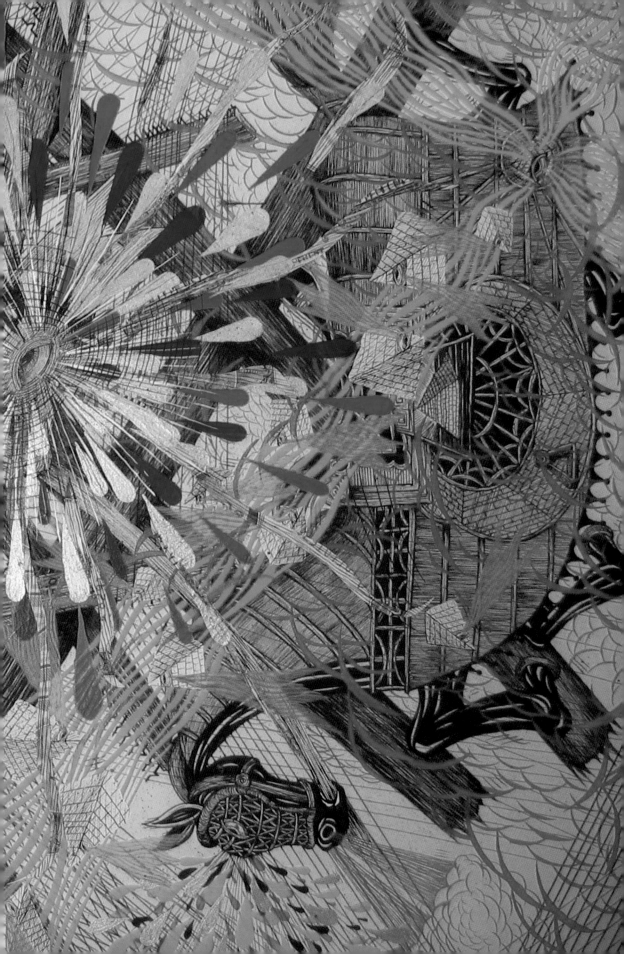

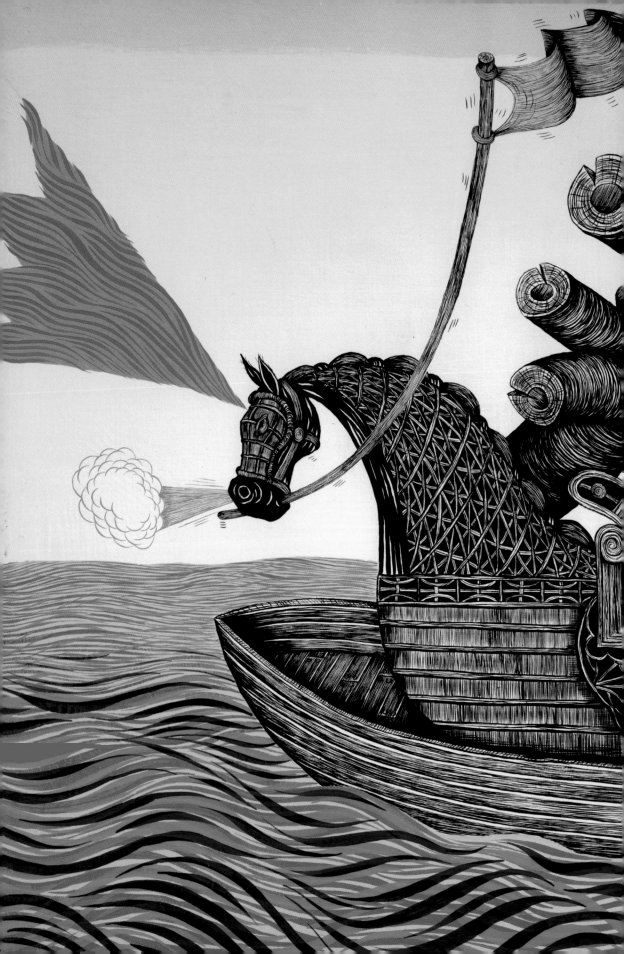

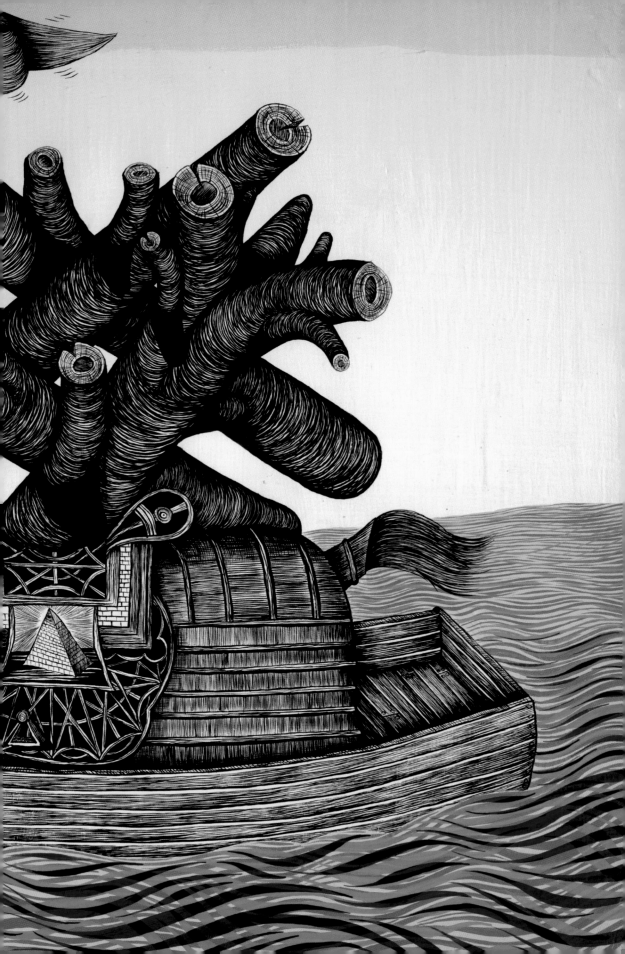

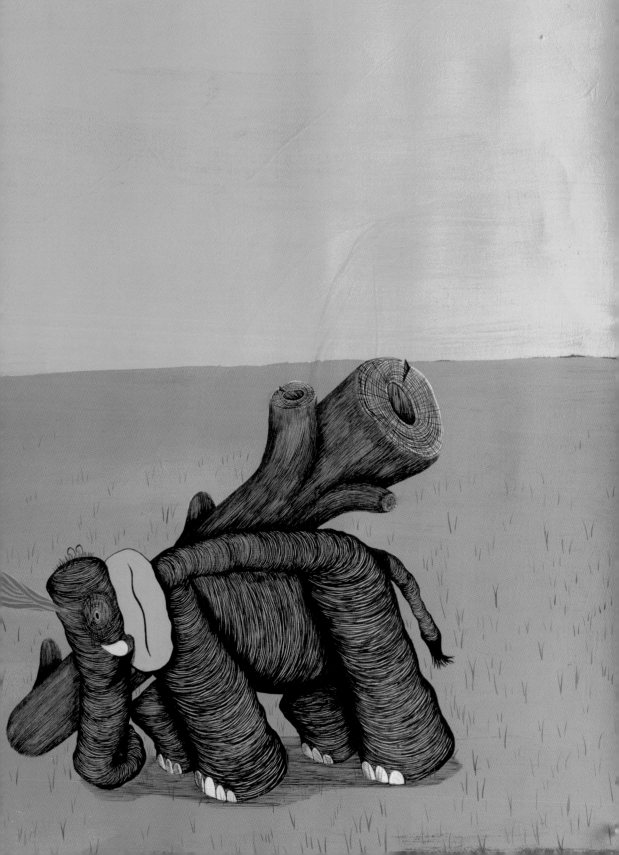

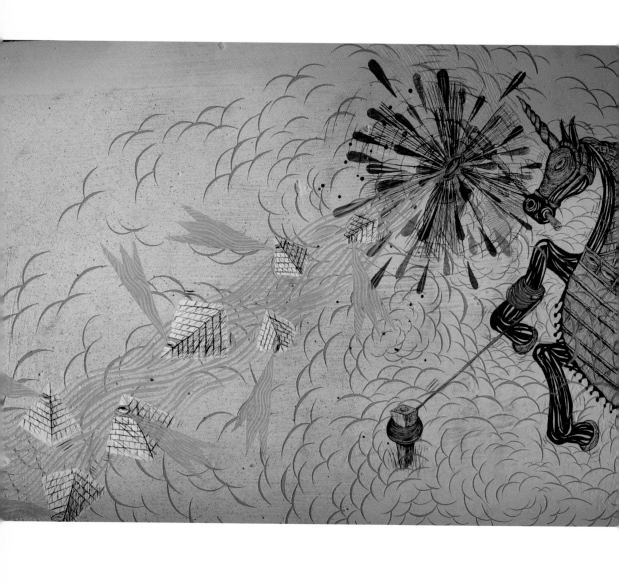

The Battle Has Just Begun

Although I've known Andrew Schoultz for only several years from working within the San Francisco arts community at Intersection for the Arts, I feel like he's been an artist whose work I've been familiar with my entire life. He's also someone who I've had the opportunity to get to know on a personal level from the many conversations over cigarettes while working on a project together or bumping into each other in the city somewhere. The work is an extremely accurate reflection of who Andrew is as a person—full of strong convictions and deep-rooted beliefs, earnest and full of integrity, bold and sensitive, socially engaged and critical, and embodying an old world work ethic. Through the fortunate opportunity to see hundreds of his works over the years in exhibitions at galleries, on walls throughout San Francisco, and the many pieces he miraculously works on simultaneously in his studio, I've been consistently struck by the level of his artistic output, and the degree of thought, insight, and time that goes into each piece. Andrew's what a common friend of ours, Mark Pearsall, has termed an "art athlete"—someone so focused and constantly striving to improve his artistic vision, both conceptually and technically, and always re-defining the standards of what he can achieve. He is thoroughly dedicated to his work, and the level of integrity in which he lives his life and by extension the way he approaches his artwork is a constant source of inspiration. Andrew's one of the hardest working artists I have met. He understands that to work hard and realize a vision requires a lot of sweat, and he's not one to shun calluses and aching arms.

The most impressive aspect of Andrew's work is the sheer accessible immediacy of it, and the breadth of its impact and appeal. He's refined his vision over the years by working both in the streets and in the studio, and in places such as Portland, Maine; Yogyakarta, Indonesia; Sun Valley, Idaho; Los Angeles, California; Detroit, Michigan. Whatever the piece may be—a full wall mural, a painting on a wood panel, a lithograph—there's a universality of this work that transcends age, class, culture, education, avocation. I've seen looks of wonderment and fascination from an entire spectrum of people when they encounter his work—lawyers, toddlers, homeless folks, politicians, collectors. Maybe its because of the use of bold colors and our common understanding of a certain comic style that his work references. Or maybe it's because of the impossibly intricate, detailed line work that infuses his entire body of work and the open-ended narratives that inhabit and define his pieces. But beyond the surface of his un-questionable ability to meticulously handle a paint brush and balancing a growing color palette is a complex visual world that really hits at the heart of what he is doing through his work. Andrew possesses a self-defined language of characters and objects that he utilizes through an infinite number of variations to comment upon the state of our world. Whether it's his flying birds, massive trees and piles of logs, stoic elephants, ships exploring at sea, erupting mountains and churning waves, brick pyramids and smoking chimneys, or armor clad horses, they all are parts of an ongoing narrative of the effects and affects of power play in society—the haves and have-nots, the struggles and triumphs, construction and destruction, humankind and nature. Andrew is always one to verbally and artistically highlight situations of inequities, of senseless consumption and unnecessary waste, of the growing divide between those who struggle to survive and those who prevail through greed and consumption. His work unfolds the more you dig into the depths of his pieces—and unlike other art that is also rooted in a dialogue with our social-politic, he doesn't hit you over the head with his perspective on the world. He leaves it up to us, the viewer, to look for the dots to connect, to comprehend the frozen instant of movement, to assign intentionality to running horses, plodding elephants, sailing ships, flying birds and arrows.

And Andrew's got the vision and chops to pull all of this off. What starts off as a number of large swatches of paint on a wall or a piece of wood panel or paper seems like a random assortment of colors and shapes. But as the hours and days pass, you can see the masterplan that Andrew had envisioned all along. Lines get painted in, and his characters start to re-emerge again in a new visual drama. He lays down thick heavy lines that frame out the armature of his armor clad horses, begins to detail the armor with thousands of fine point cross hatched brush strokes, articulates the mass of a tree with curved lines and shadows—and what begins to emerge is another timeless dialogue, pieces of art that perfectly reside in the now, yet look like fantastical reflections that could have come from religious tomes from centuries ago or apocalyptic dreamworlds from an unforeseeable future.

Kevin B. Chen

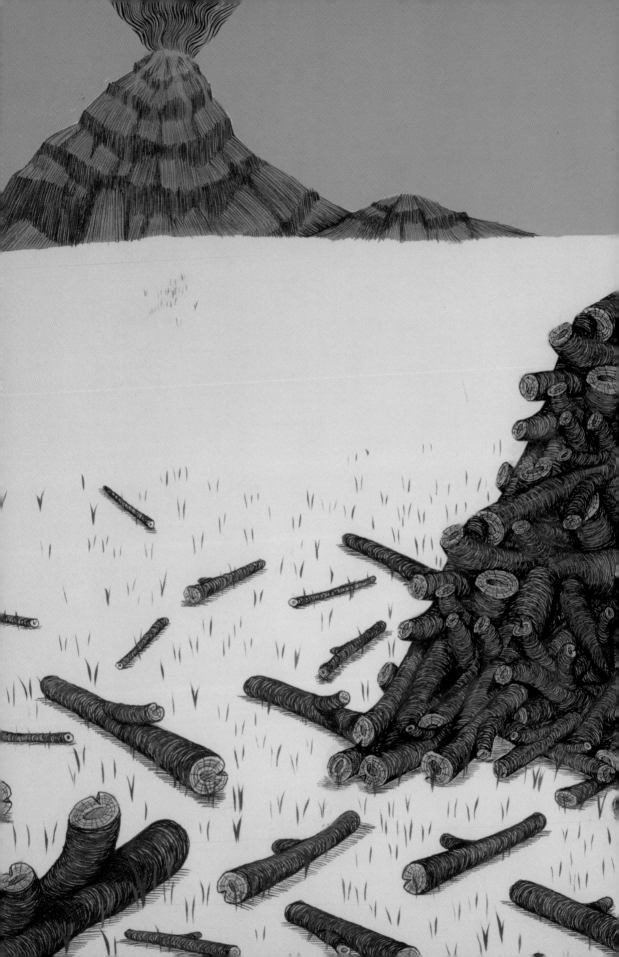

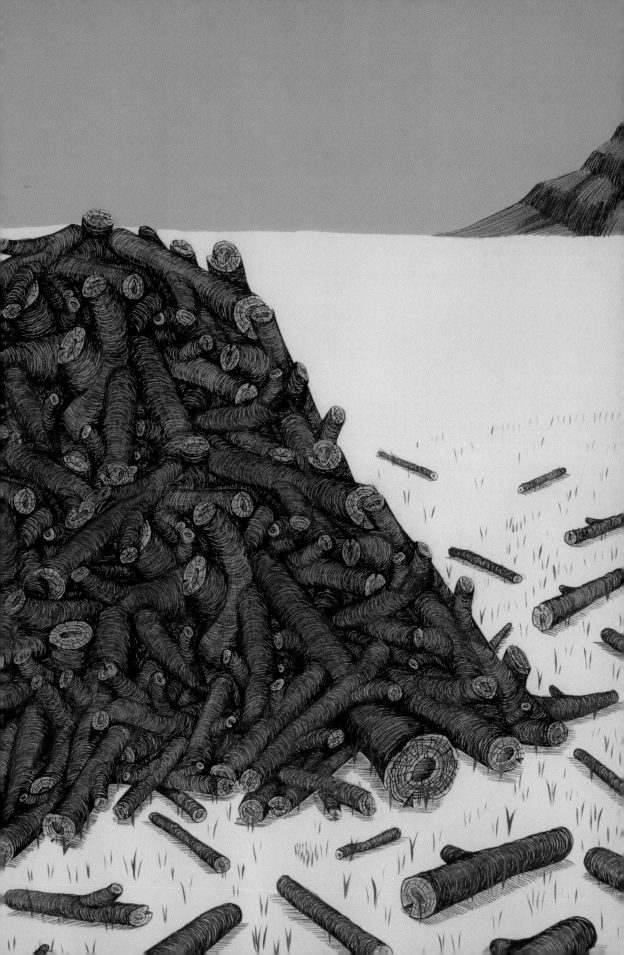

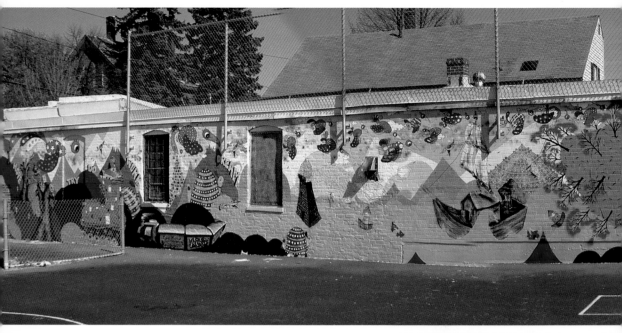

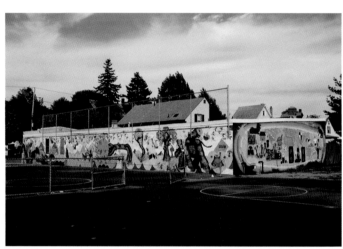

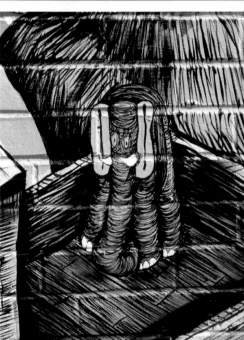

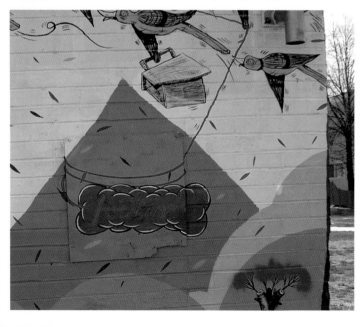

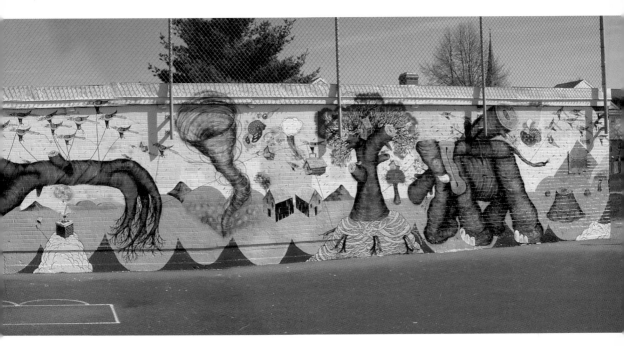

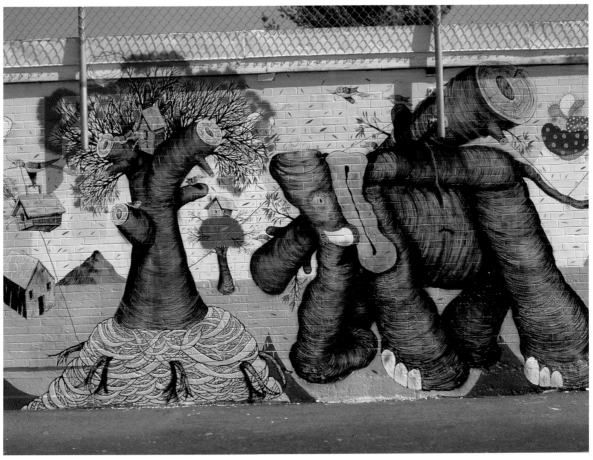

Portland, Maine, 2004.

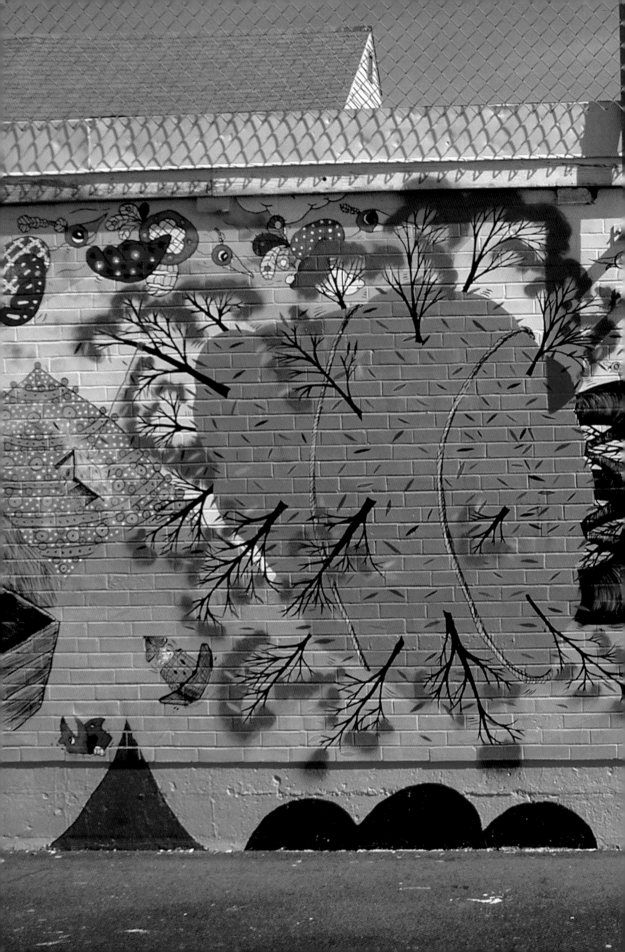

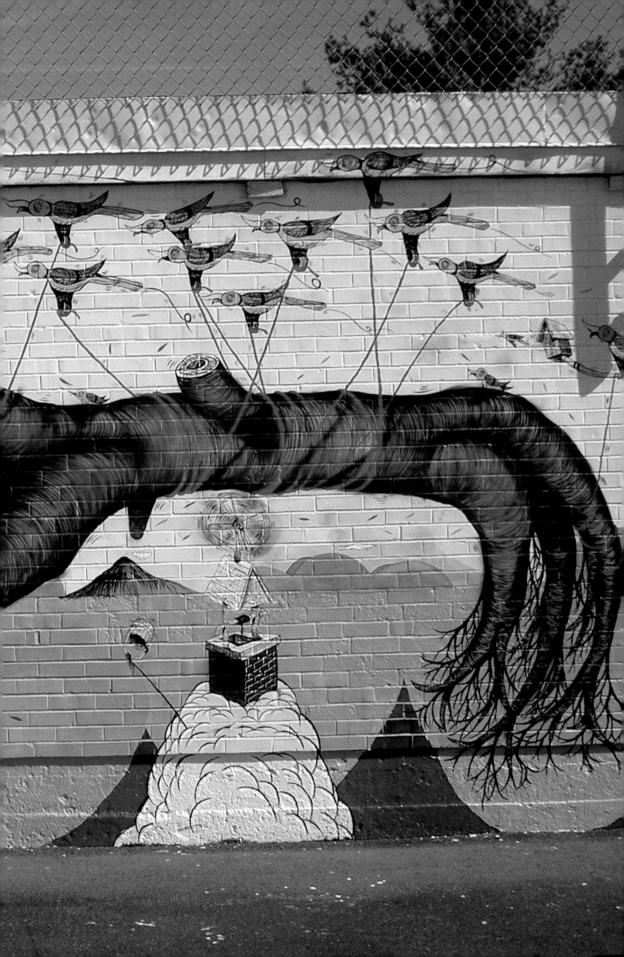

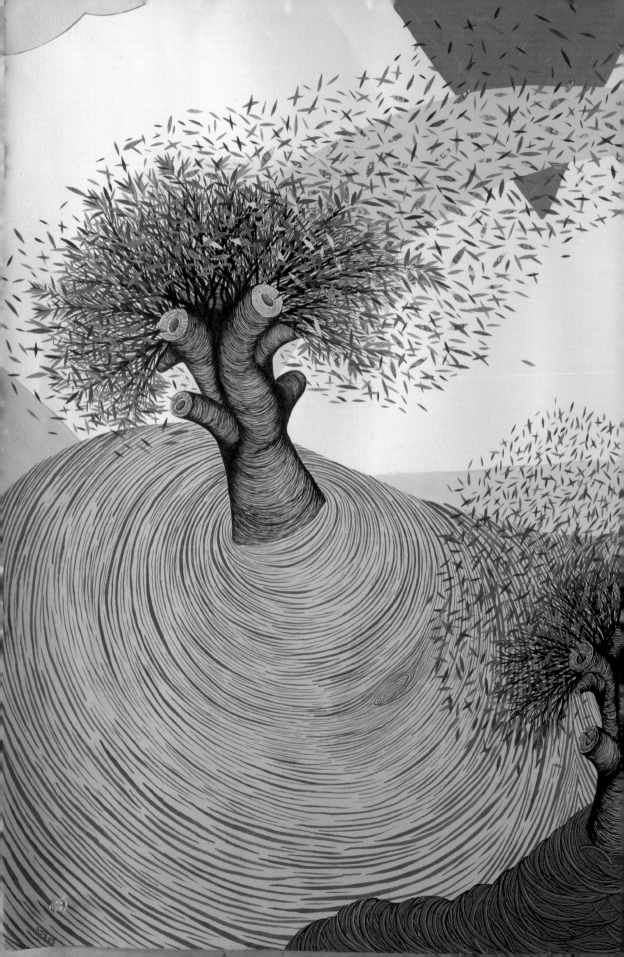

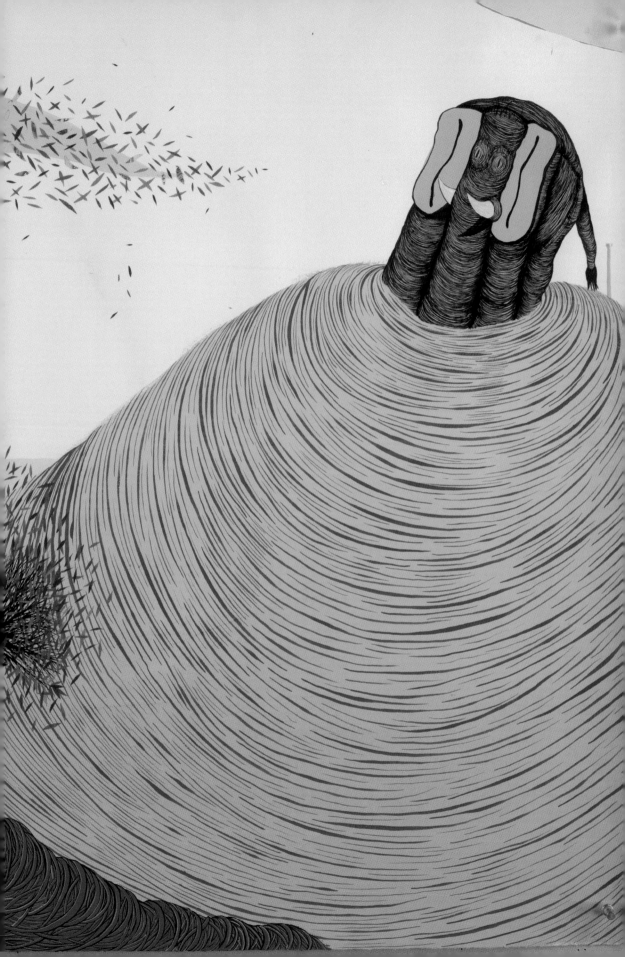

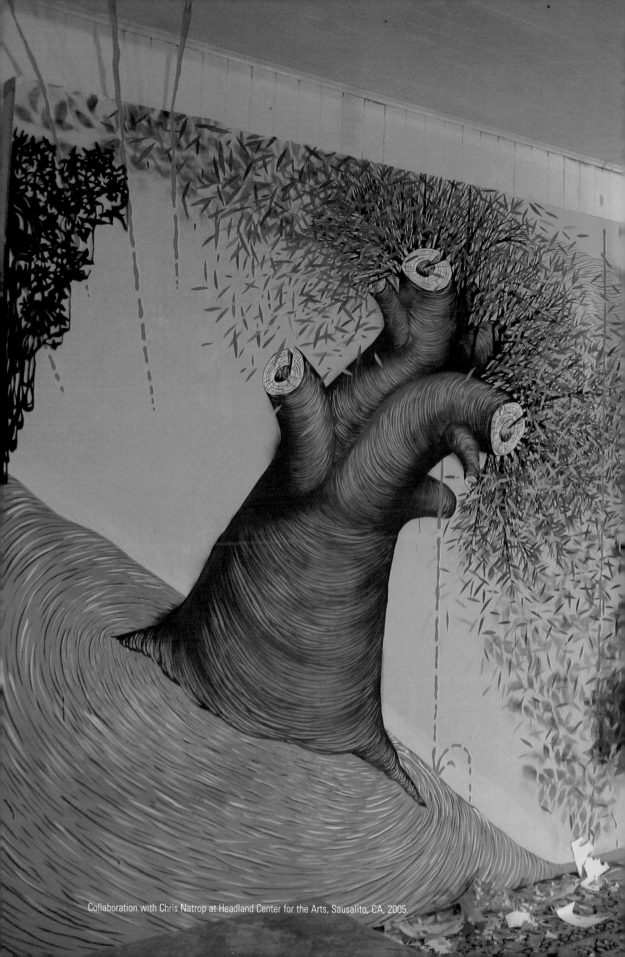

Collaboration with Chris Natrop at Headland Center for the Arts, Sausalito, CA, 2005.

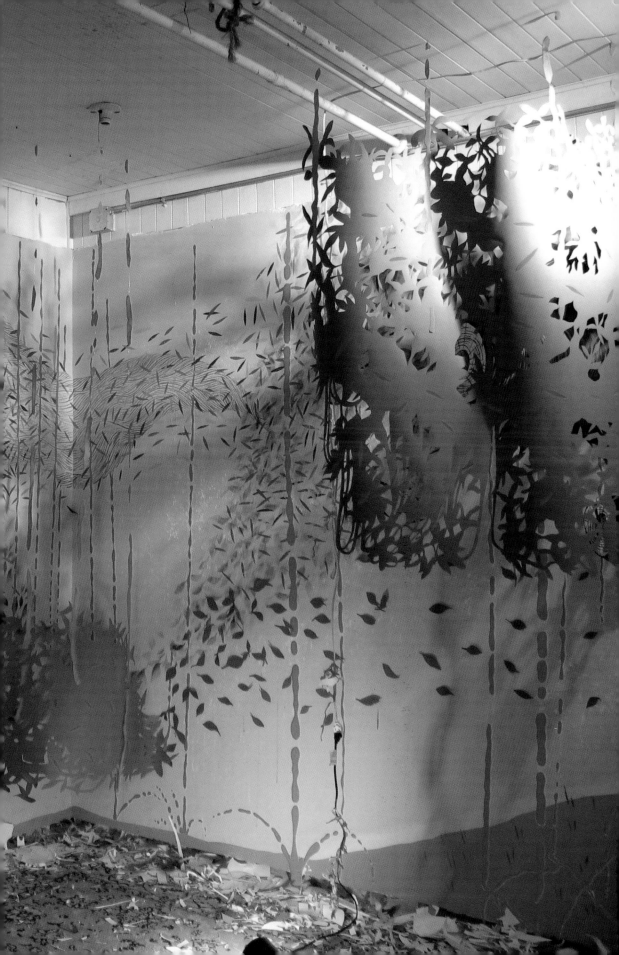

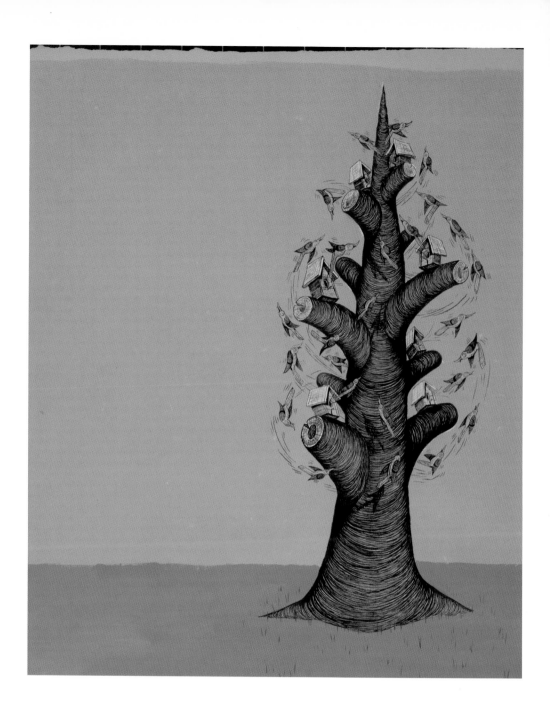

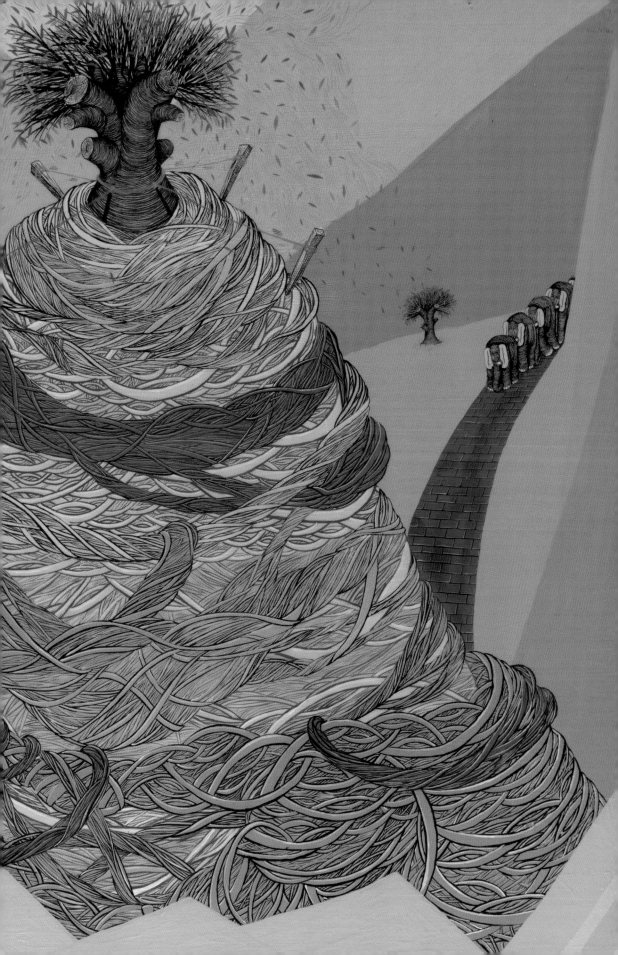

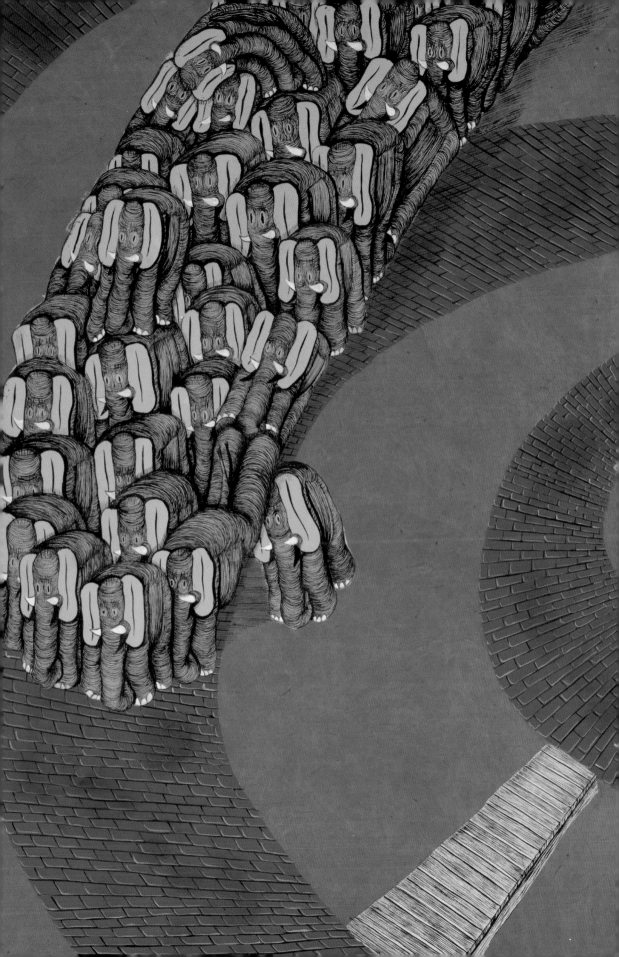

For many years I have been interested in creating nondefinitive narratives in my work. It has led me to no longer feel the need to explain my images. Of course, there are politics and personal meanings in my work, but I think it is important to not eliminate the viewer's ability to get other meanings or draw different conclusions than what my intentions are. In Contemporary Art I think there has been way too much emphasis placed upon artist intent. Indeed it is an important aspect of art, but at times I think it can be very alienating to viewers. I would rather engage with them, and encourage them to make their own decision about what a piece of work is saying or not saying. What a viewer gets from a piece of art is just as valid as the artist's intent.

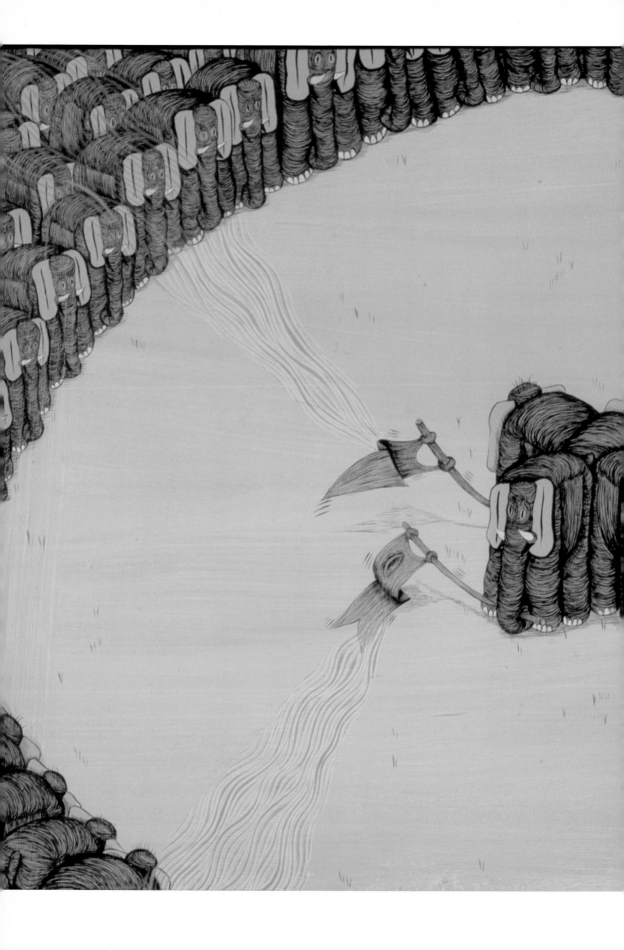

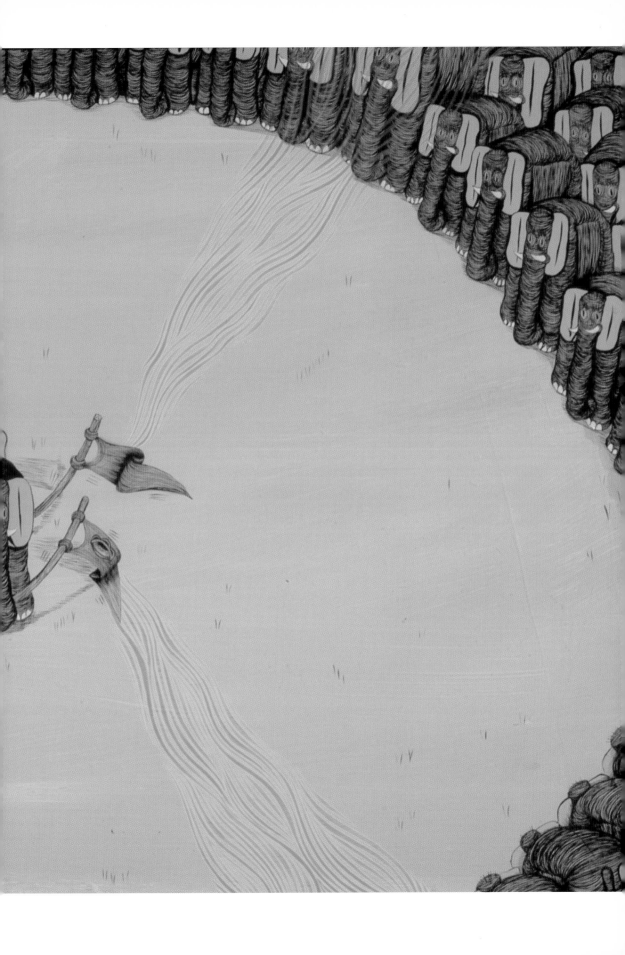

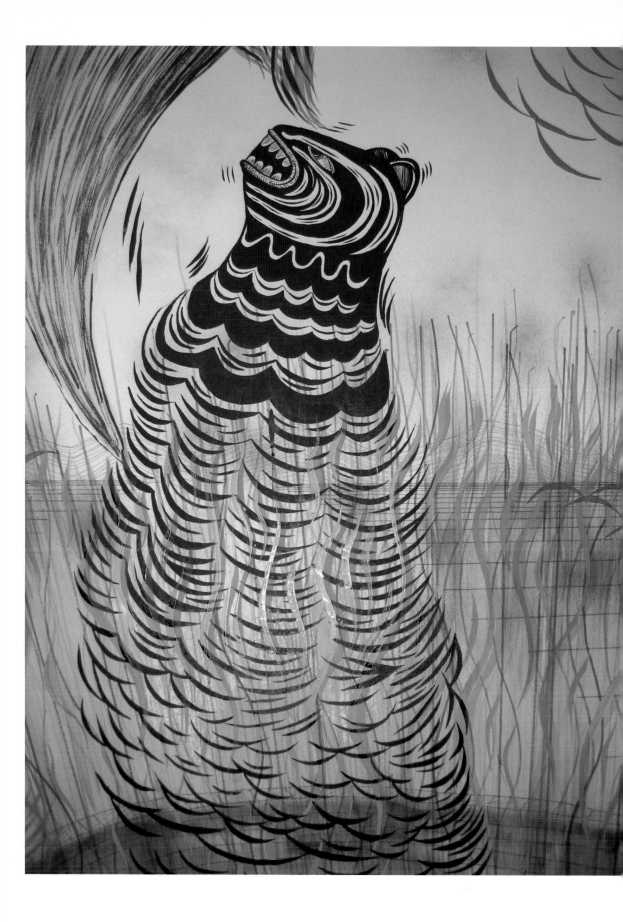

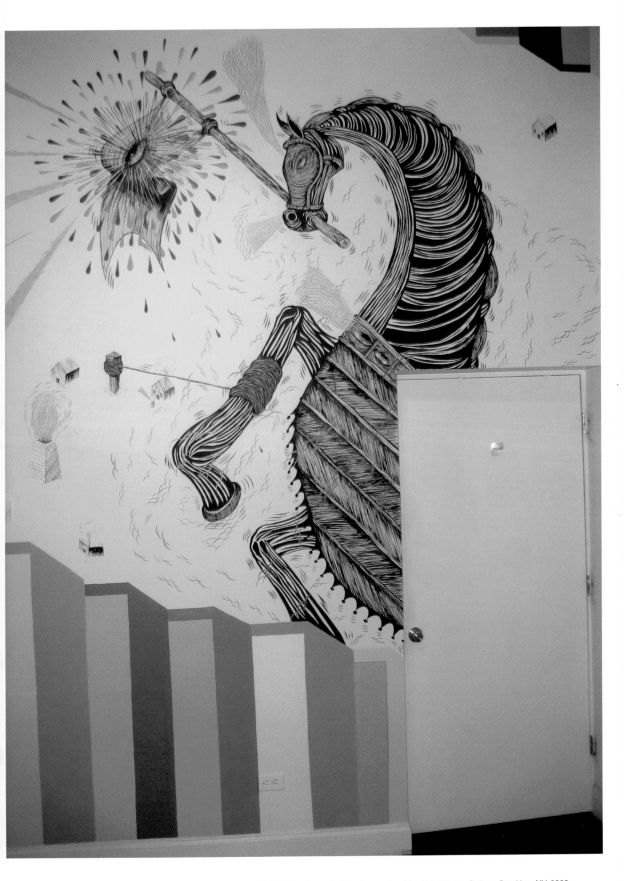

"Small Worlds," Collaboration with Greg Lamarche at McCaig-Welles Gallery, Brooklyn, NY, 2006.

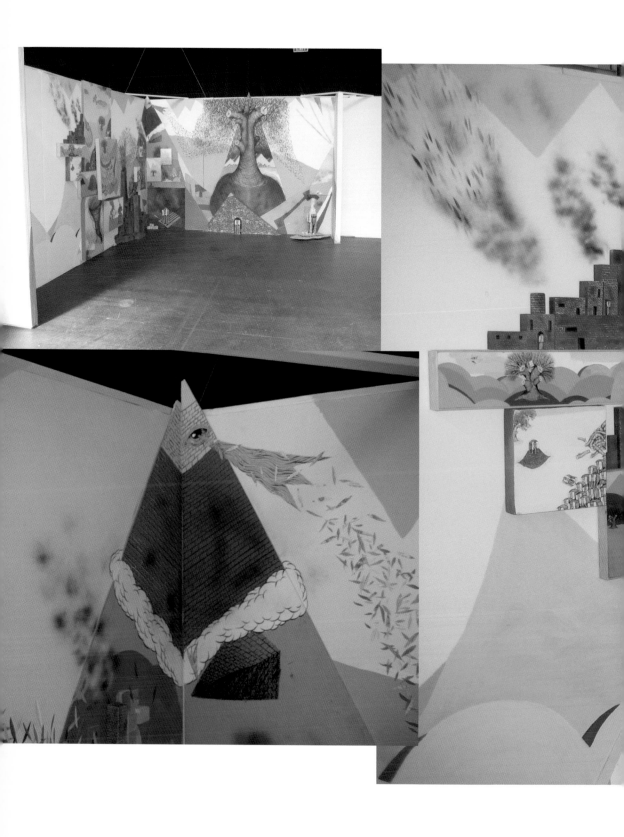

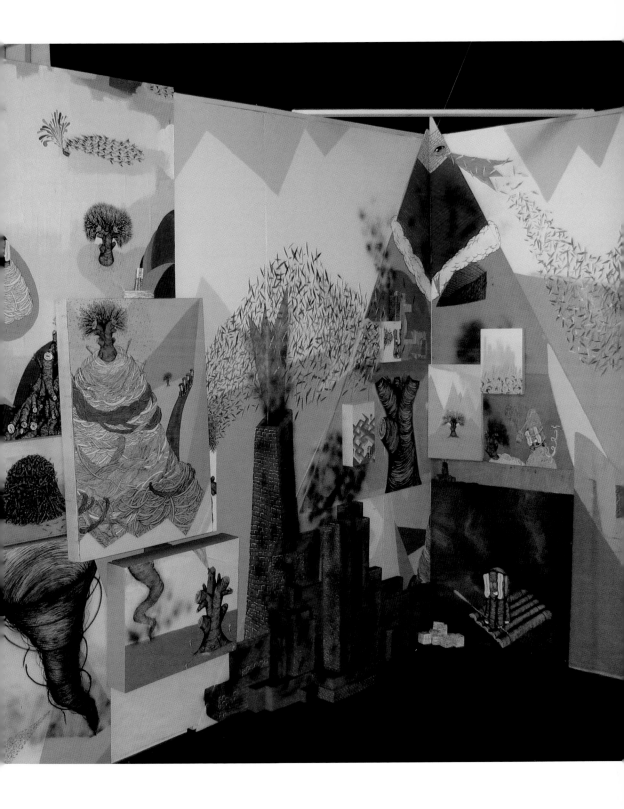

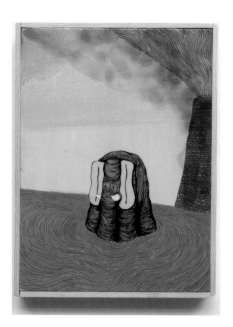

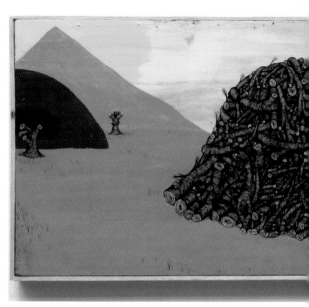

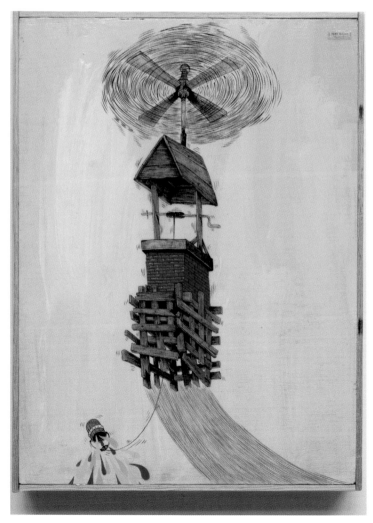

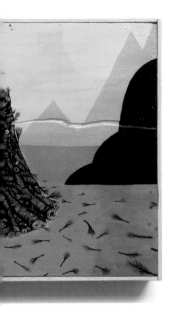

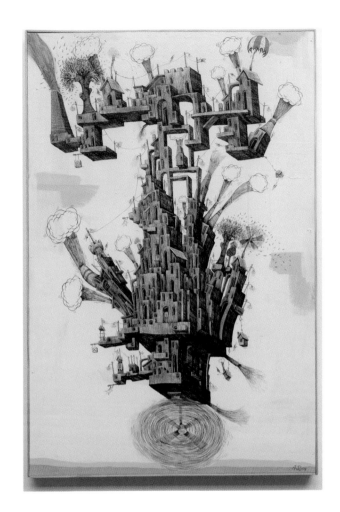

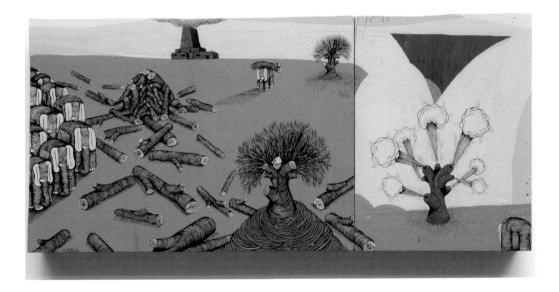

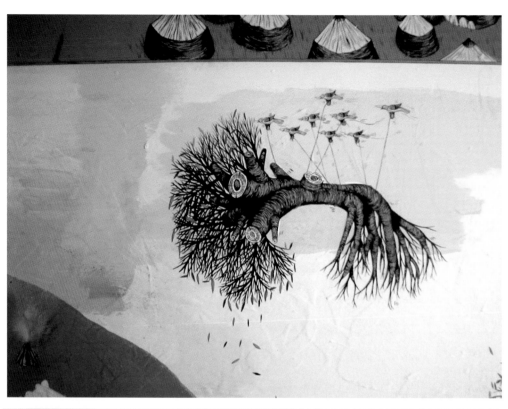

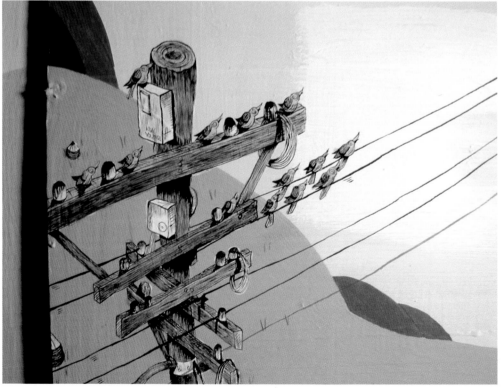

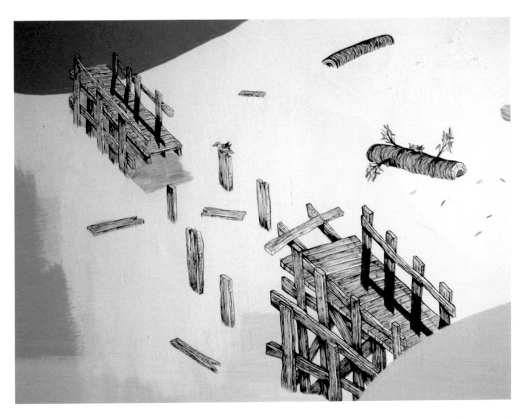

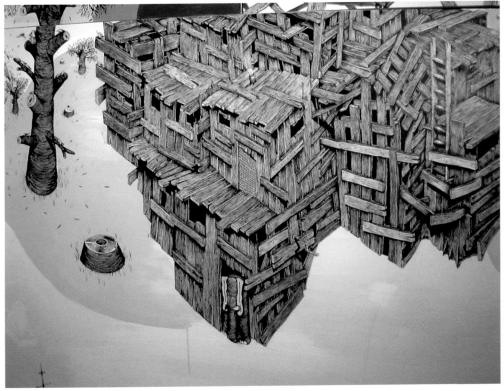

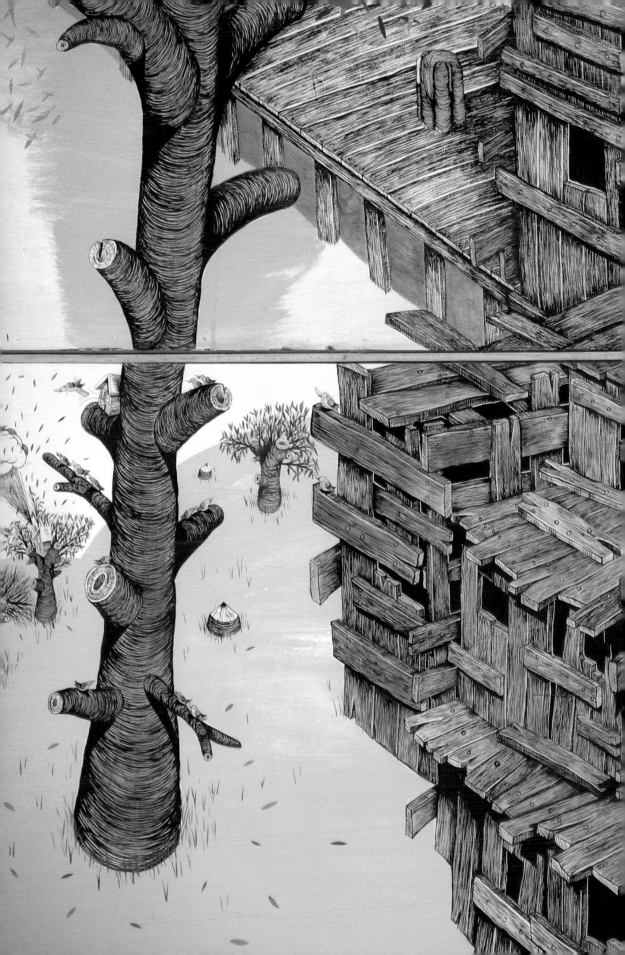

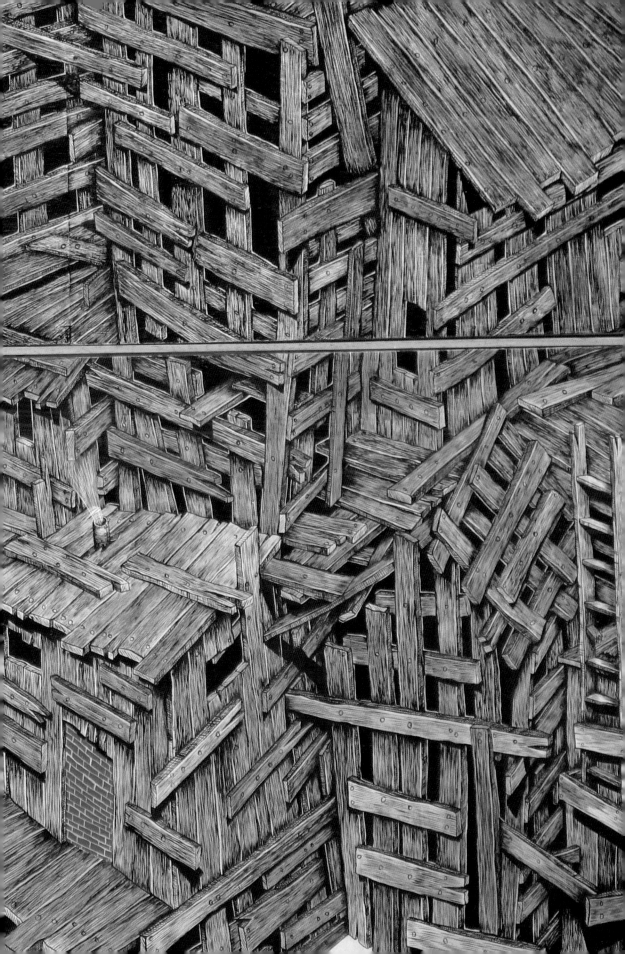

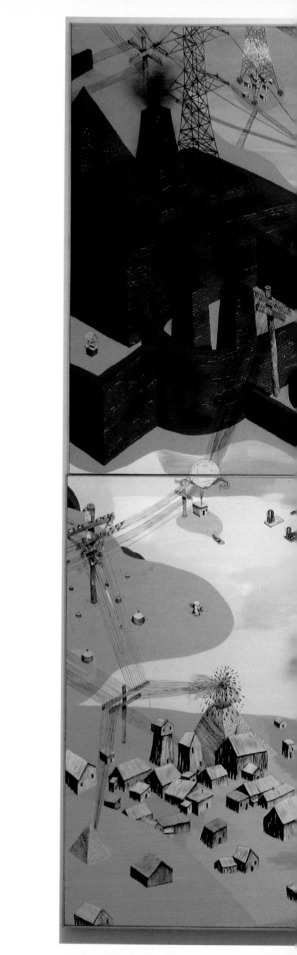

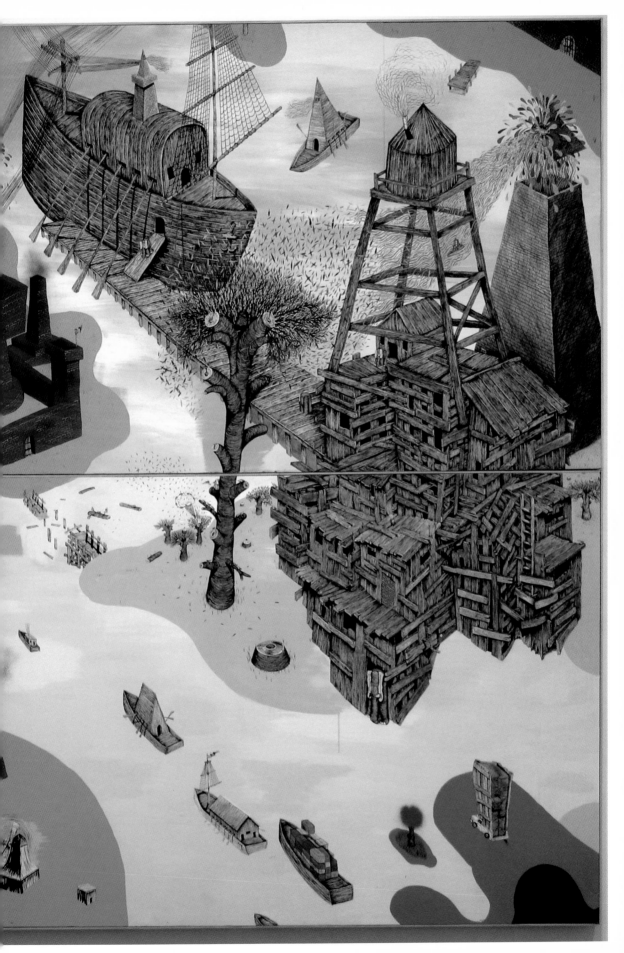

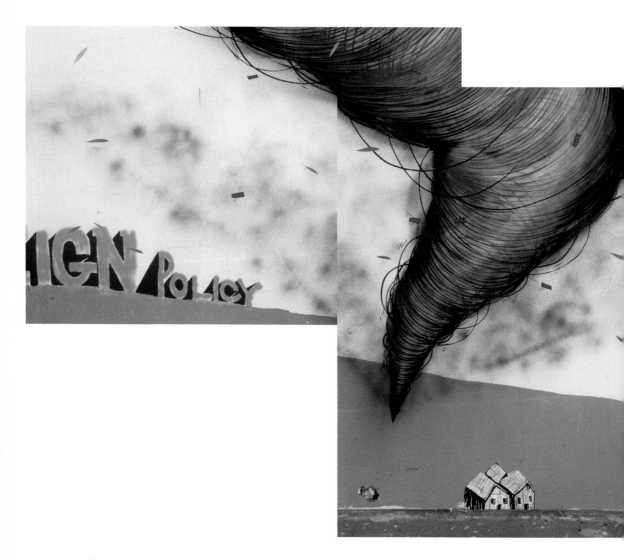

Compared to most artists these days I would say I am very political. Compared to most political activists these days I would say I am not political at all. It is actually kind of funny how that works. I try my best to be conscious of current social-political issues, and try to address them in my work. There is definitely a political undertone to all of my work. I have been involved with political activism in the past, and most likely will be again in the future, but there are some people who devote their whole entire lives to political activism and in contrast to them, I would feel very phony claiming to be a political person.

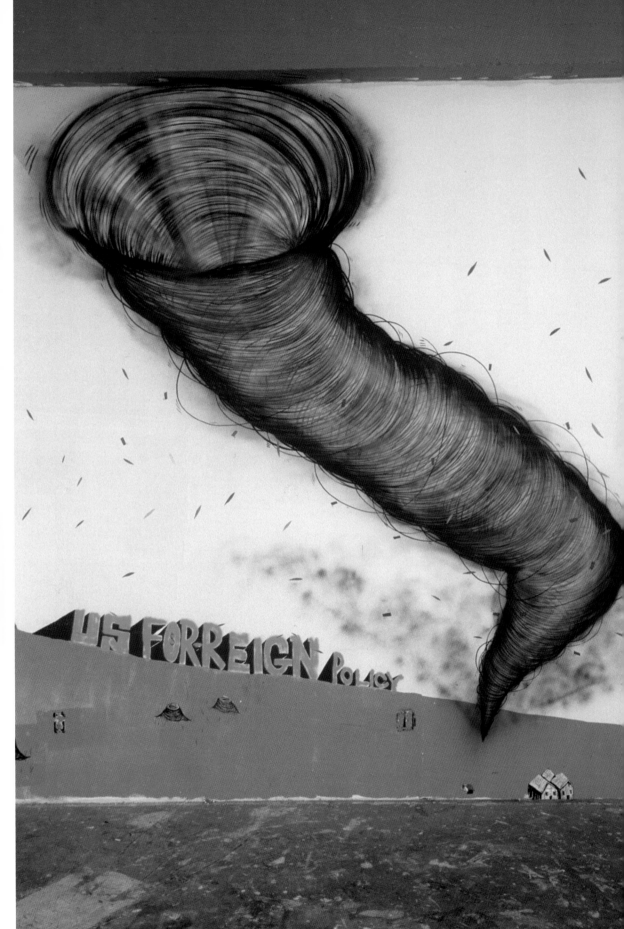

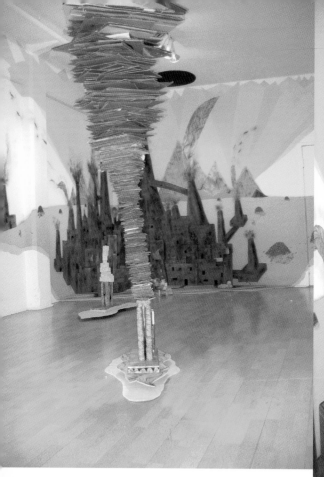
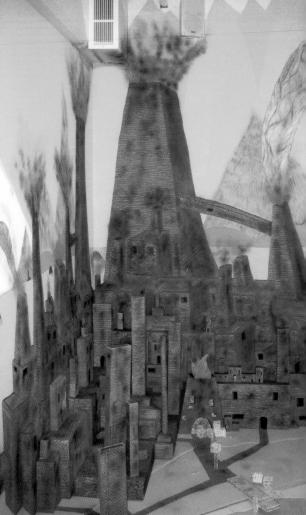
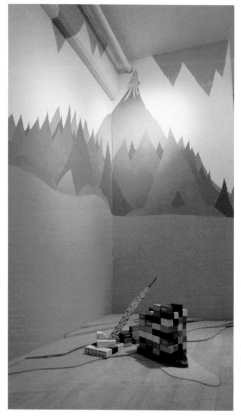
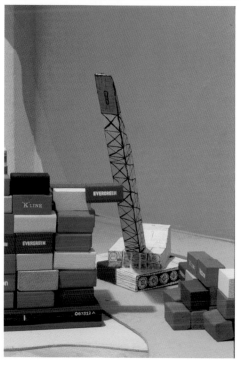

"Black Hole Theory," Intersection for the Arts, San Francisco, CA, 2005.

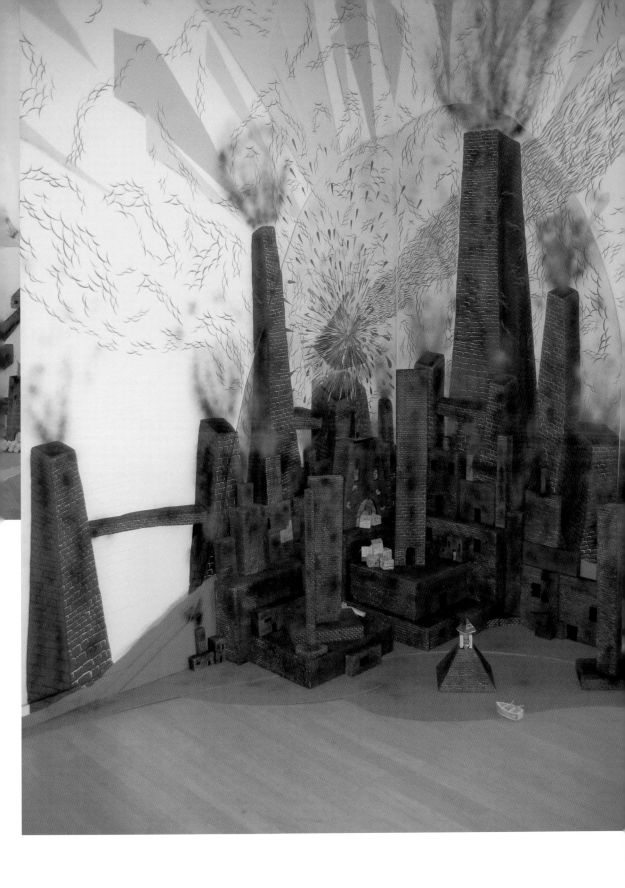

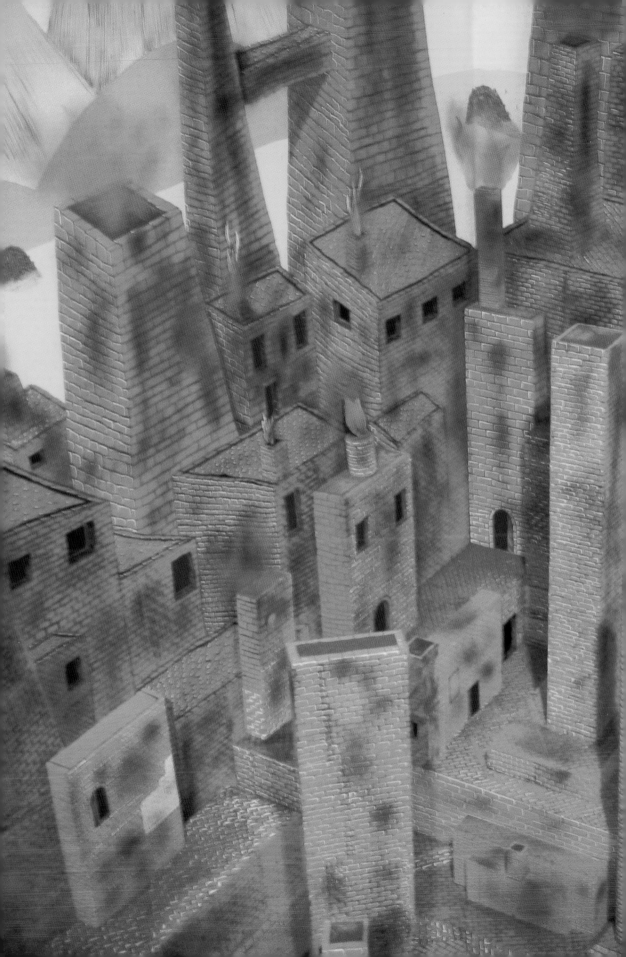

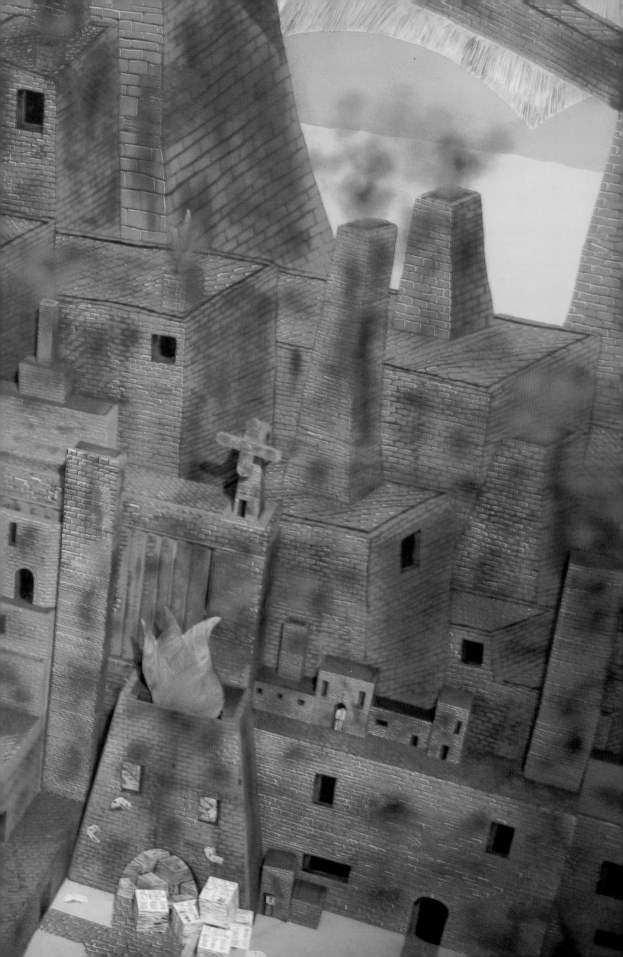

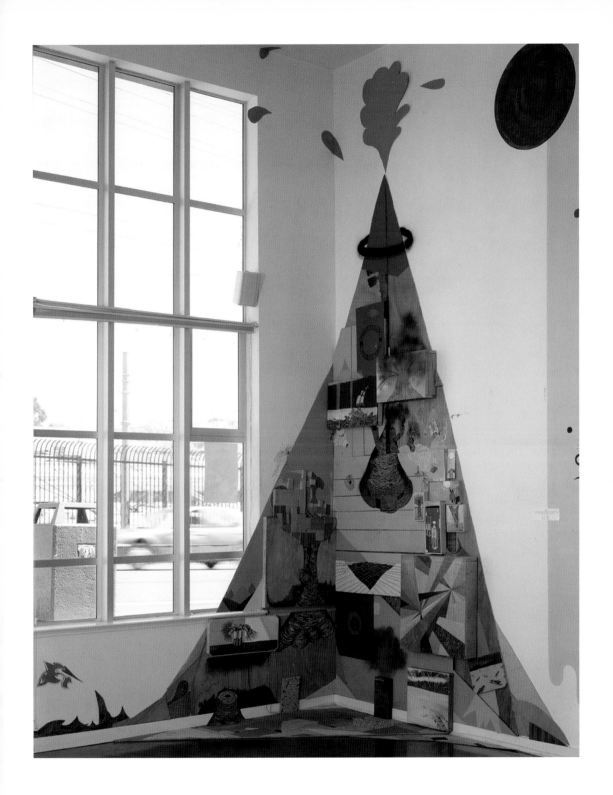

Collaboration with Alicia McCarthy at Culture Cache' Gallery, San Francisco, CA, 2004.

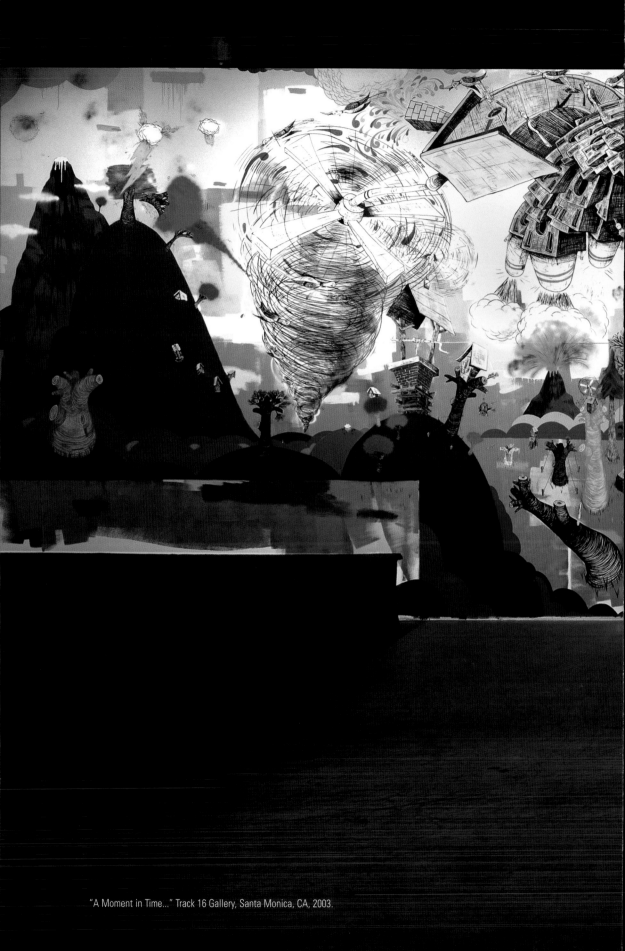

"A Moment in Time..." Track 16 Gallery, Santa Monica, CA, 2003.

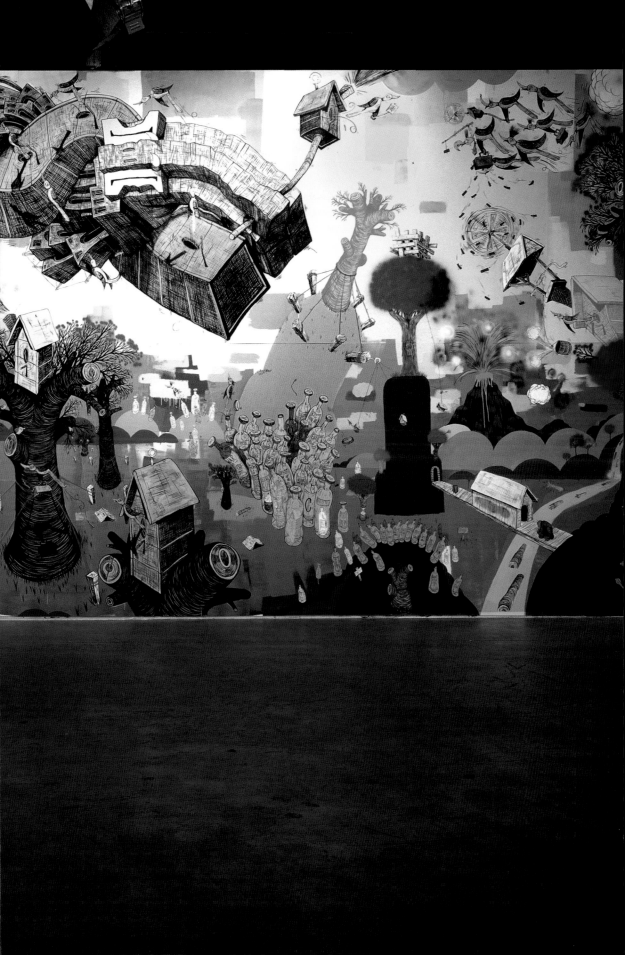

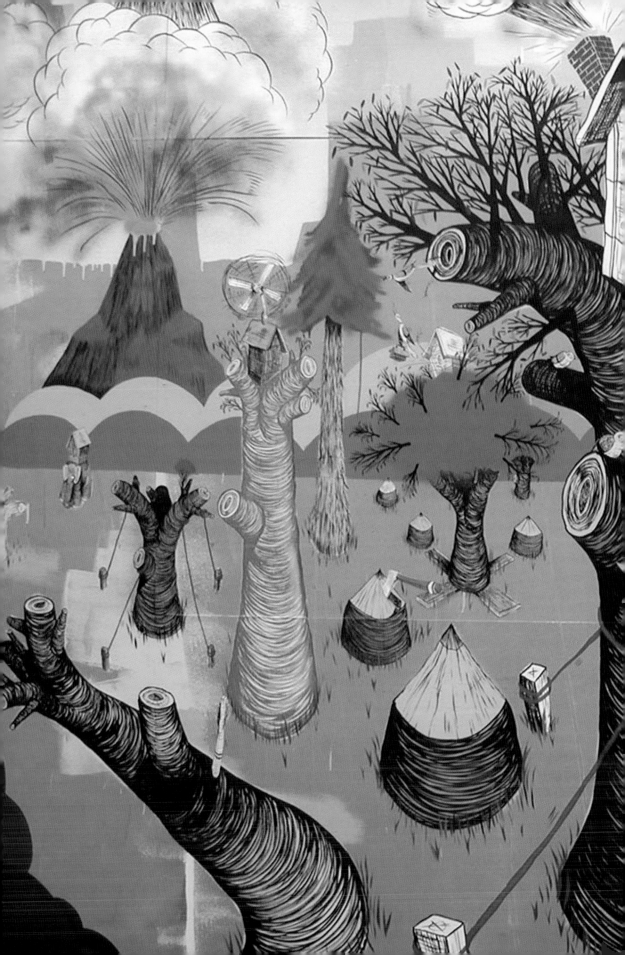

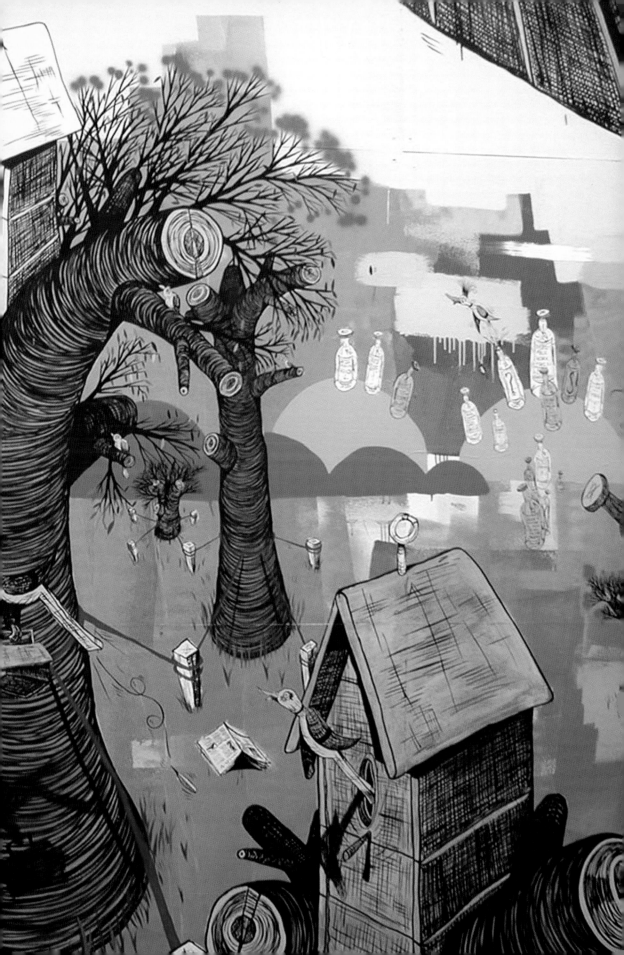

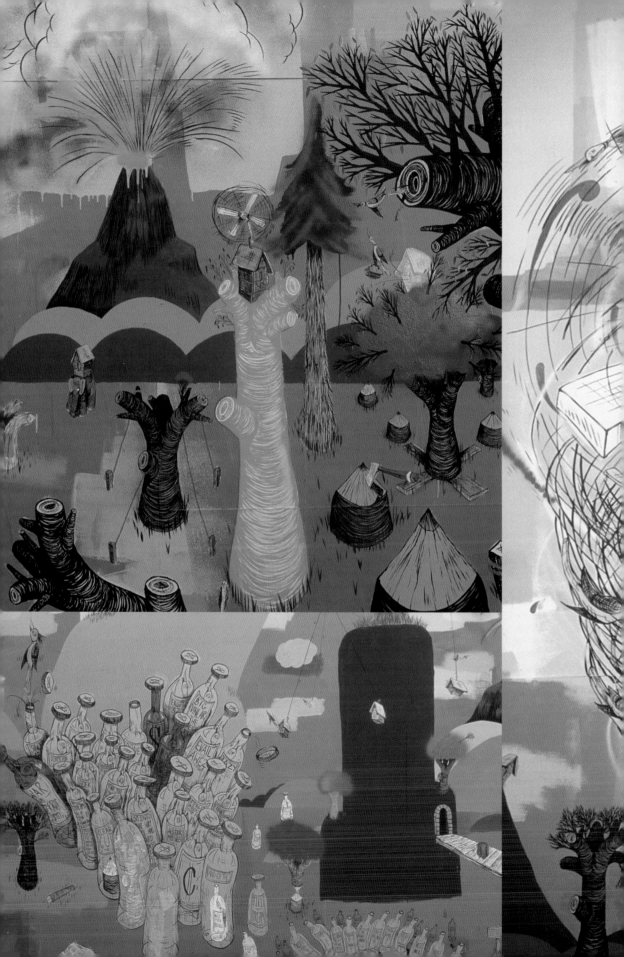

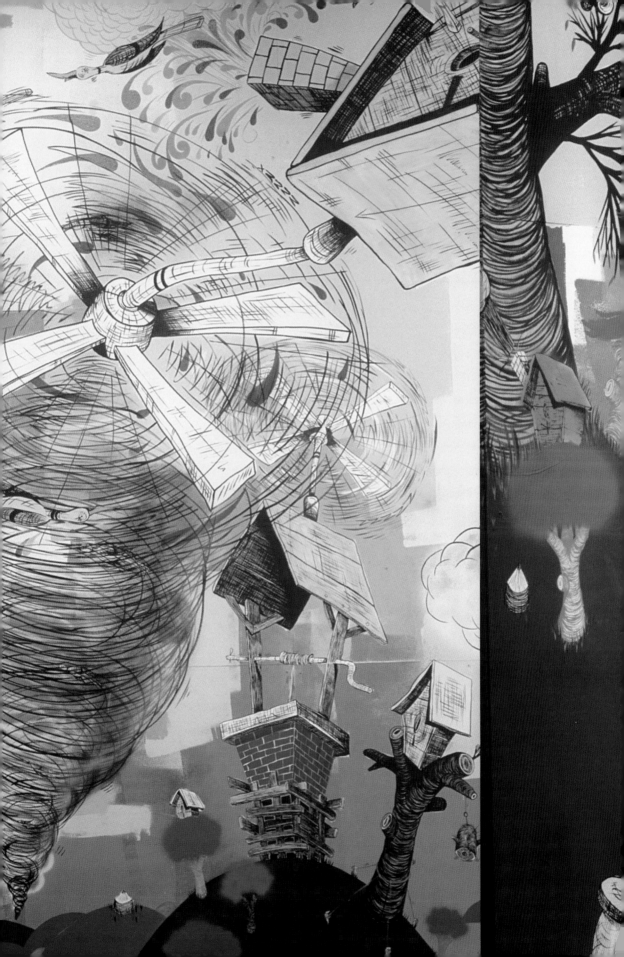

Yogyakarta, Indonesia.

Sama/Sama International Exchange Project
July 2003

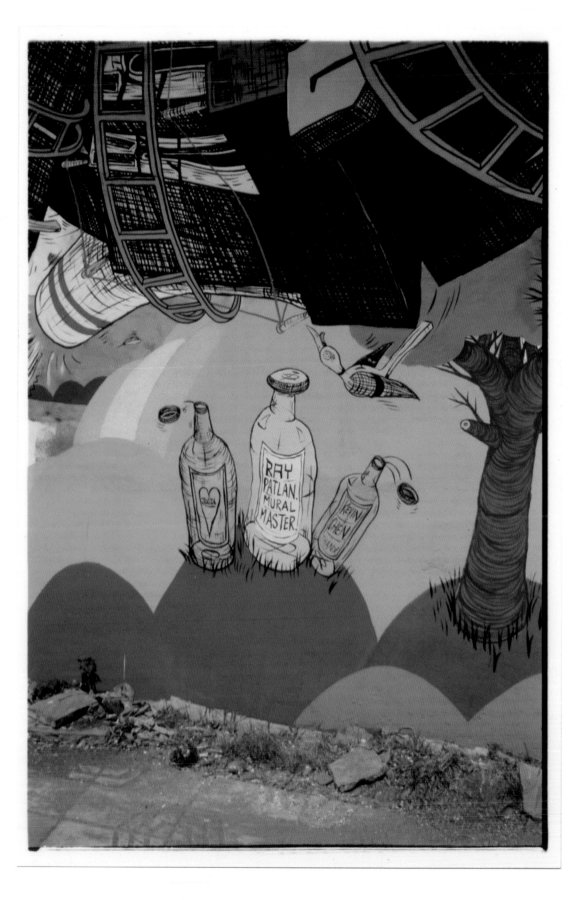

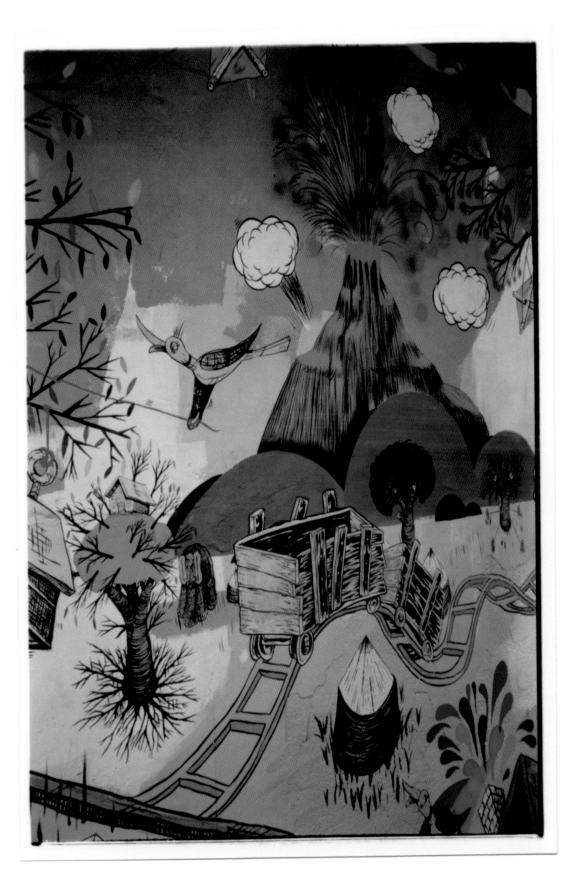

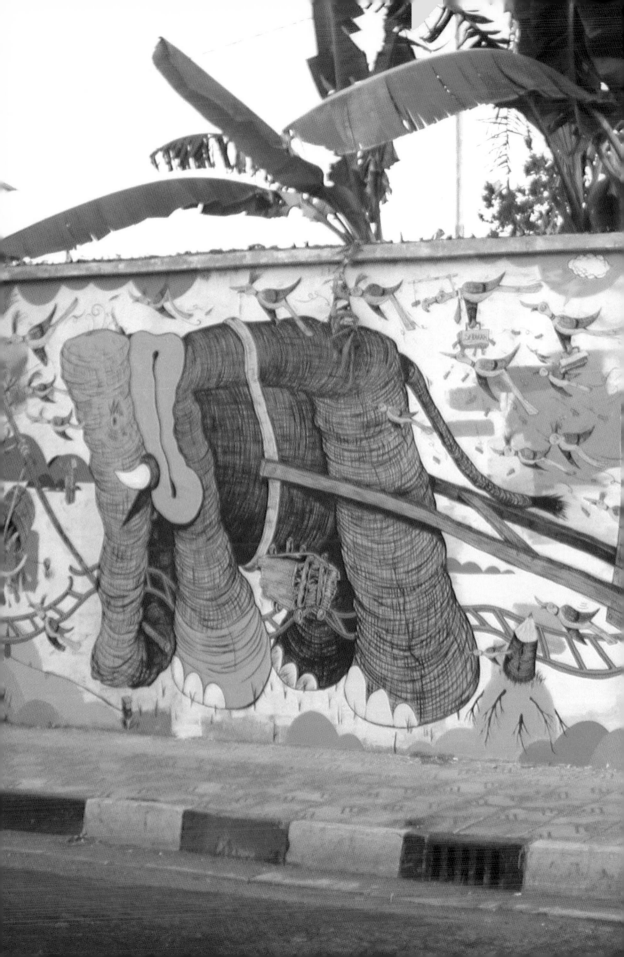

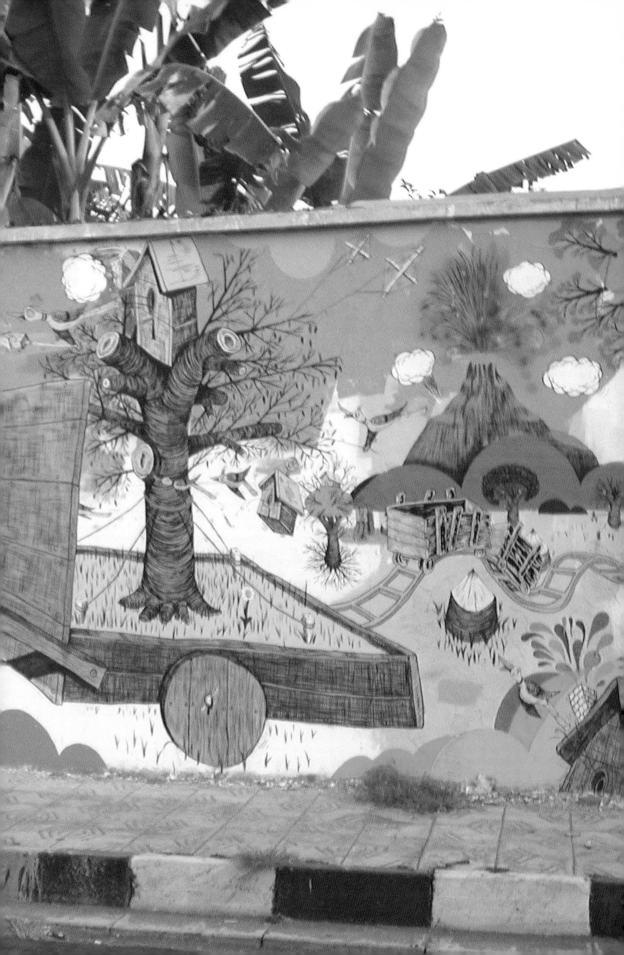

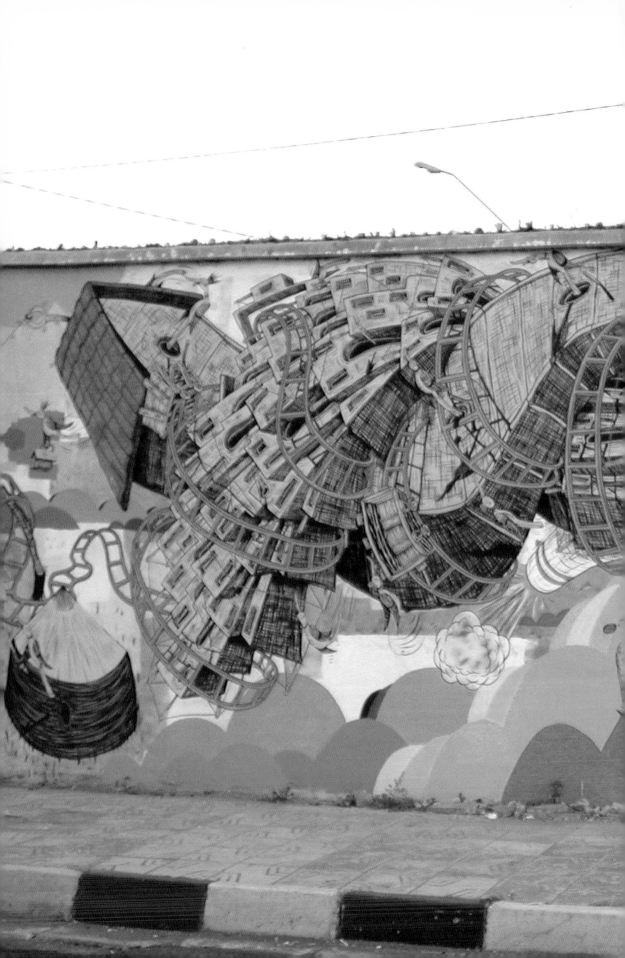

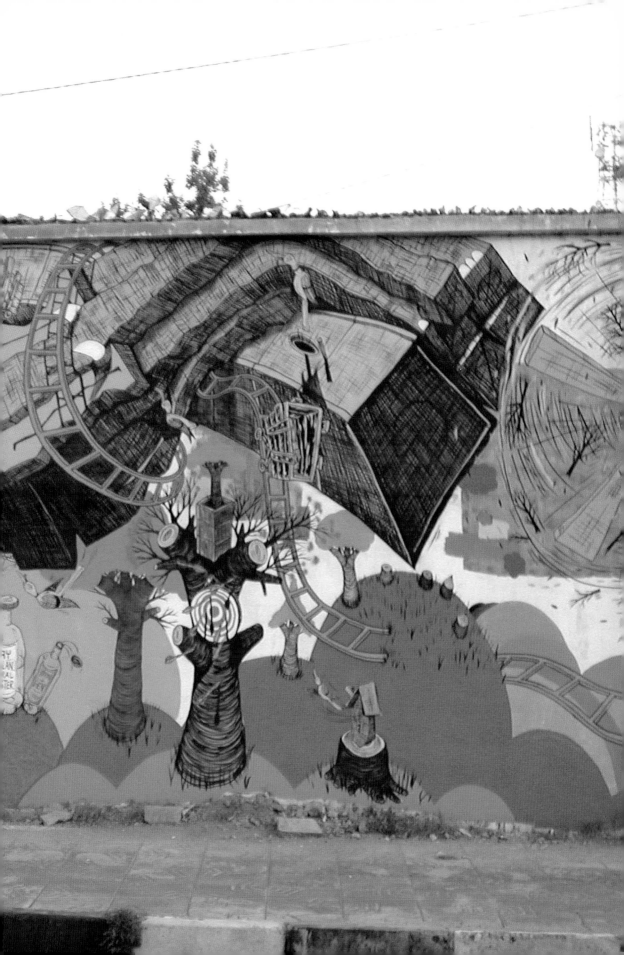

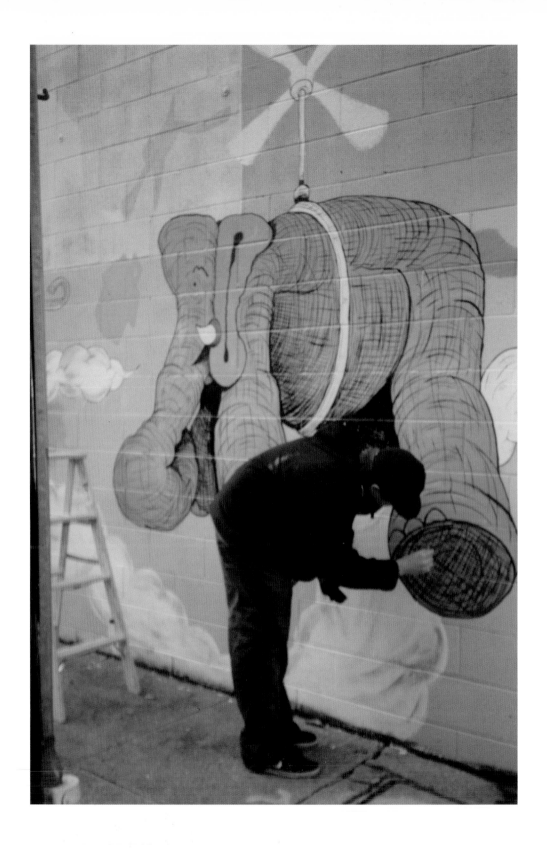

Birch Street Mural Project, 2002.

555 FULTON ASSOCIATES

January 9, 2002

██████████████
DBA Birch St. Mural Project
c/o
Rainbow Grocery
1745 Folsome Street
SF CA 94103
1-415-863-0620

Dear ██████████████

 This letter will follow up on our telephone conversation of
January 7 regarding you painting on our wall in the 500 block of Birch
Street.
 We want you to stop painting on our wall and return it to it's
original condition.
 By way of background, a man had painted on about 1500 square feet
of our wall when he was asked to stop. That was at about 2:00PM January
7. He said he was angry you had not told him the permission had not
been granted.
 What legal right did you think you had to paint on our wall. You
say a Mr. Edward Fowler had visited my office six months ago. I was out
of the country. The secretary told him not to do anything without my
permission. We had turned down a similar request a few years ago. Was
that you ? You say the neighbors like what you are painting. That may
or may not be true but it does not contravene our right to paint our
wall as we please. You are using our wall to solicit money. You suggest
that your graphics remain in perpetuity. You "guarantee" that your work
will displace the graphic trespass of the gang tags that we and the
city continually paint out. You agree that gang tags are a graphic
trespass but find it offensive that we consider your symbols a similar
trespass. What endorses your work above others?
 Re-painting the wall is a bigger job than cleaning up some
tagging. Our insurance company might be able to help but that can get
complicated.
 Please get back to me next week regarding how you would like to
proceed.

Thanks

Yours truly,

Mike Berline
Manager

010802G,555

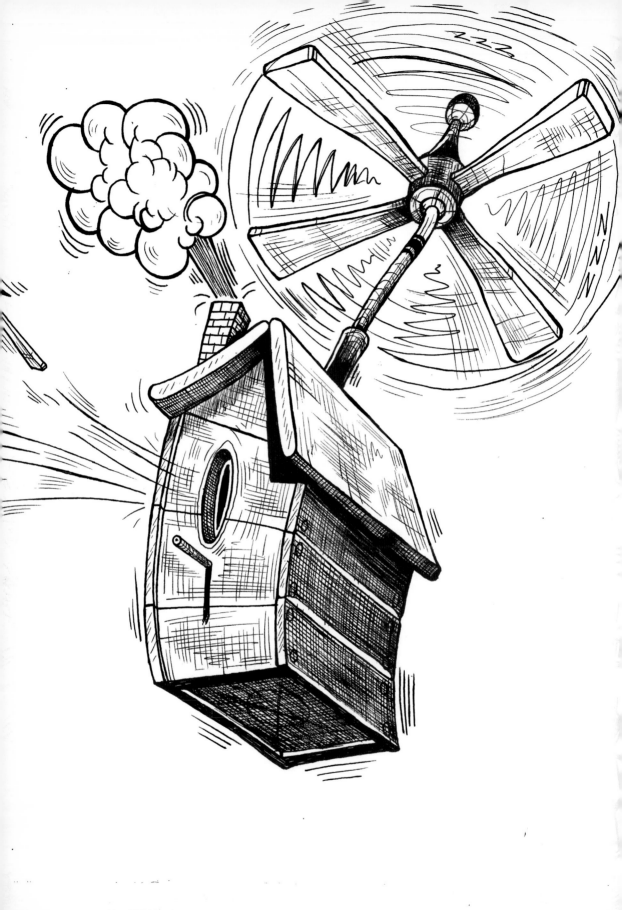

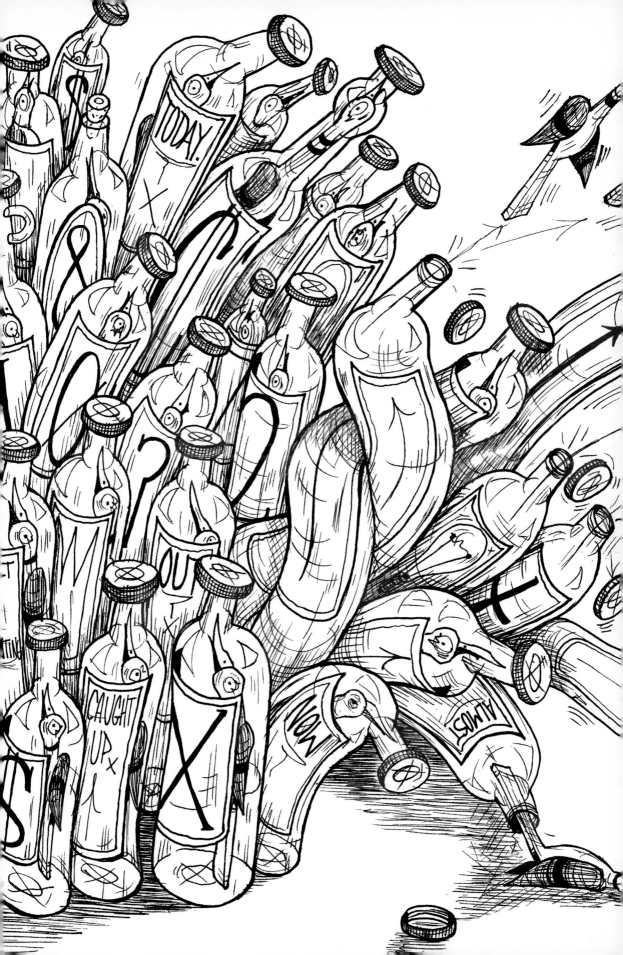

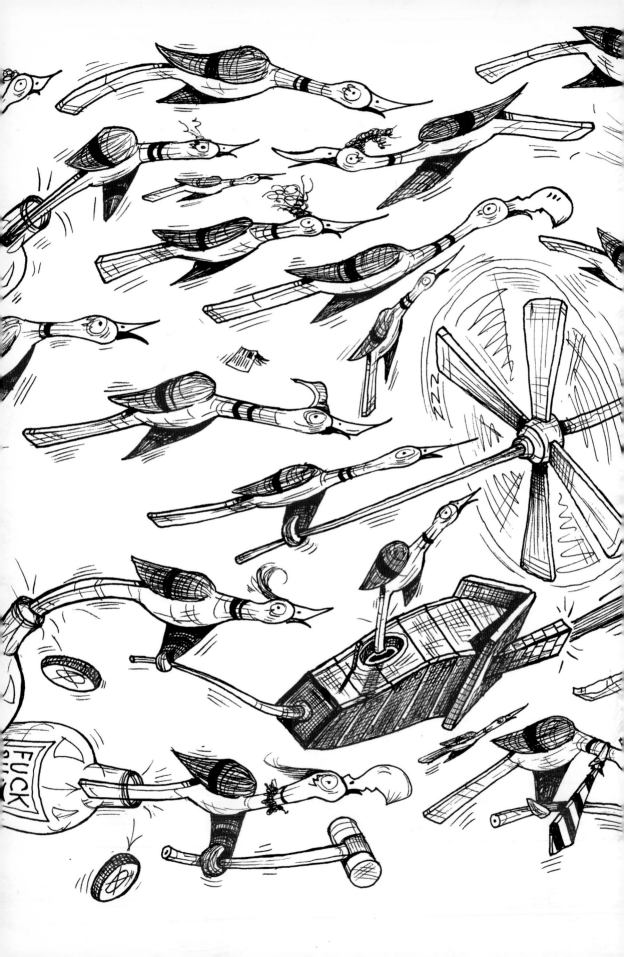

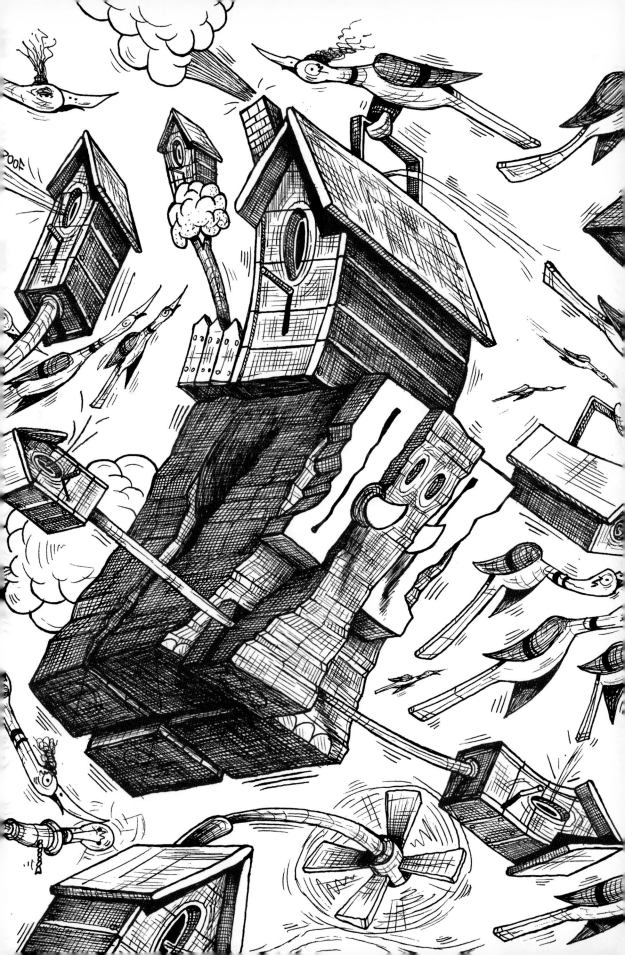

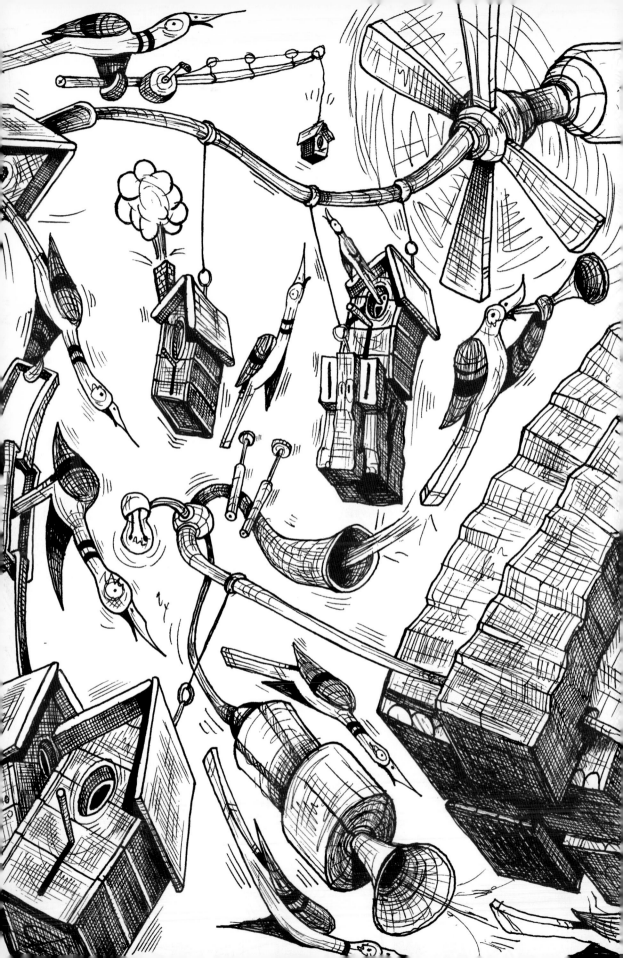

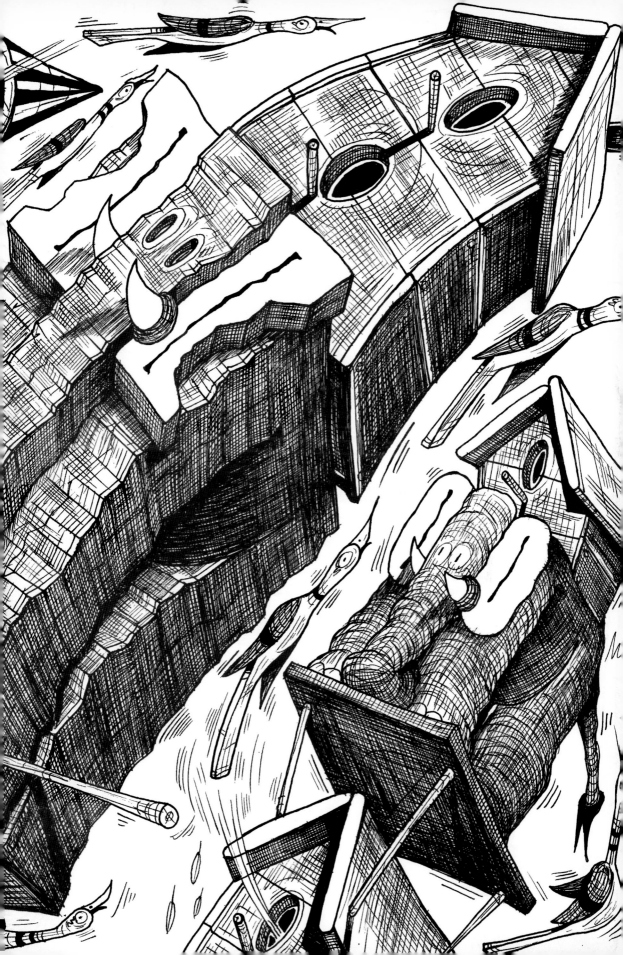

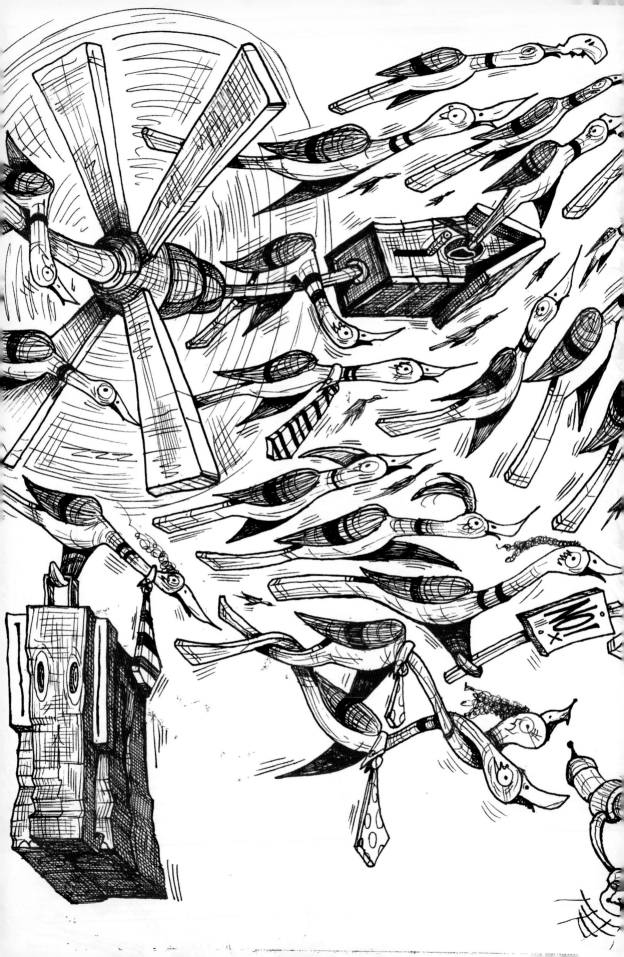

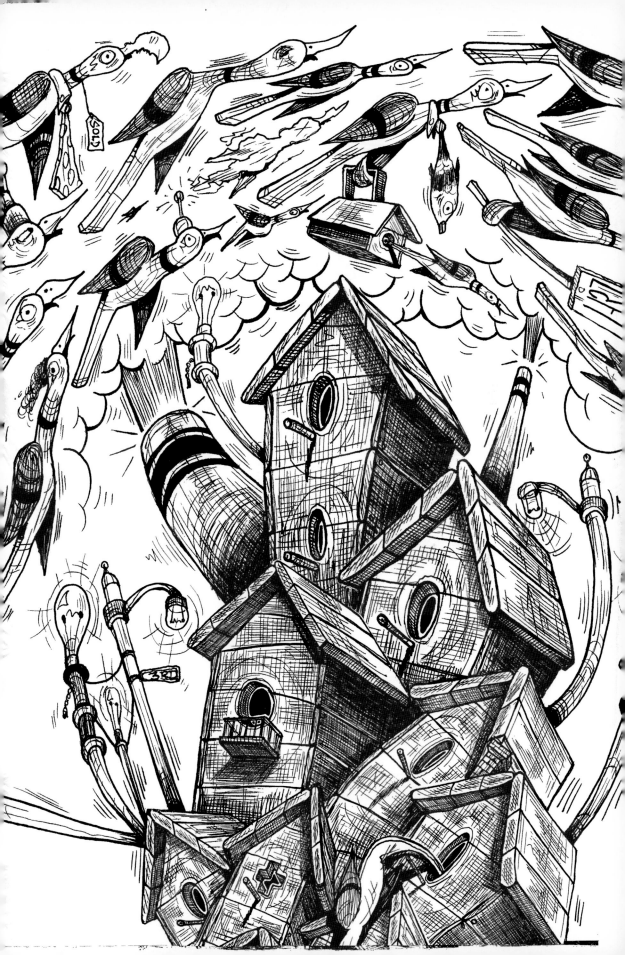

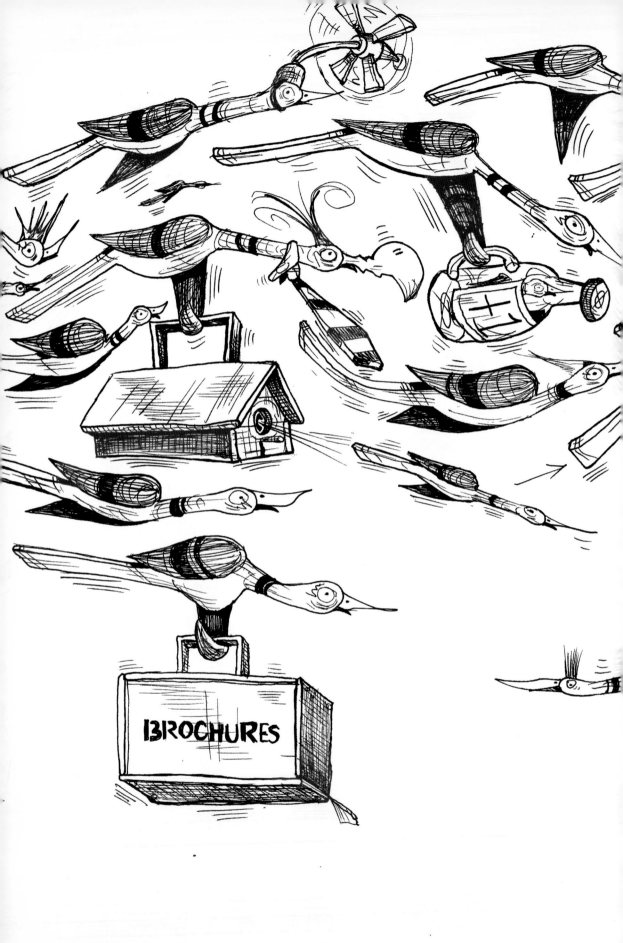

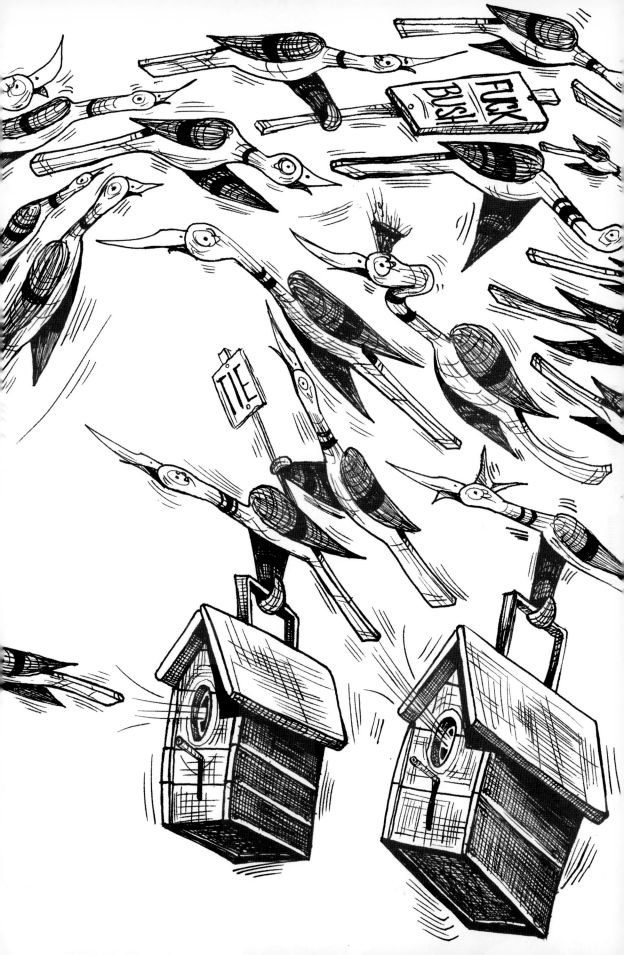

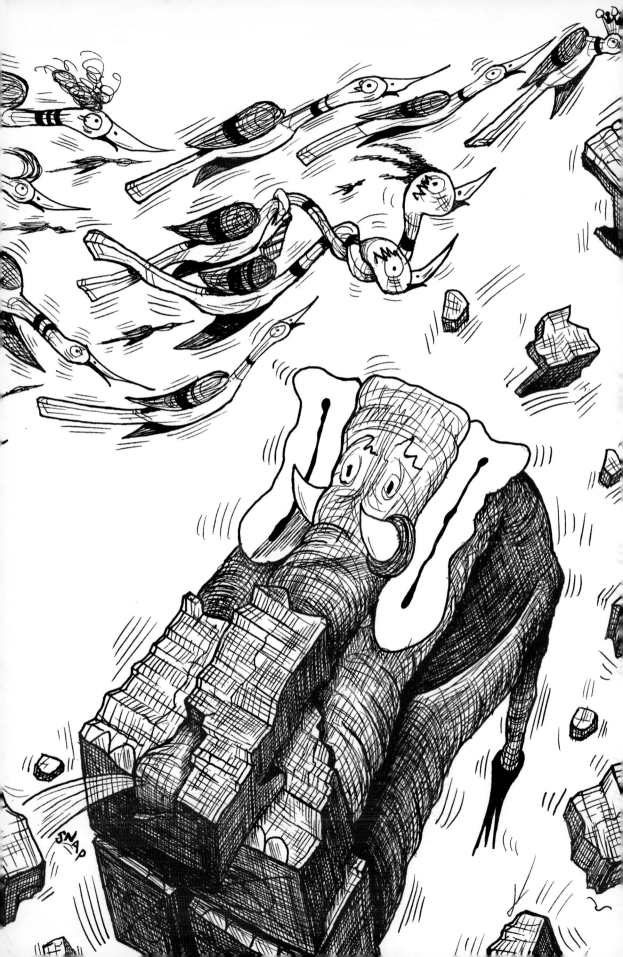

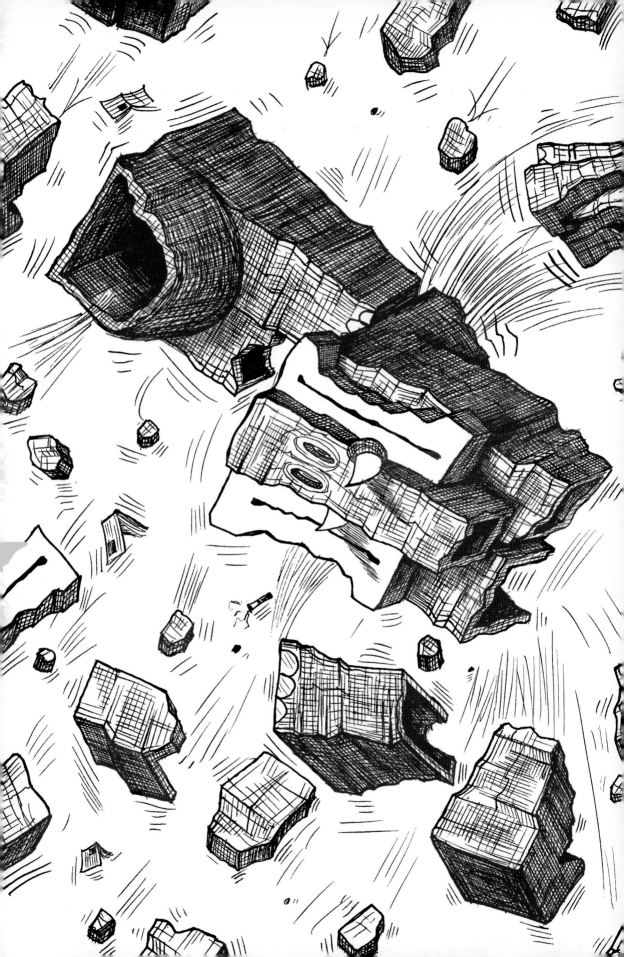

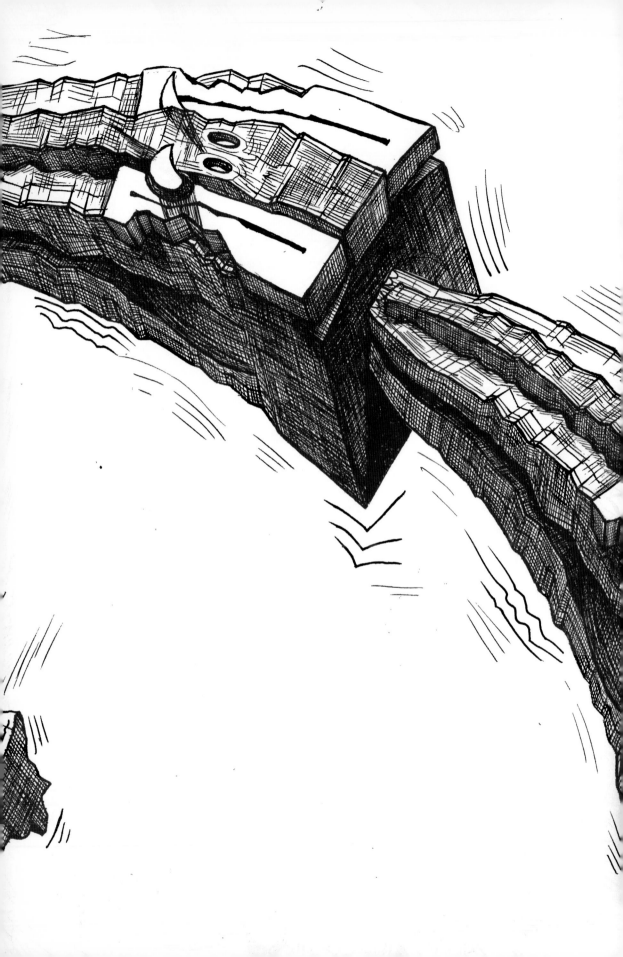

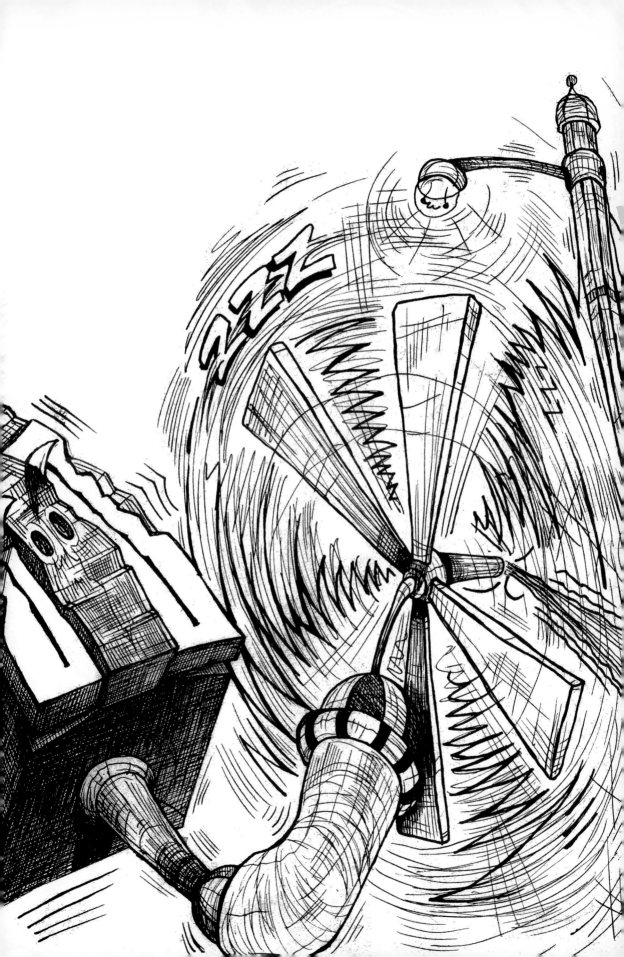

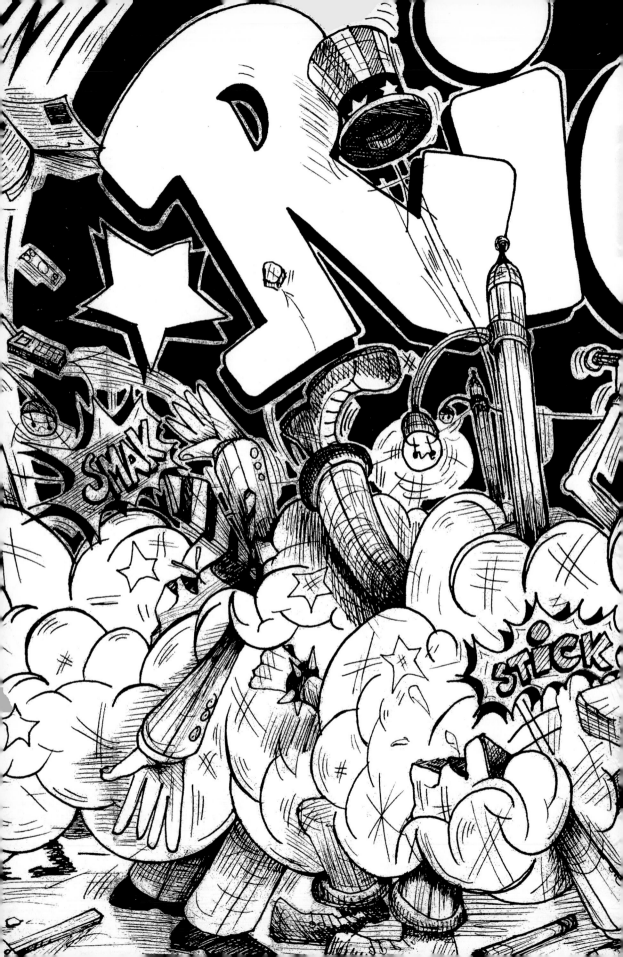

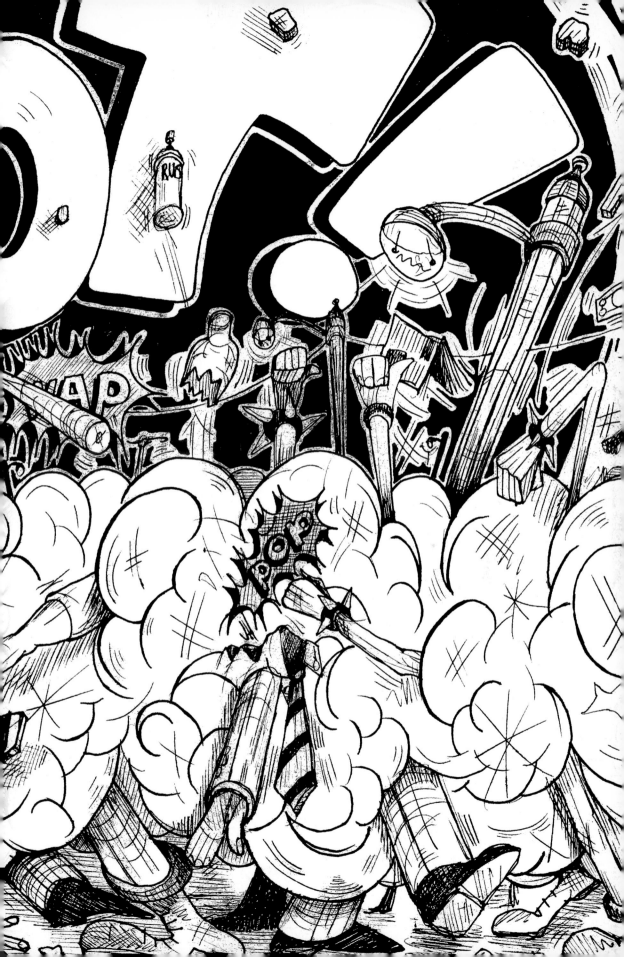

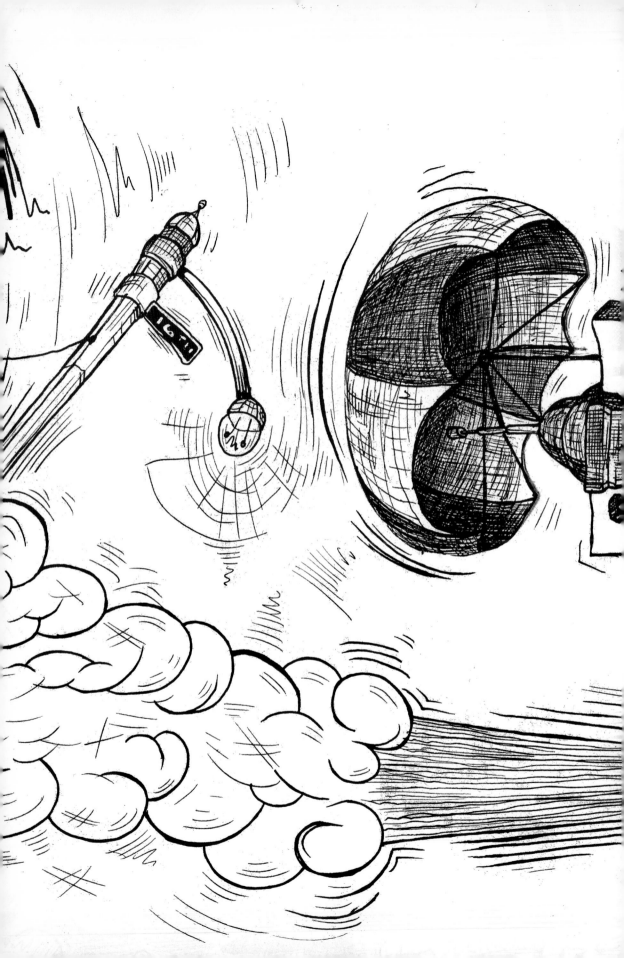

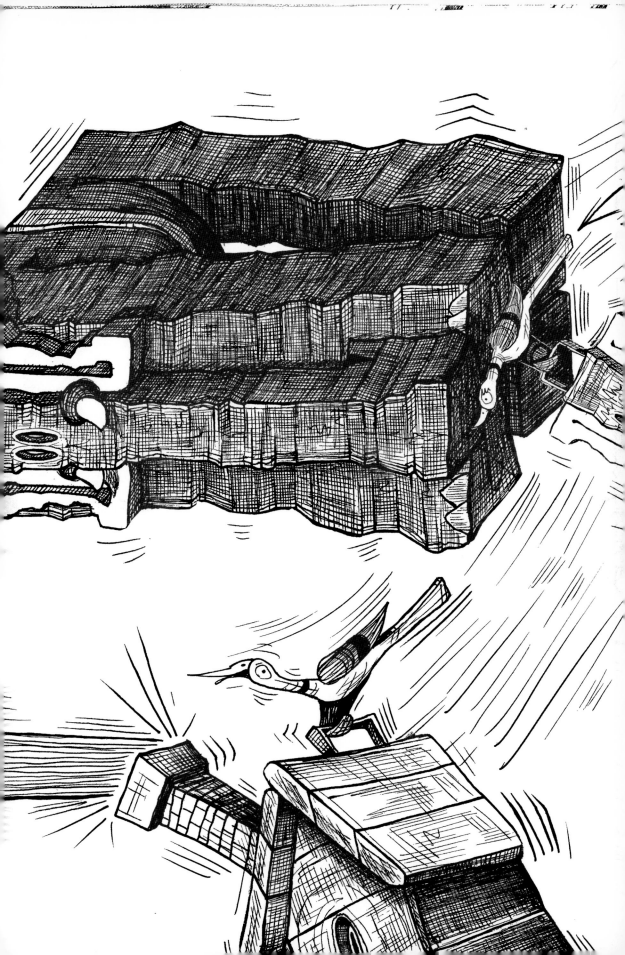

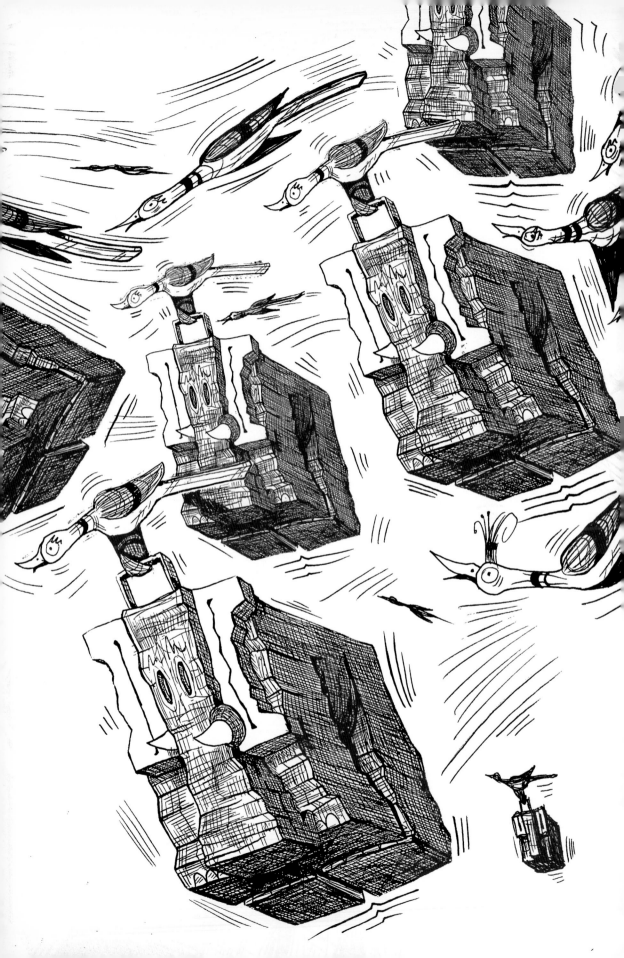

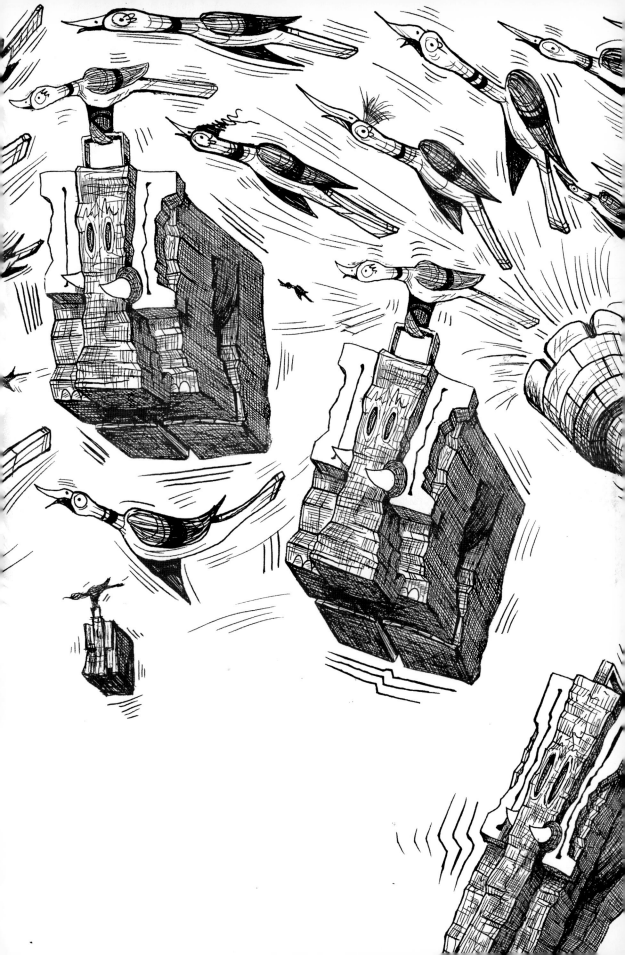

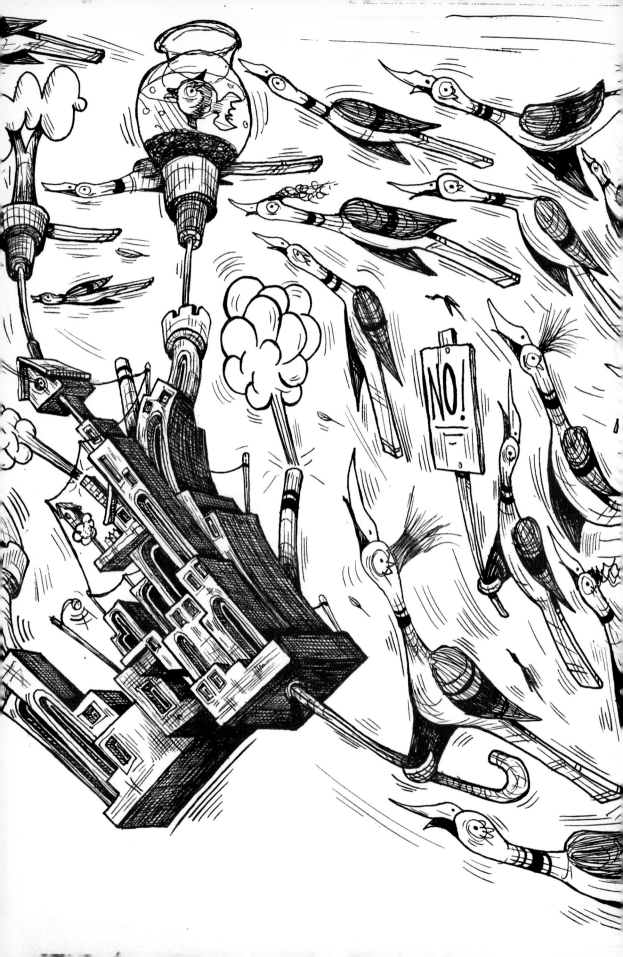

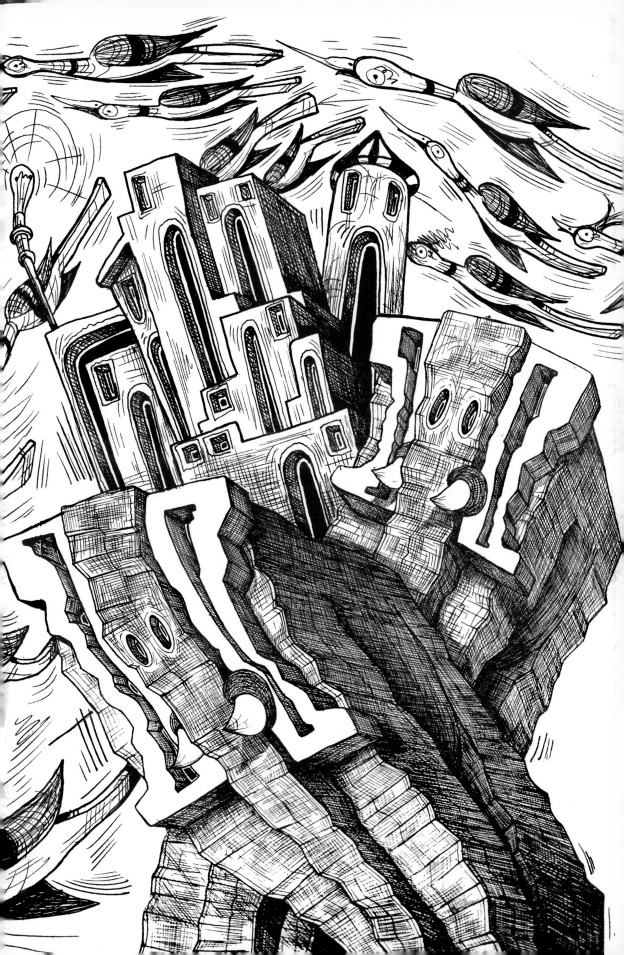

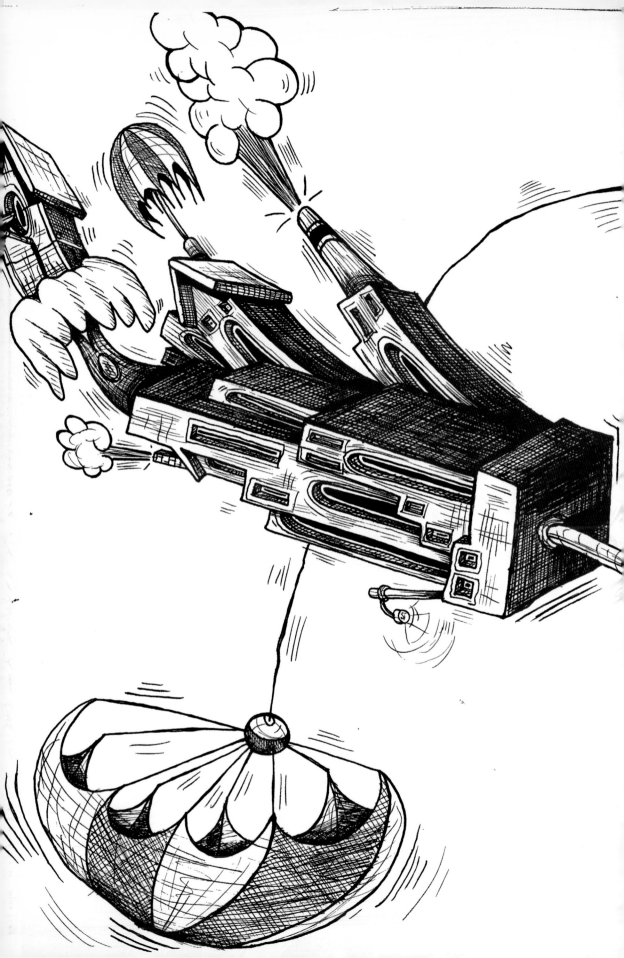

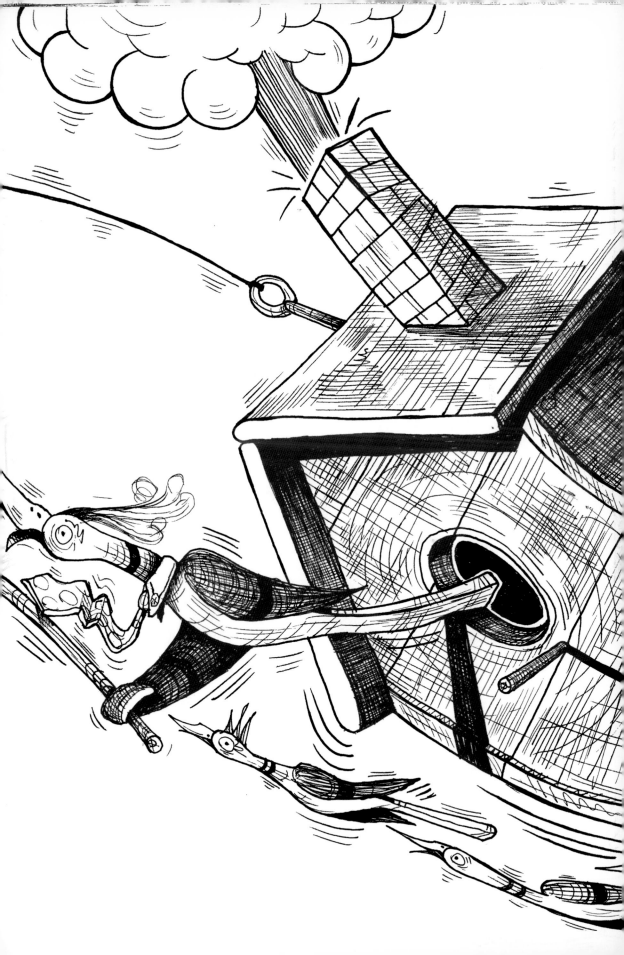

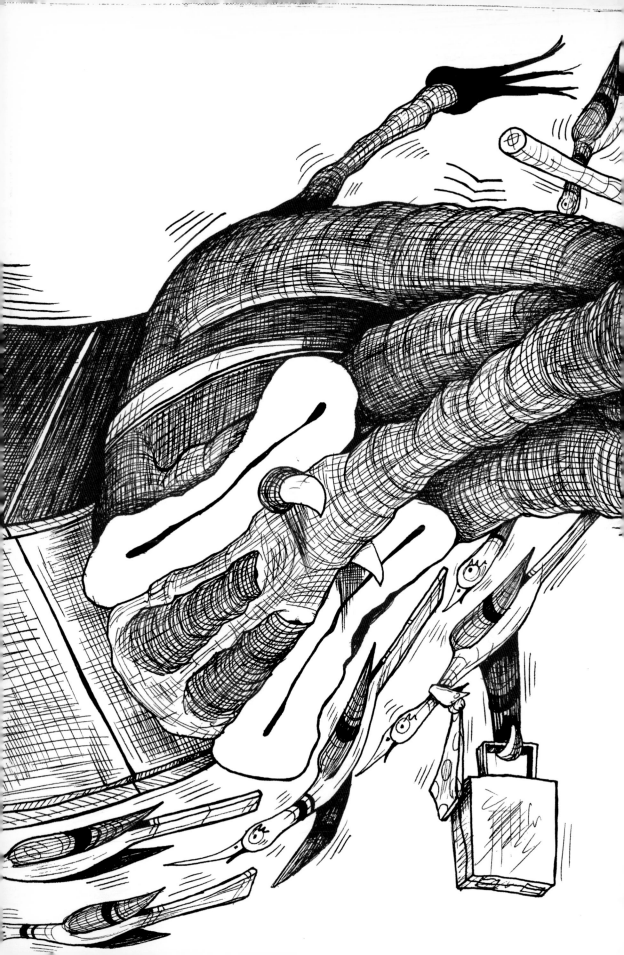

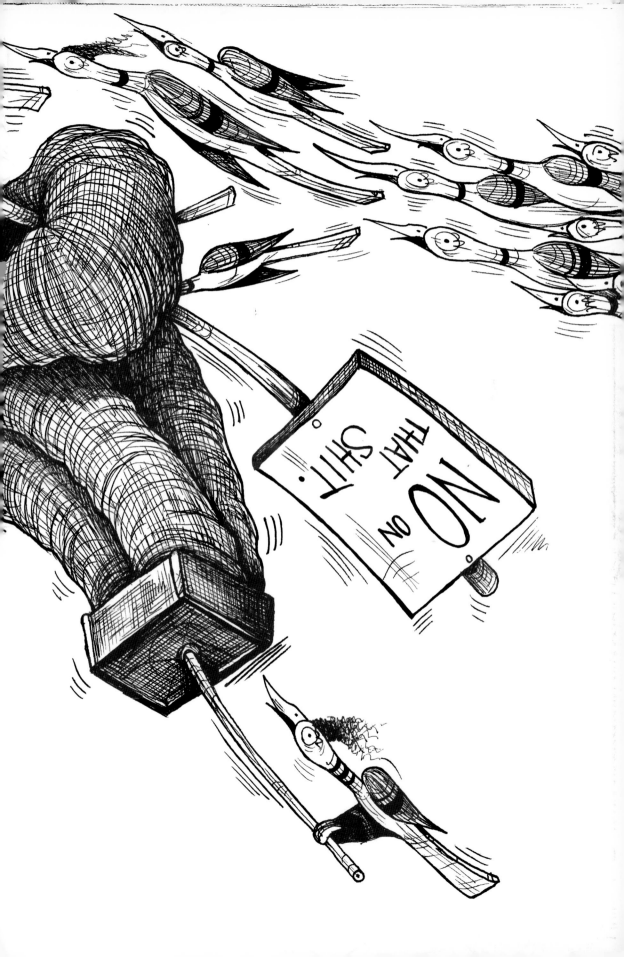

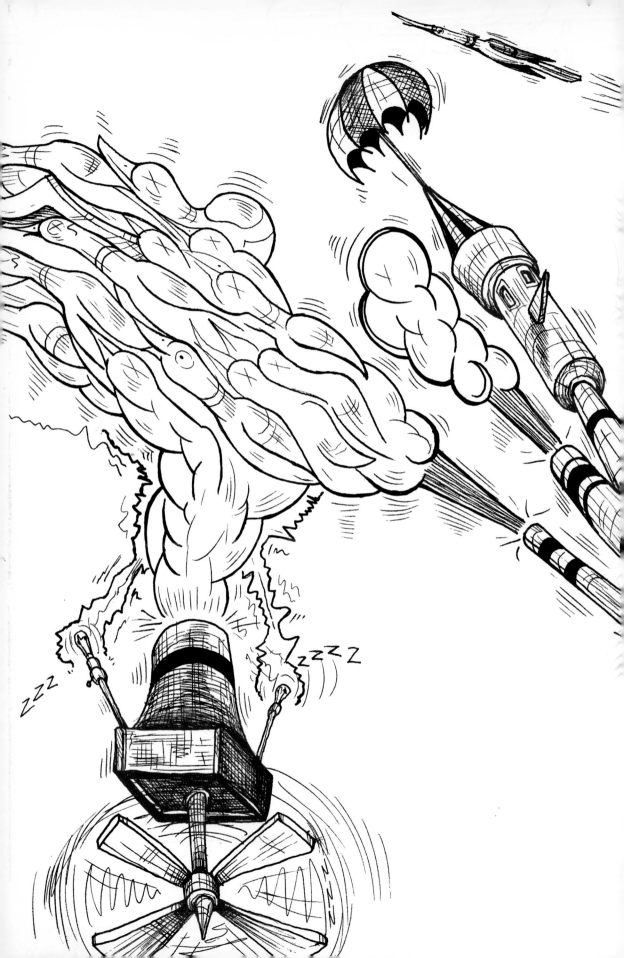

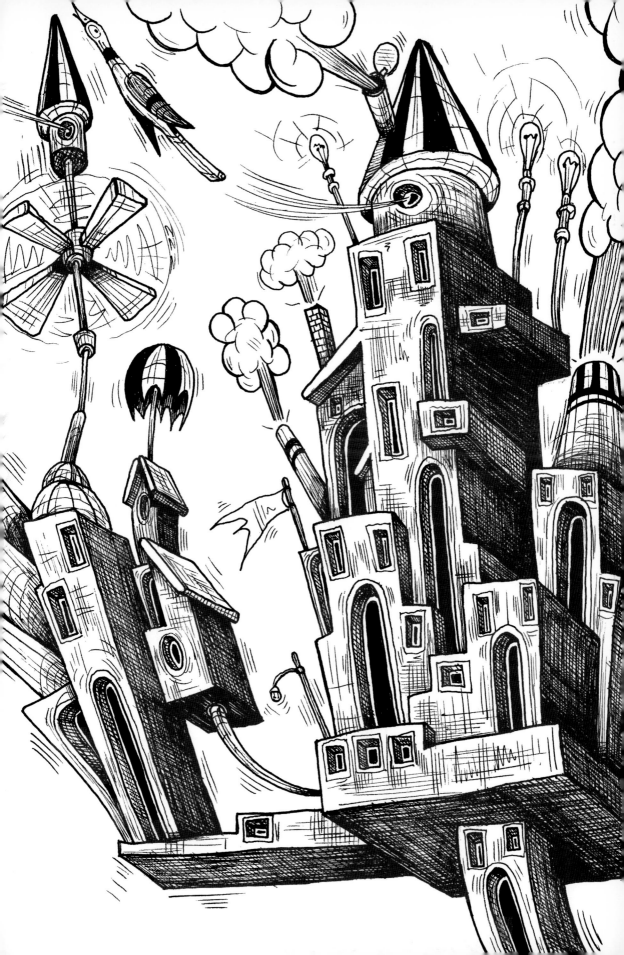

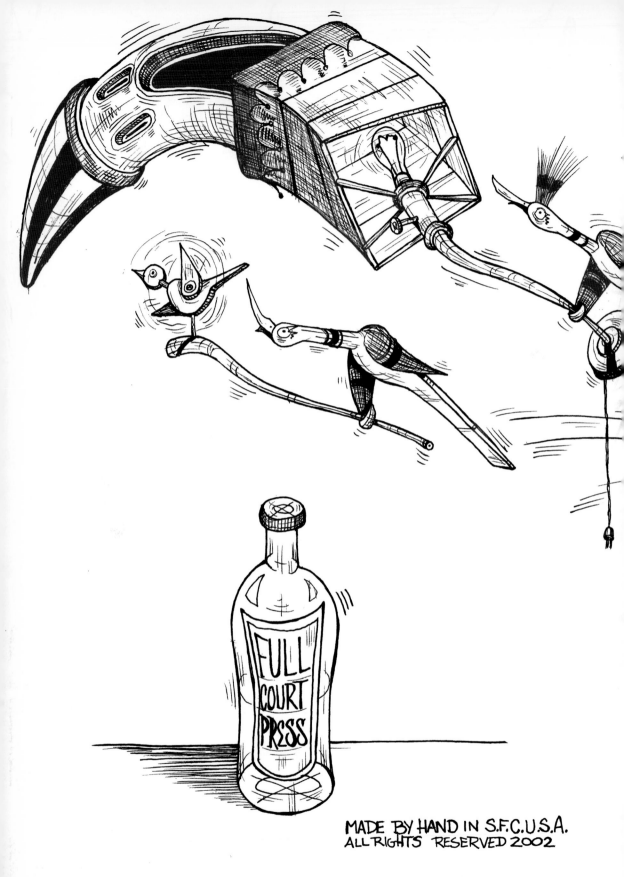

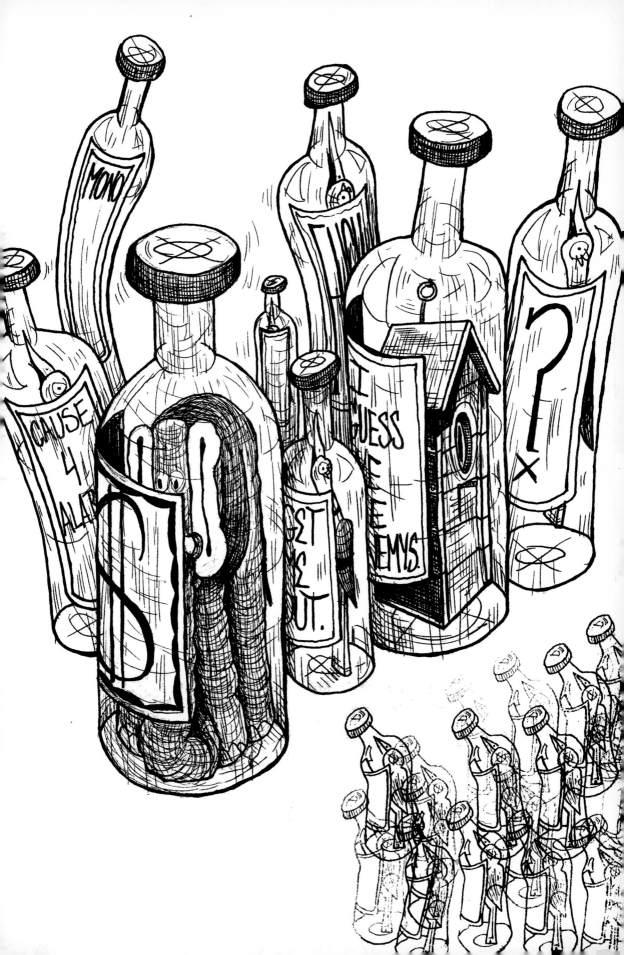

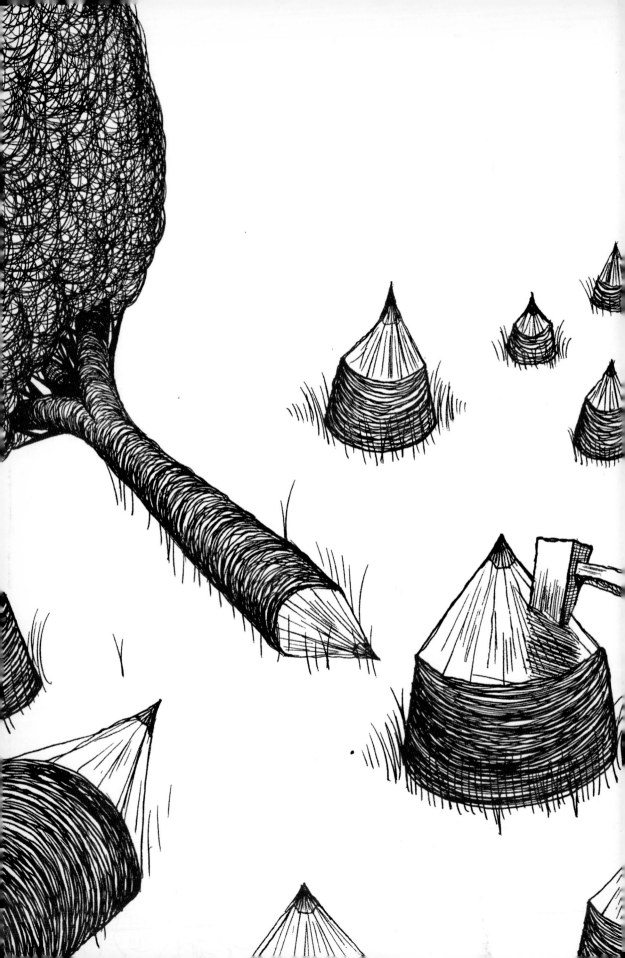

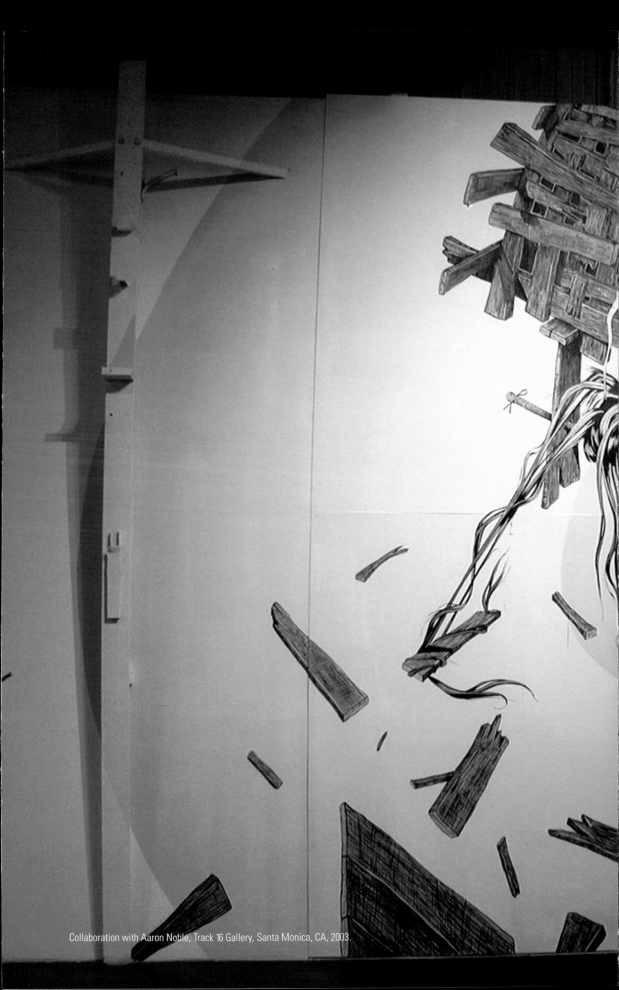

Collaboration with Aaron Noble, Track 16 Gallery, Santa Monica, CA, 2003.

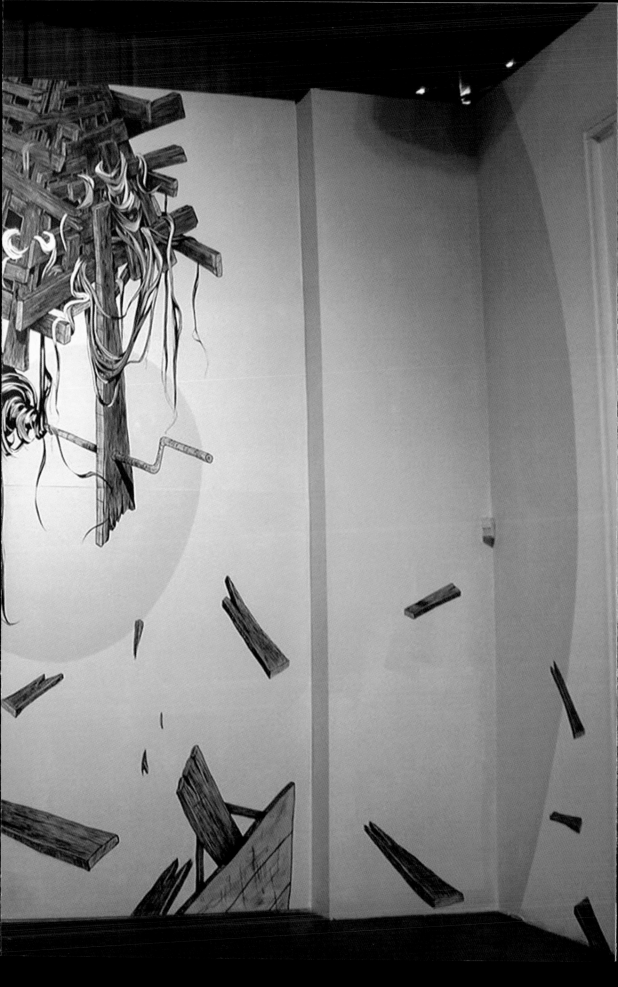

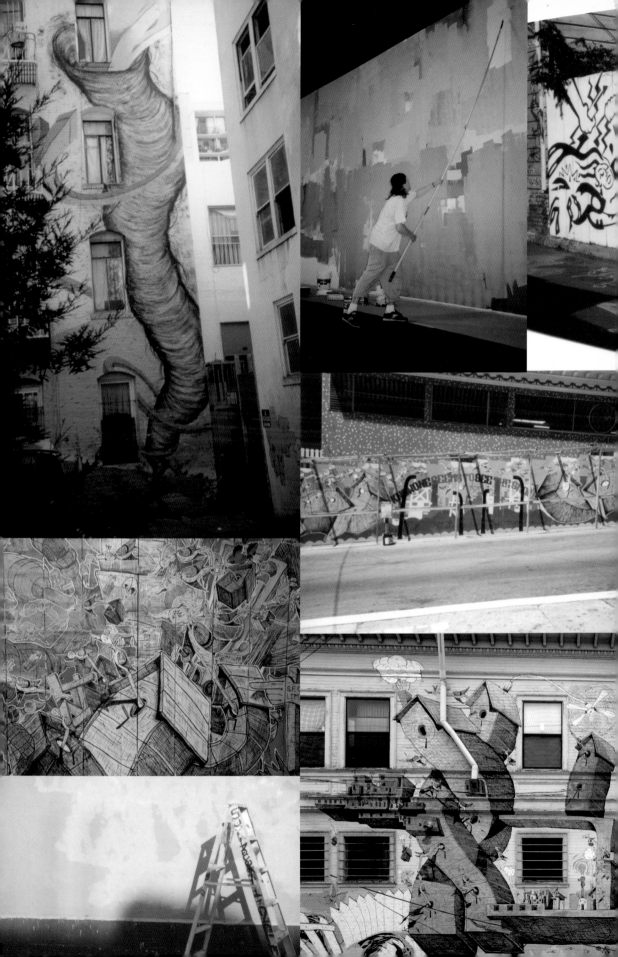

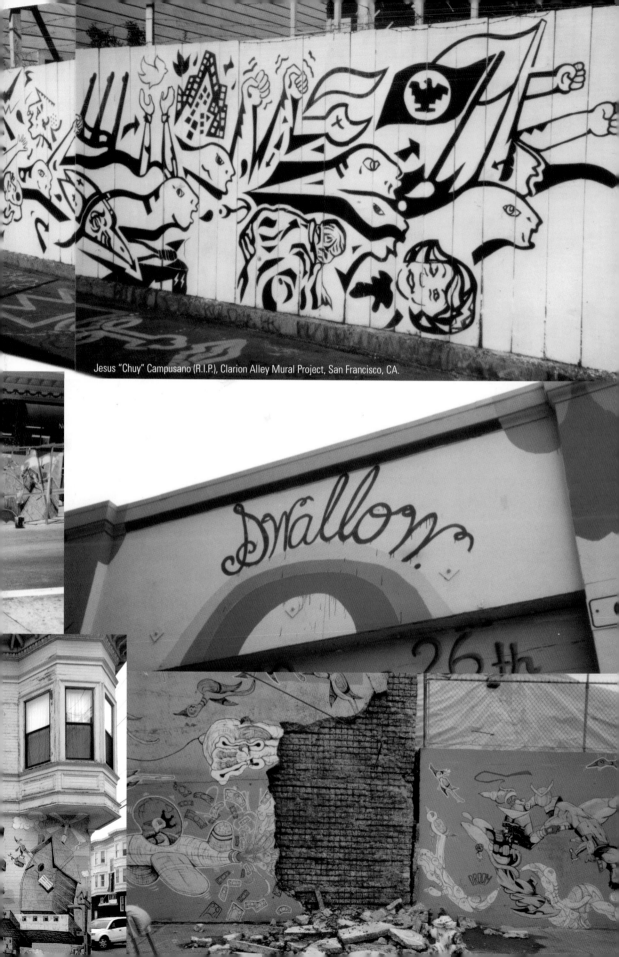

Jesus "Chuy" Campusano (R.I.P.), Clarion Alley Mural Project, San Francisco, CA.

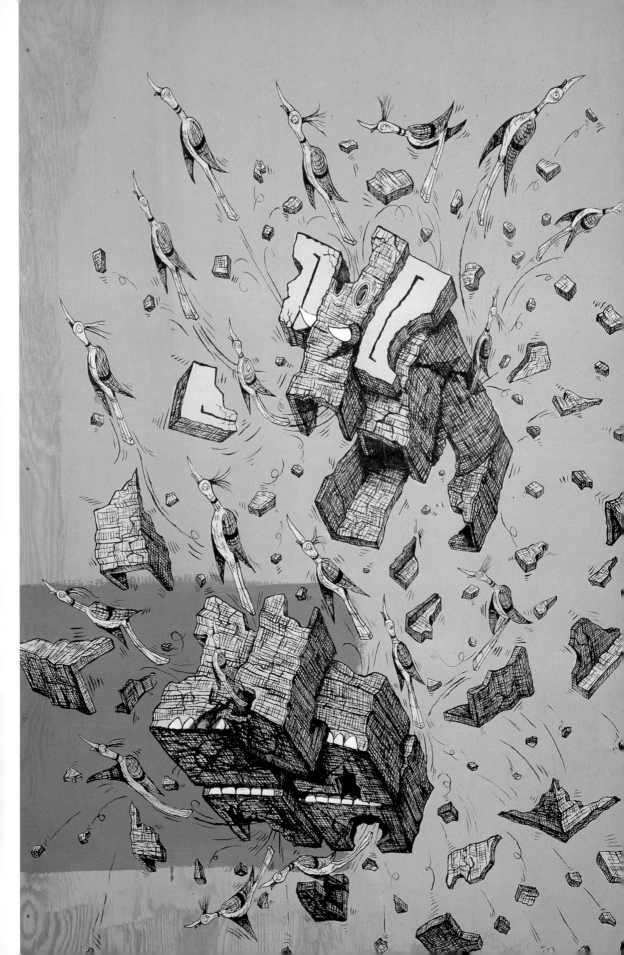

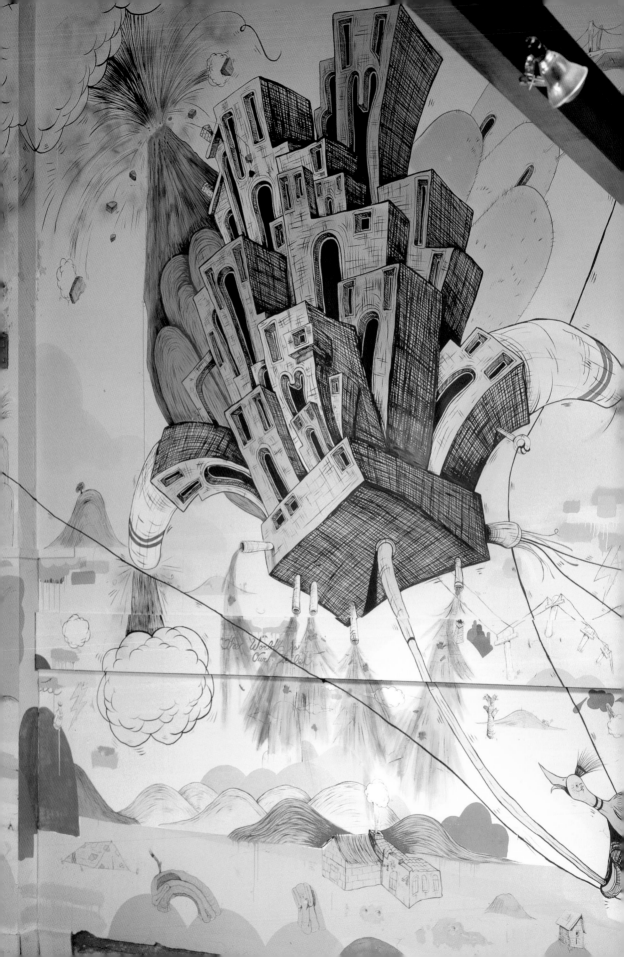

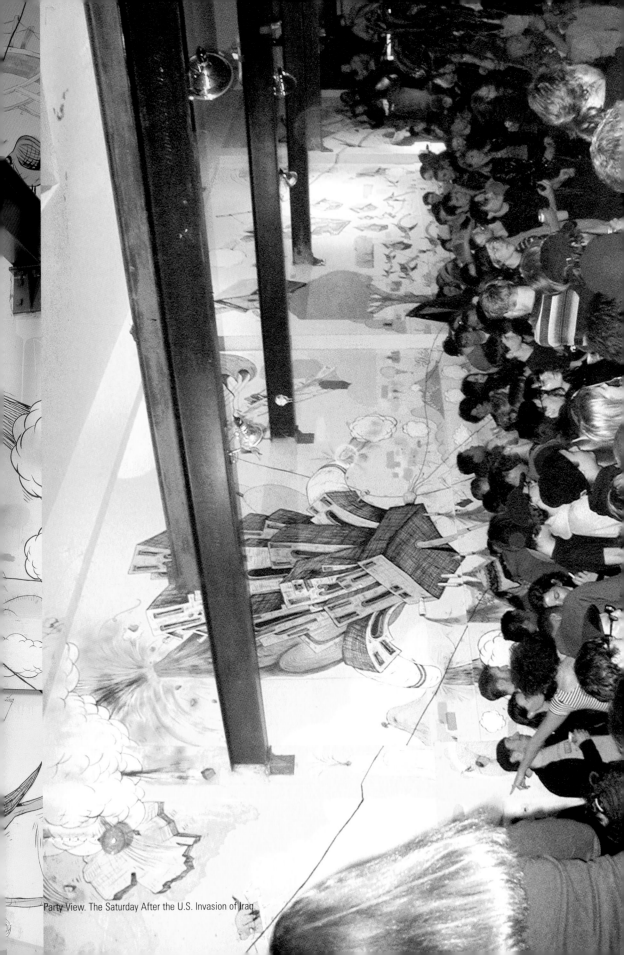

Party View. The Saturday After the U.S. Invasion of Iraq.

When asked about painting in public, its audience, & public space issues.

I do like to engage people with my work, however, I would not exactly say it is my favorite place to work anymore. I still love it, but it is far from my favorite place to paint. It is very unpredictable. The weather, lighting, and access to a bathroom, among many other things, at times, make it very frustrating. The logistical problems are many. There are always distractions and inconveniences with it. I have been jumped while painting, had my bag and supplies stolen, bricks have been thrown at me, just to name a few. Engaging with people on the street is great, but sometimes I feel more like a sitting duck.

I am not complaining at all. This is what you are dealing with when you are putting up work in the streets, whether legally or illegally, and honestly, I wouldn't want it any other way. I don't enter lightly into doing public murals anymore. They are a ton of work, and even greater commitment. There's not really any money in it either, not that that has ever been a reason for not doing a mural. On the flipside though, one of the things I love about it, is the sheer size and scale of it. The potential for both of these, is both exciting and amazing to me. You can paint things larger than you ever could in your studio or almost any museum in the world, storage is never an issue and for the most part they are permanent.

But definitely, the part I love the most about doing public work is the audience. It is perhaps the most unpredictable, diverse audience that you can possibly address in a given place. It is far more diverse than the audience that walks into a gallery or museum. Public work is out there for who ever happens to walk by. One minute a plumber could be looking at it, the next minute a single mother with her children could be walking by, and the minute after that, some stiff businessman, who doesn't have an ounce of interest in art, could be strolling through. I guess what I am saying is that it is out there for everyone. Rich, poor, old, young, black, white, liberal, conservative, etc. etc...

This audience is interesting to me because it is very far from preaching to the choir because the choir is never the same. You are addressing an audience with art that is oftentimes ignored by art. The chance to spark a viewer's interest in something, that they would normally not be interested in, however narrow that chance may be, excites me and seems like a purpose for a piece of art to aspire to.

Unfortunately, the purpose for most of the art being created these days, is to hang over someone's couch. I am drawn to the undiscriminatory aspects of creating something in the public, for the public. There is another responsibility that goes with it. You are there, on-site, to answer for whatever it is that you are putting up. With some of my murals, this has turned out to be a very extended amount of time. There is a lot more responsibility with doing public art than most people, including artists, would ever imagine. A good mural or piece of public art should work with the environment and community it exists in, not against it. It should be relevant, and seek to connect with those who must live with it.

This responsibility's weight has gotten considerably heavier for me in the recent past. This consideration is important, because it is what separates public art from all the crummy advertisements and billboards everywhere. A billboard or advertisement doesn't qualify as working with the environment it is in, instead its purpose is simply to sell you something. This is an important distinction for me to make. I am not trying to sell anyone anything with my public work. It sure does feel like corporate America owns our public space these days and no doubt, this is a worthy issue to address with art.

These issues, indeed have become the company line argument and moral high ground for many artists trying to do work in the streets these days, that they are in effect competing with all this. This is necessary and respectable to some degree, however it seems a bit played out at this point in the game and not my interest at all. Although, this argument definitely works when addressing the subject to the general public. The context of putting my art in thesame category or competition as a Britney Spears billboard feels cheap and discouraging. I don't really think most good or horrible public art can even be compared to an advertisement. They live in different worlds. Don't get me wrong, there is definitely tons of horrible public art out there too. The use of our public space is always going to be a debatable subject.

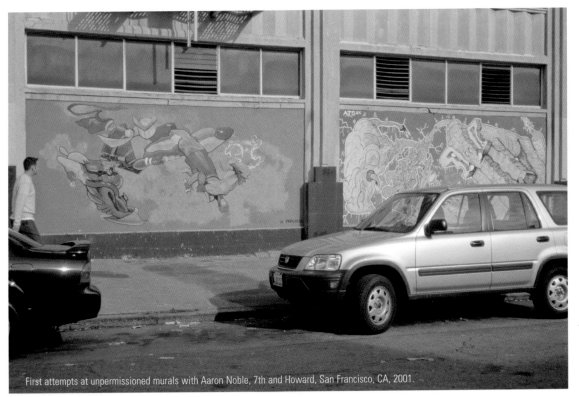

First attempts at unpermissioned murals with Aaron Noble, 7th and Howard, San Francisco, CA, 2001.

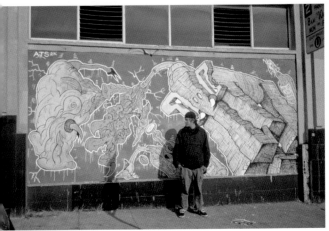

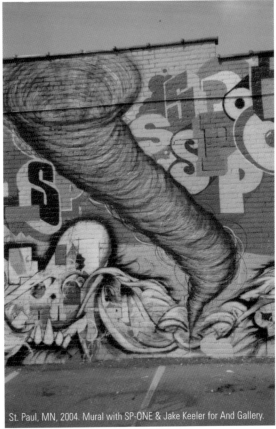

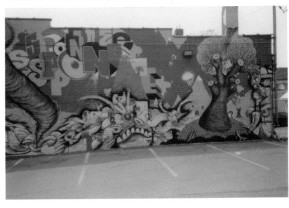

St. Paul, MN, 2004. Mural with SP-ONE & Jake Keeler for And Gallery.

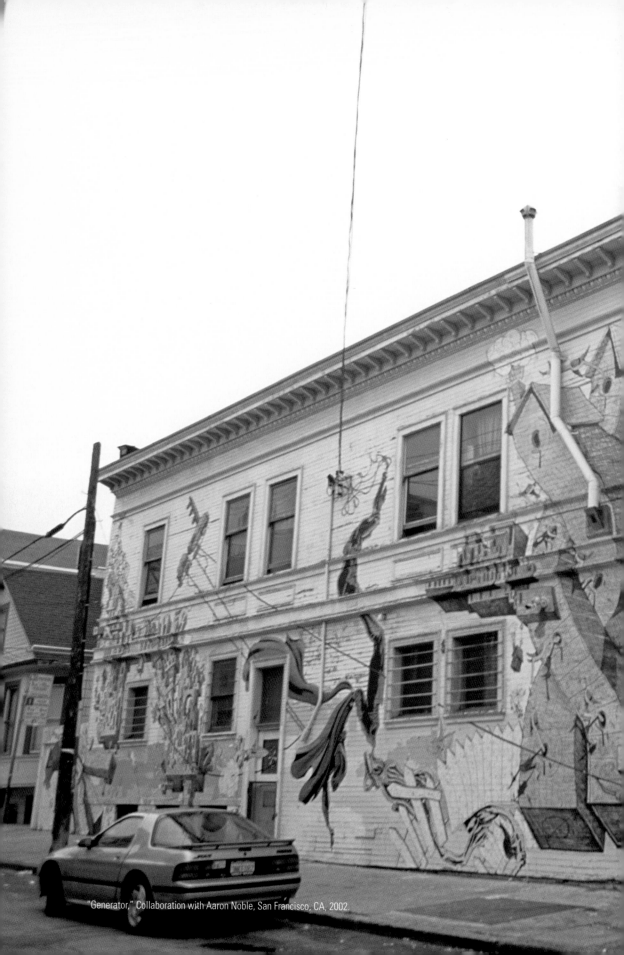

"Generator," Collaboration with Aaron Noble, San Francisco, CA, 2002.

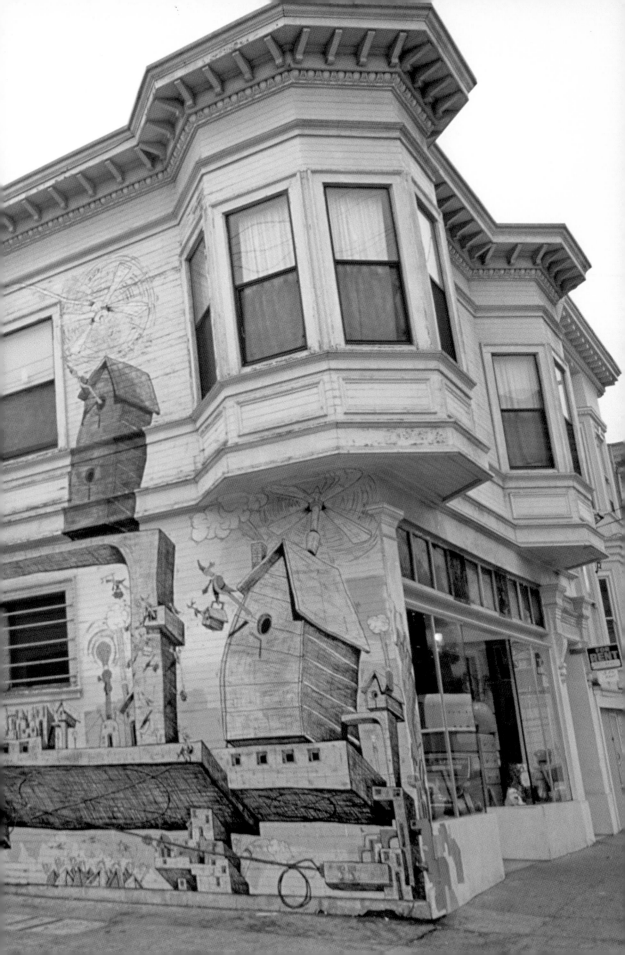

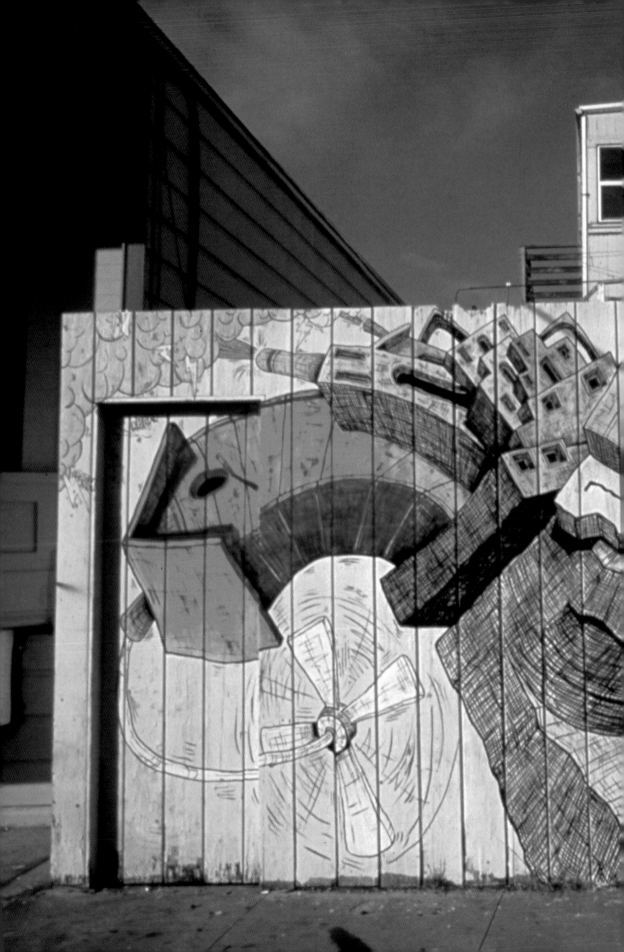

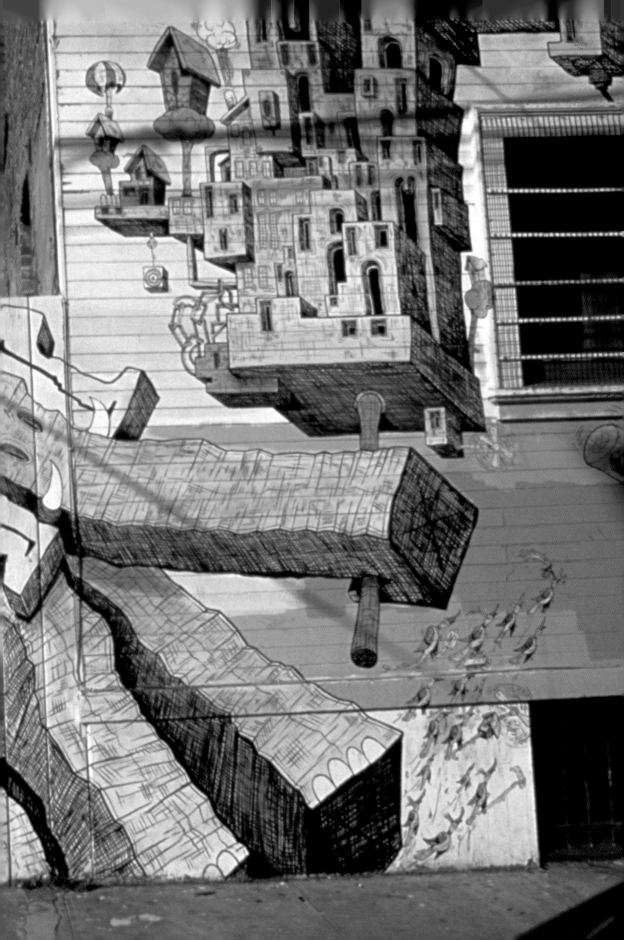

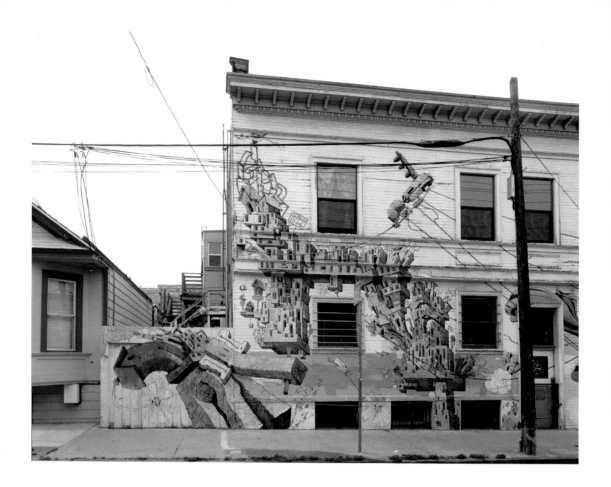

Andrew Schoultz: Then & Now.

Andy and I have been good friends for over eleven years now. We met through skateboarding. The two of us moved to San Francisco from Milwaukee together in late summer of '97. He actually moved out here a week before me to scout things out. I was 18 and he was 22.

There was less than 2% vacancy in the city at the time. People were practically living on top of one another. Finding an affordable apartment was next to impossible, especially on our shoestring budgets. The two of us were forced to split up. He stayed on a couch in a ramshackle flat in Lower Haight and I rented a tiny room in a crack-infested weekly hotel in the heart of the Tenderloin.

My money ran out by the end of the fourth week. I couch and floor surfed for a couple of months, but soon found myself virtually homeless. I had officially hit rock bottom. This is when Andy—jeopardizing his own unstable living situation—insisted that I stay with him. He took me in, fed me, and helped me get back on my feet. I've been living and progressing in San Francisco

ever since. Who knows where I'd be right now if Andy hadn't rescued me.

Andy eventually took over the lease on the Lower Haight flat. The two of us lived there together for four years. It was during this time that Andy was fully able to establish himself both as a skateboarder and artist in the city.

In '98, Long Island-based Chapman Skateboards recruited Andy to join their skate team. The company sent him on various tours and to contests all across the country. Andy was receiving a great deal of recognition within the skateboard industry. It was only a matter of time before he made it big.

As time went on, however, Andy's interest in pursuing a career in skateboarding gradually started to fade. He began focusing more on his art instead. Prior to this point, Andy was equally into both, but now he was creating art around the clock and skating for fun on the side.

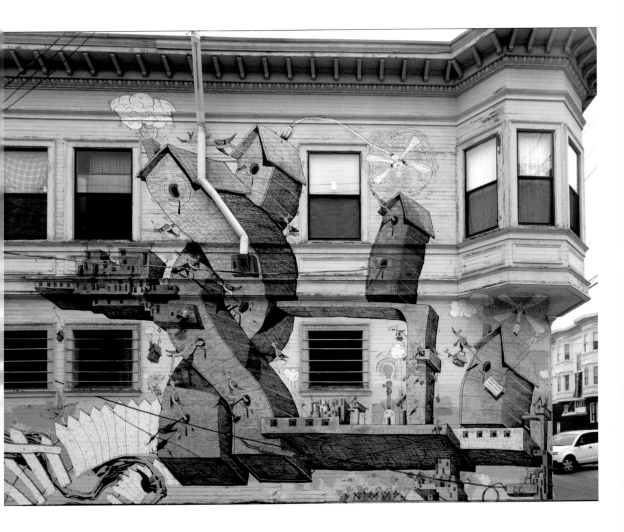

You should have seen our apartment. It was literally overflowing with Andy's paintings. I'm fortunate enough to own a handful of these early gems today. They're by far some of my most prized possessions.

I believe it was in '00 when Andy first started getting commissioned to paint large-scale murals. In my opinion, this is when his career as an artist really skyrocketed. Once a job was confirmed, Andy wasted no time getting started. He worked religiously everyday from sunrise to sunset until the mural was completed. The finished product never failed to leave me and tens of thousands of others completely awestruck. Andy's murals have helped bring life back to some of San Francisco's shadiest and most neglected neighborhoods.

Over the years, I've watched Andy establish himself as a heavyweight in the contemporary art world. He's traveled abroad to paint to murals, had shows in reputable galleries across the coast, and his work has been featured on the pages of many big name publications worldwide. Andy is proof that hard work and determination pays off.

Although Andy is no longer a sponsored skateboarder, believe me, he still hasn't lost the touch. Come join us on one of our weekly Saturday sessions and see for yourself. Andy rips!

I'm honored that Andy asked me to write this piece for his book. The two of us have been through a lot together over the years. Andy was like a brother to me growing up. He showed me the ropes, looked out for me, and has by far had more influence on me than anyone else in this world. I have so much love, admiration, and respect for Andy that it's somewhat difficult for me—the writer—to put into words. I'll just leave it at that. Enjoy the book.

Travis Jensen

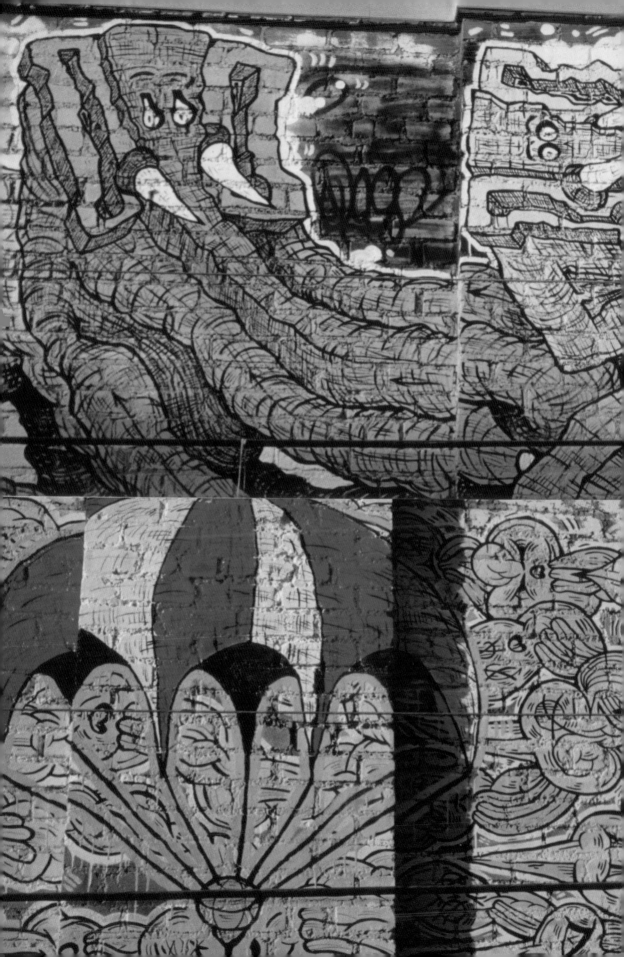

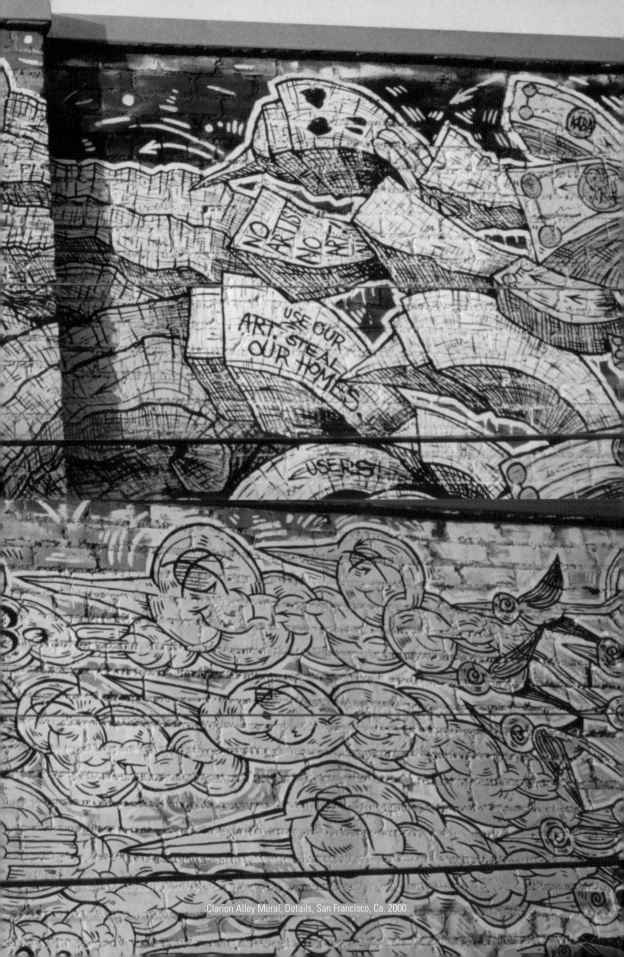

Clarion Alley Mural, Details, San Francisco, Ca. 2000.

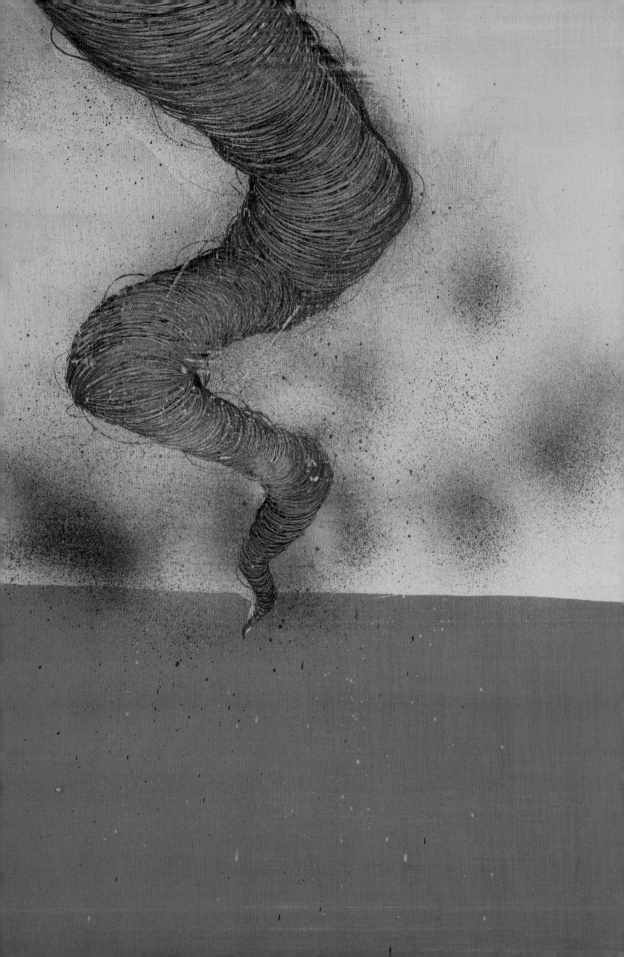

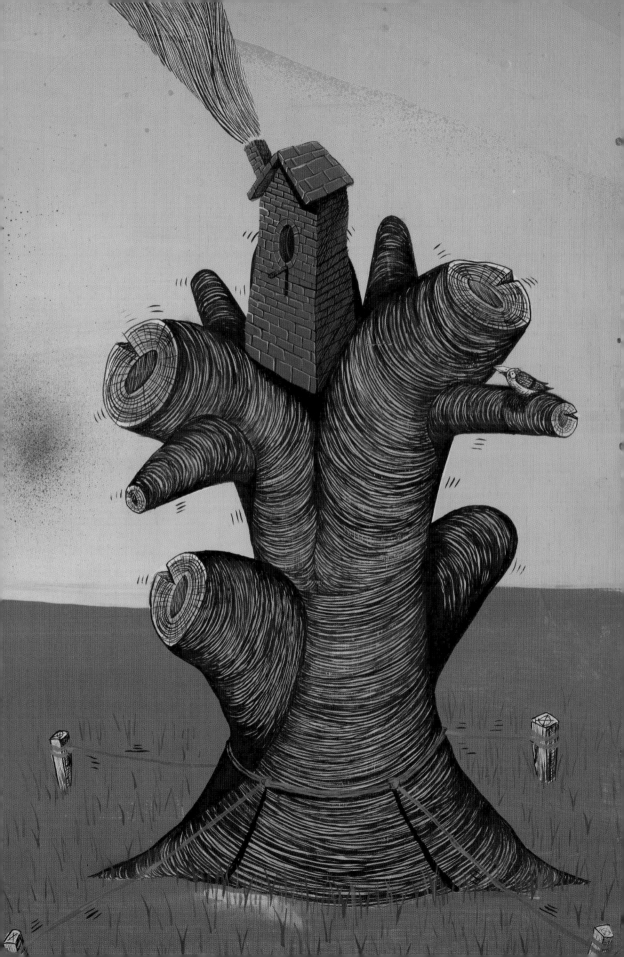

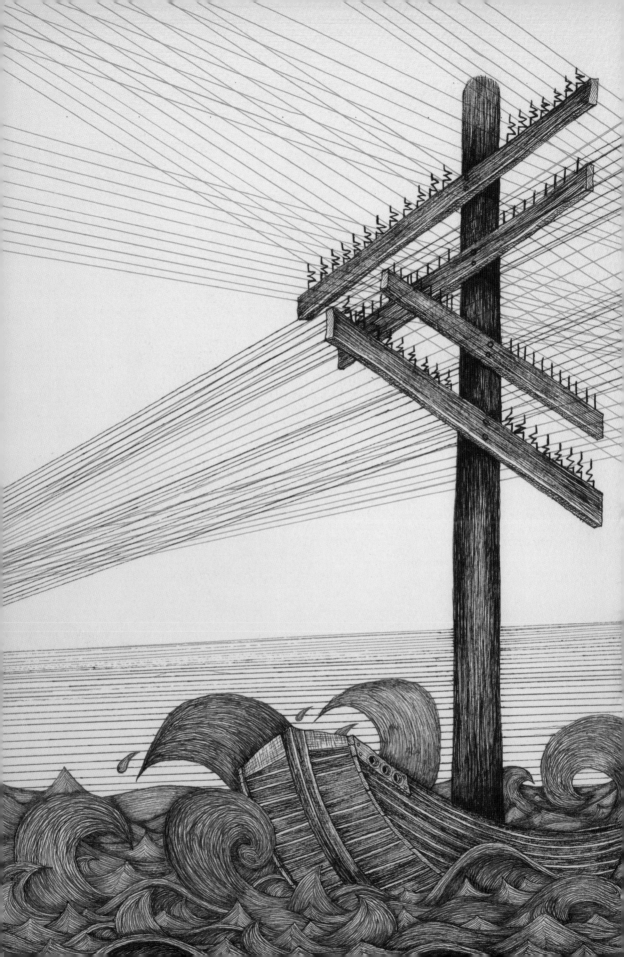

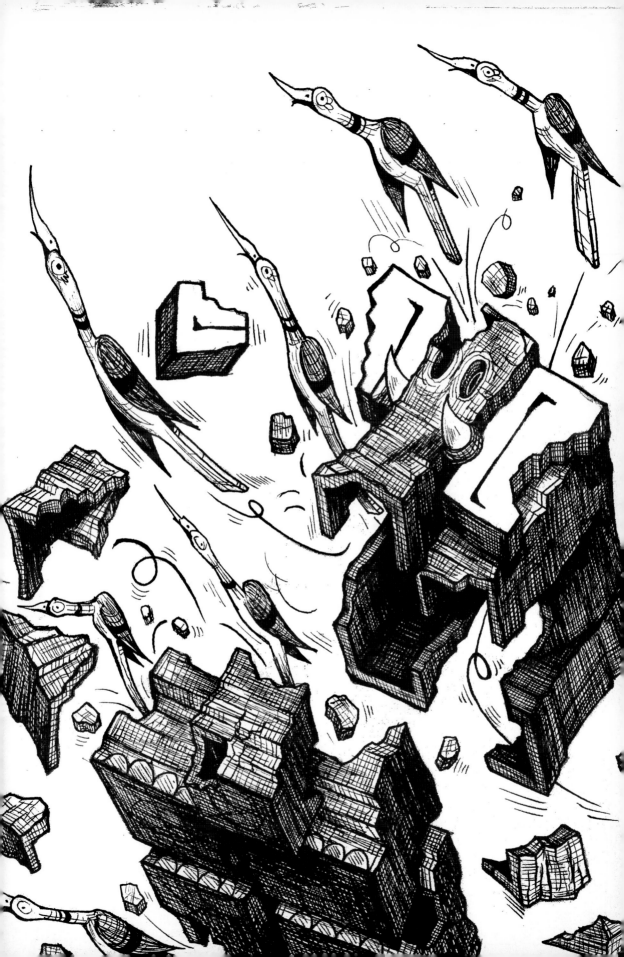

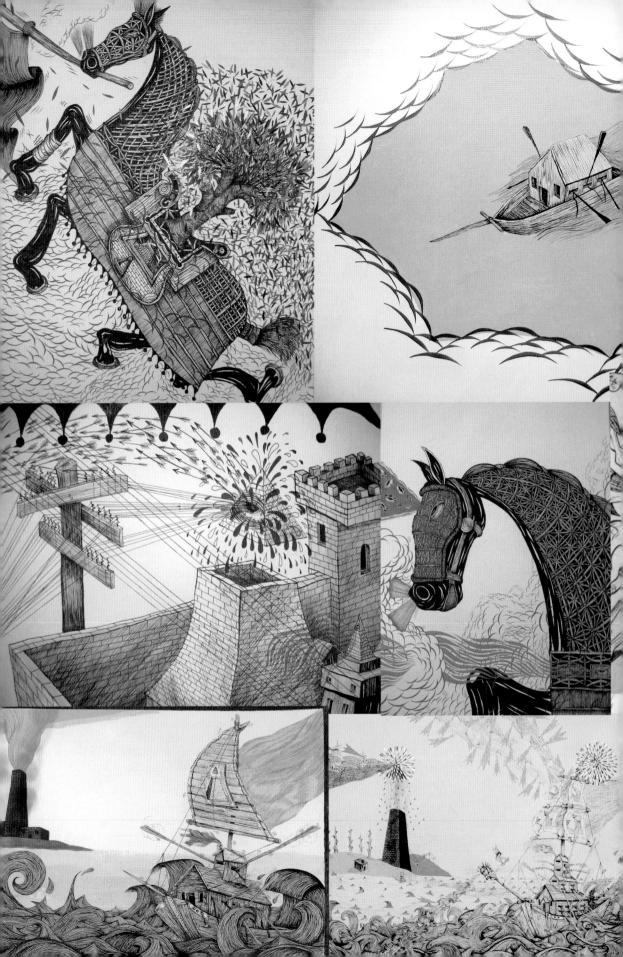

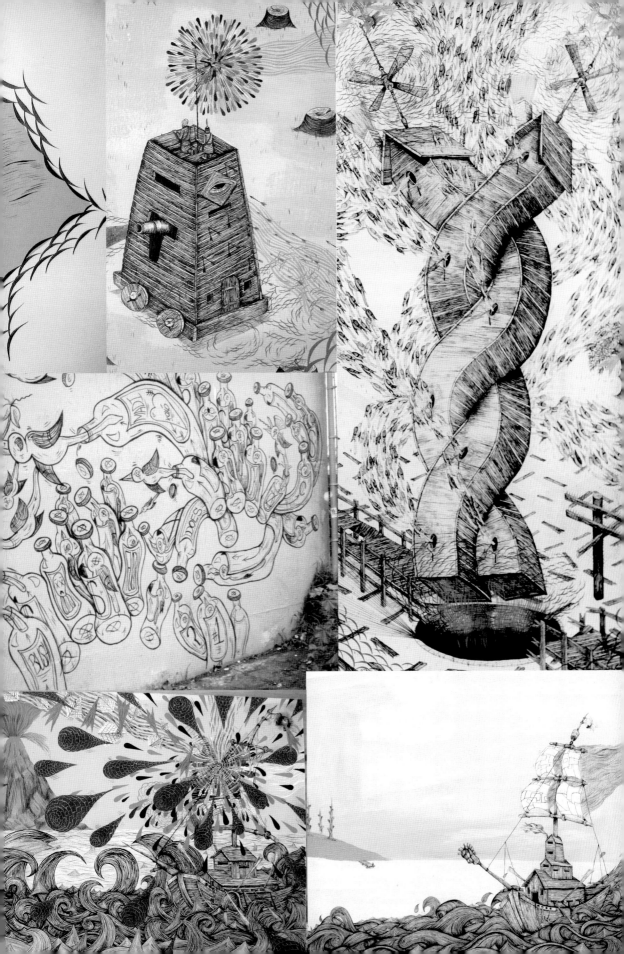

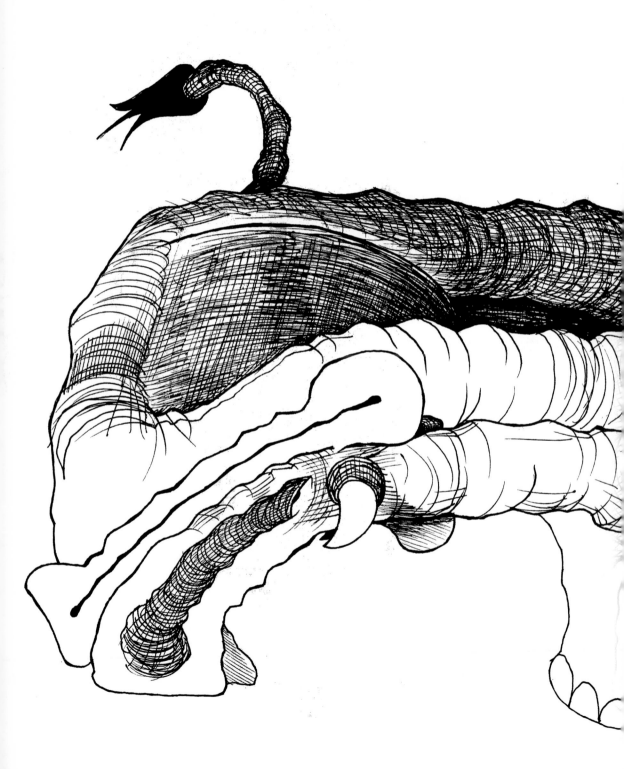

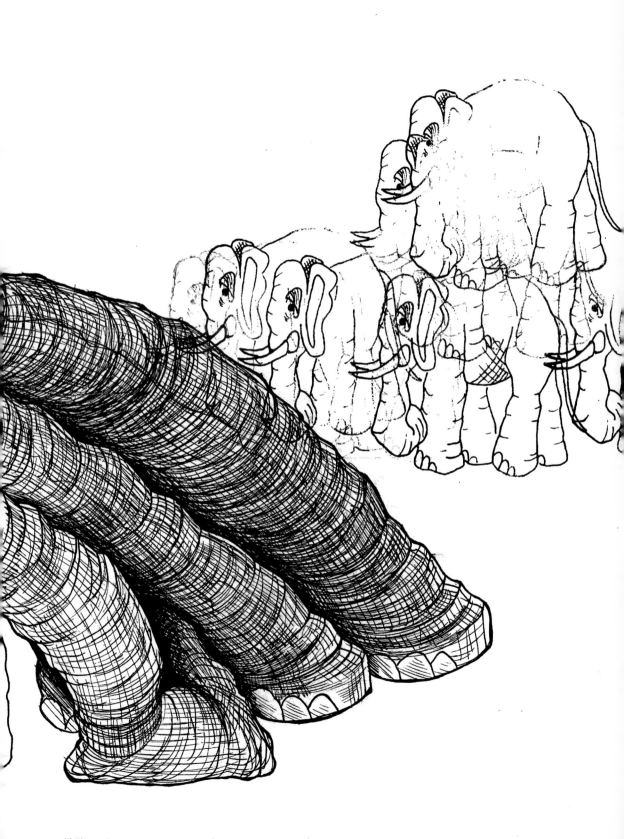

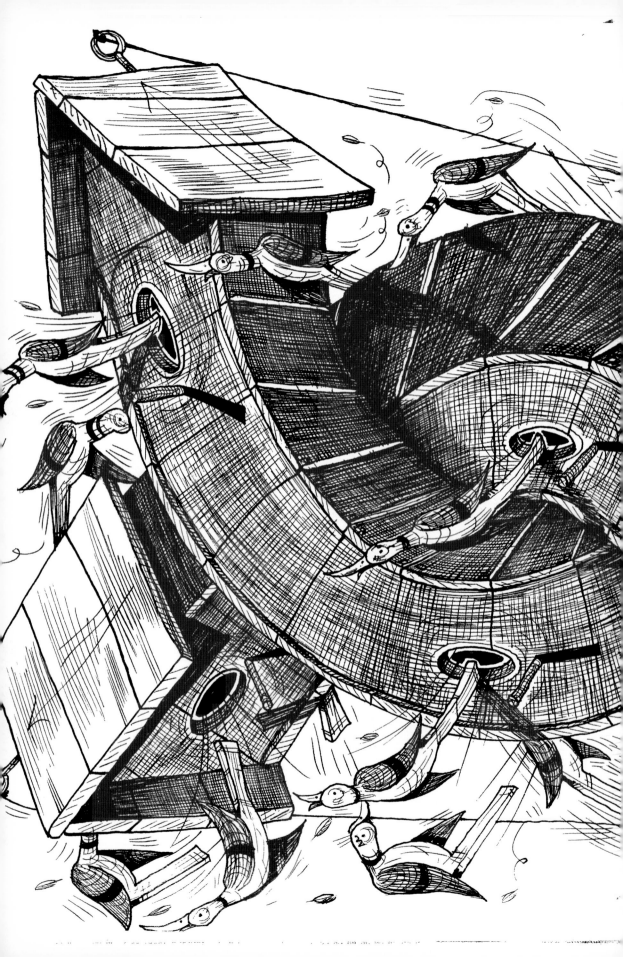

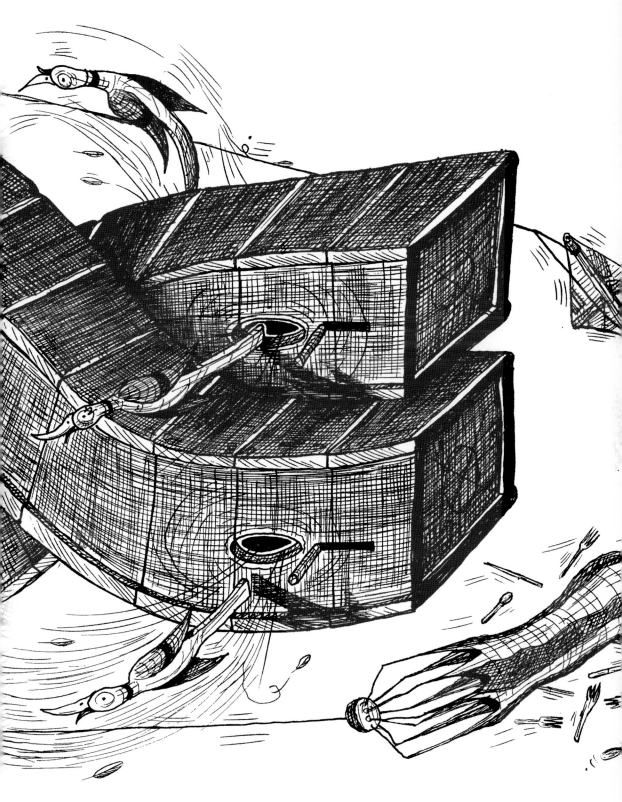

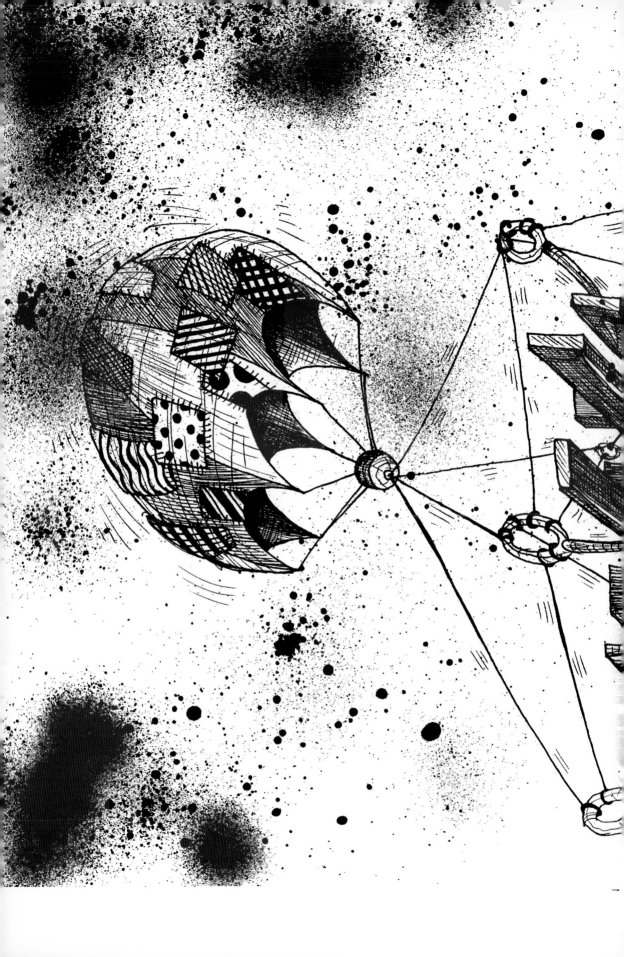

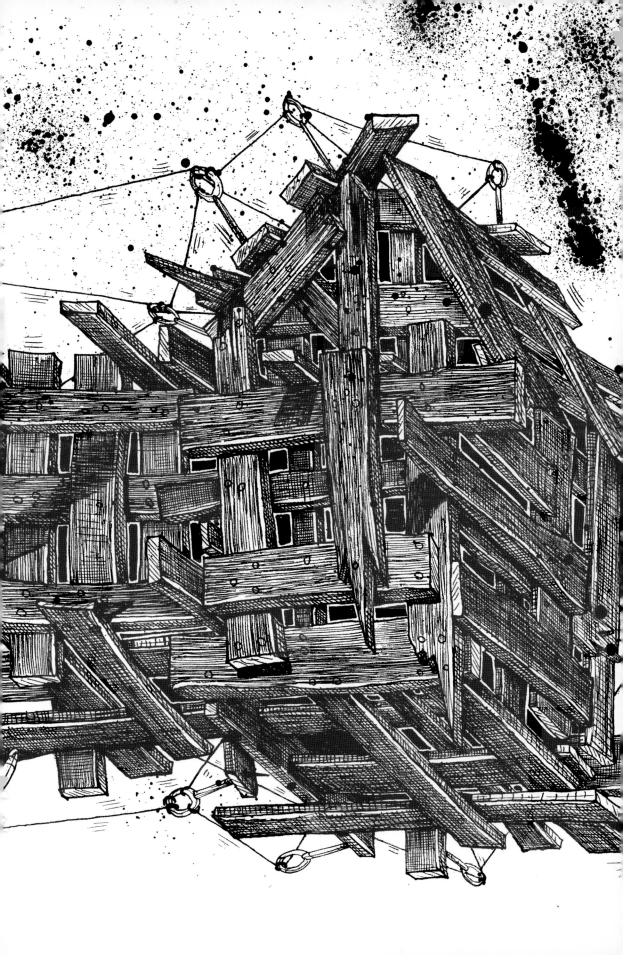

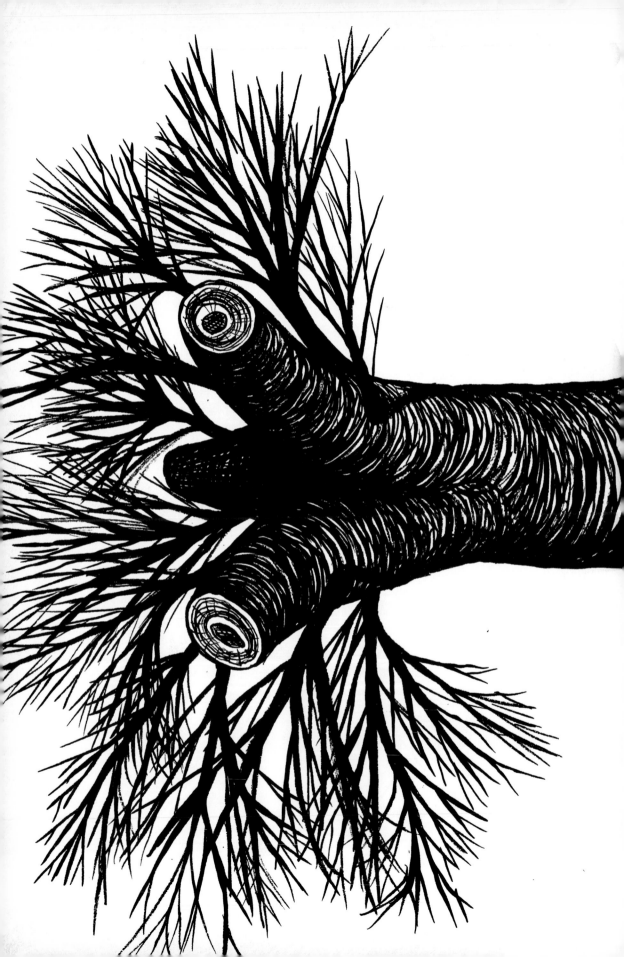

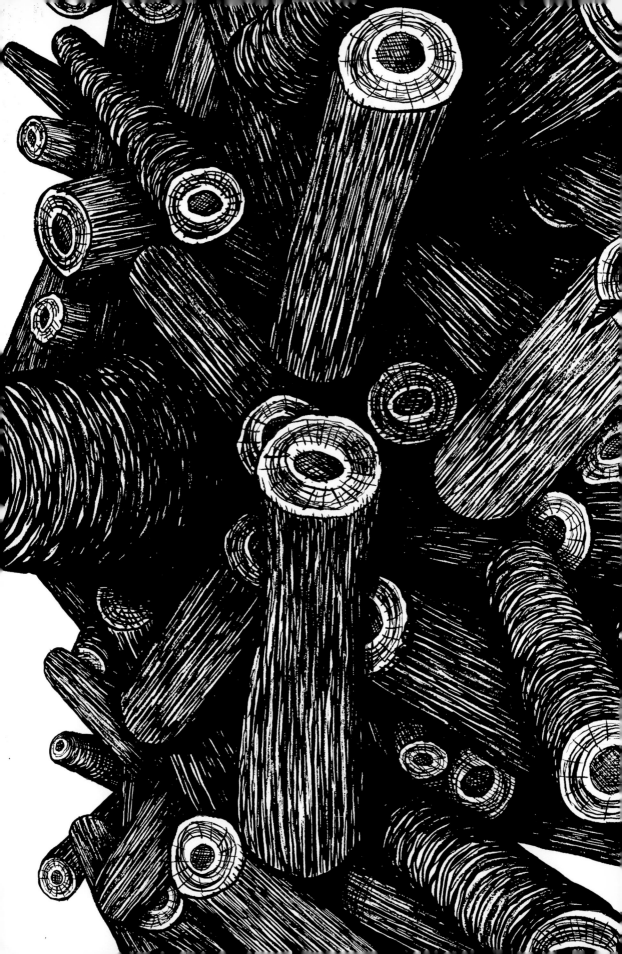

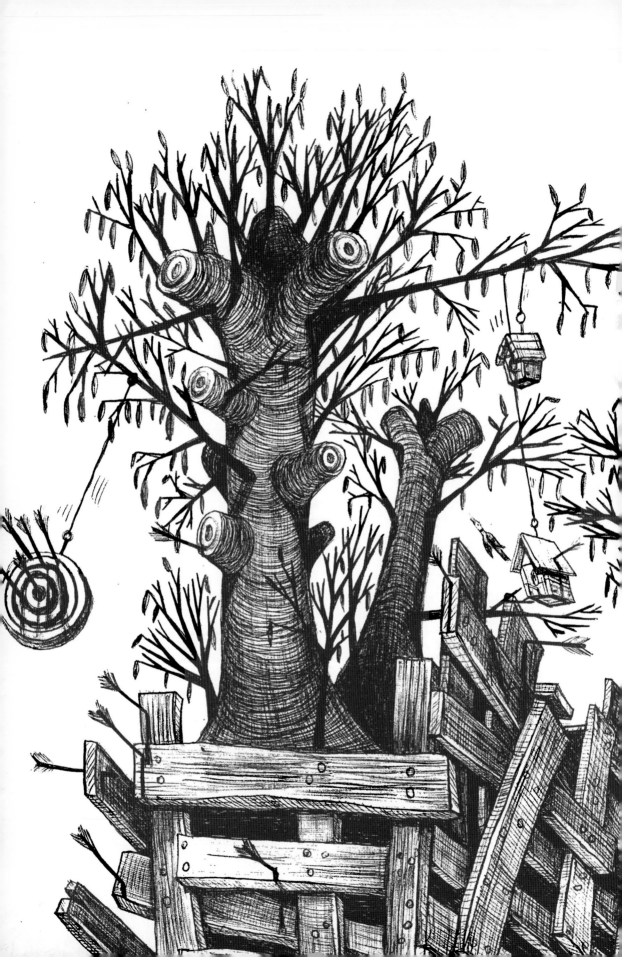

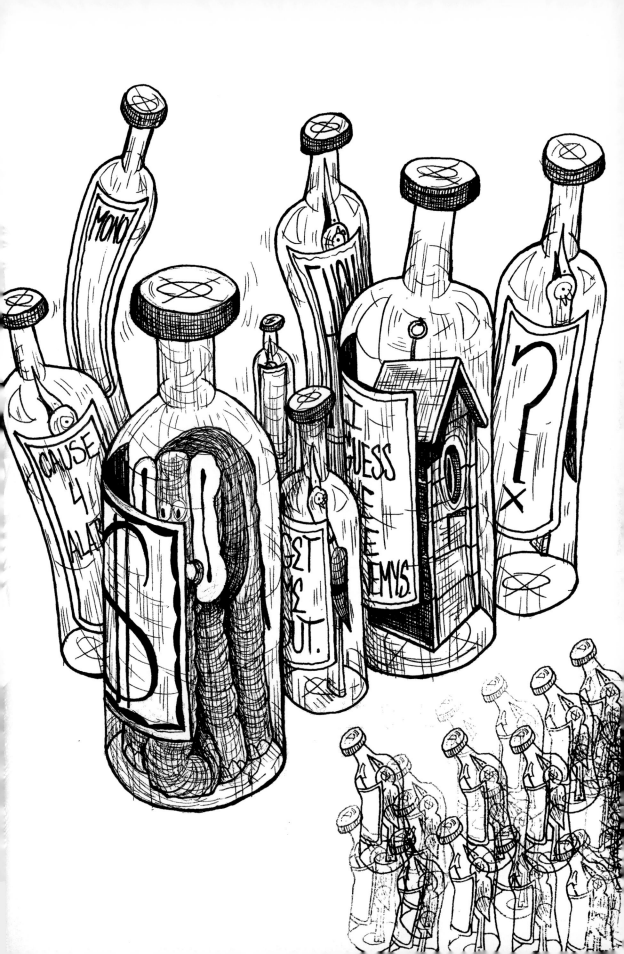

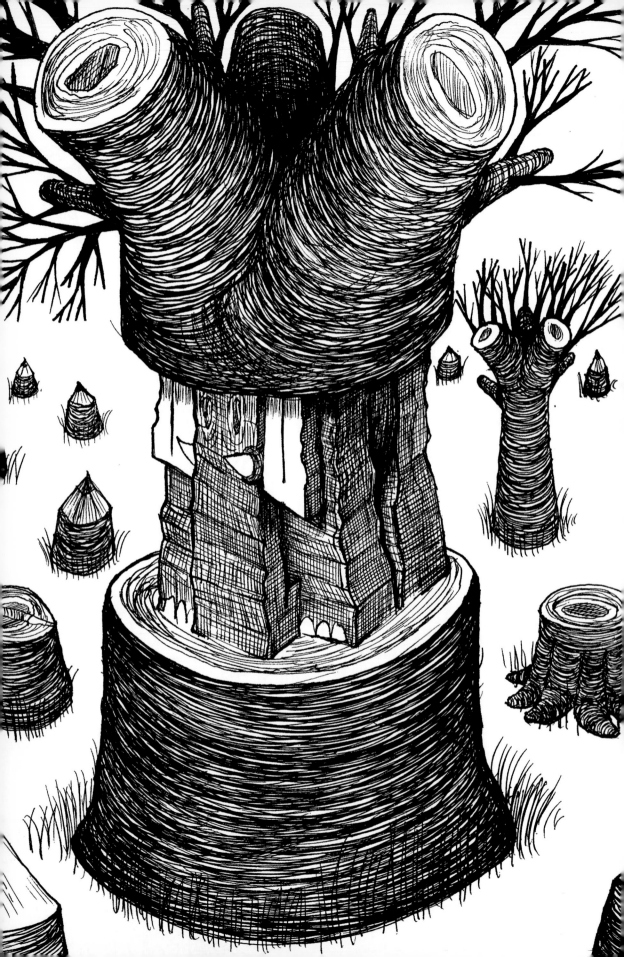

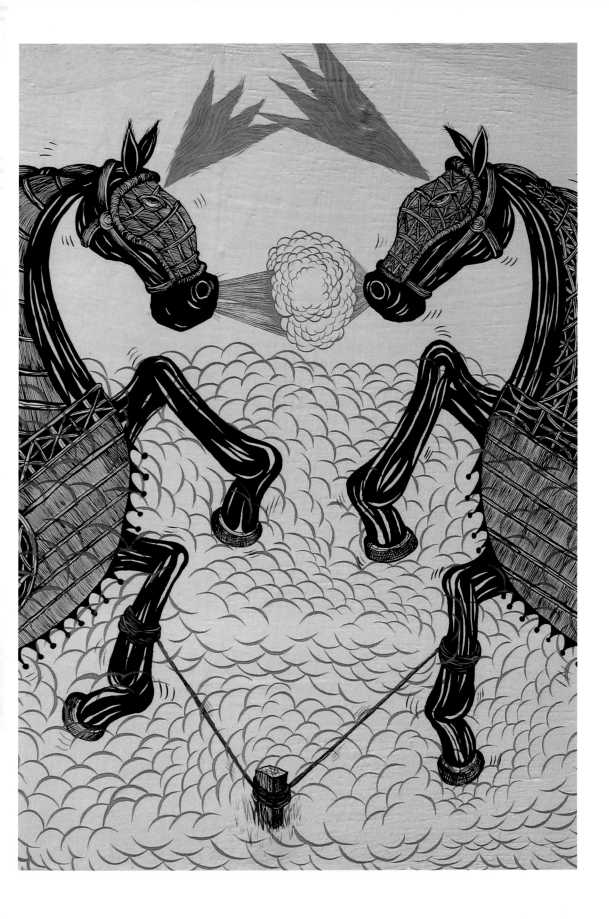

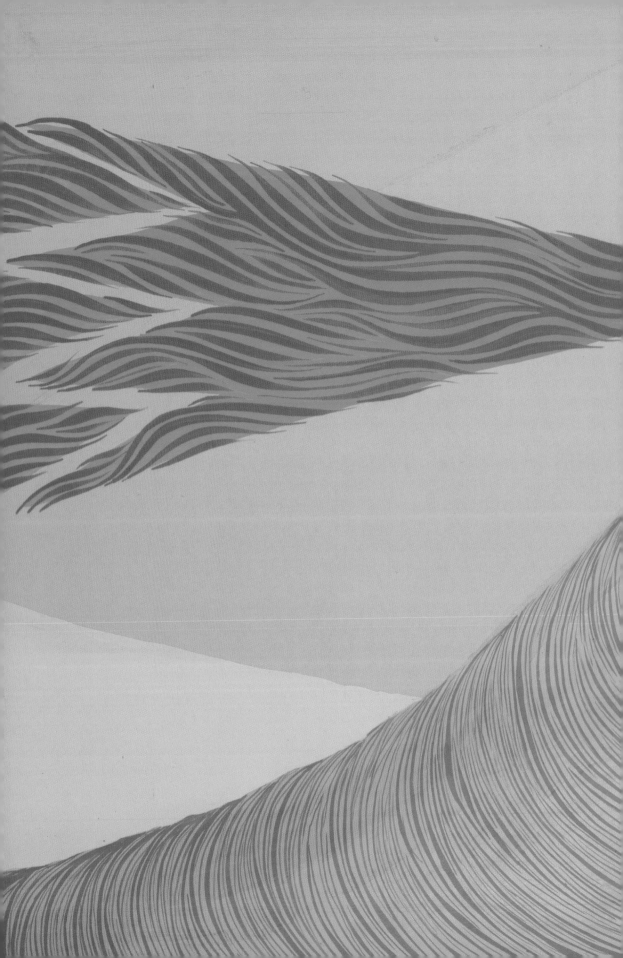

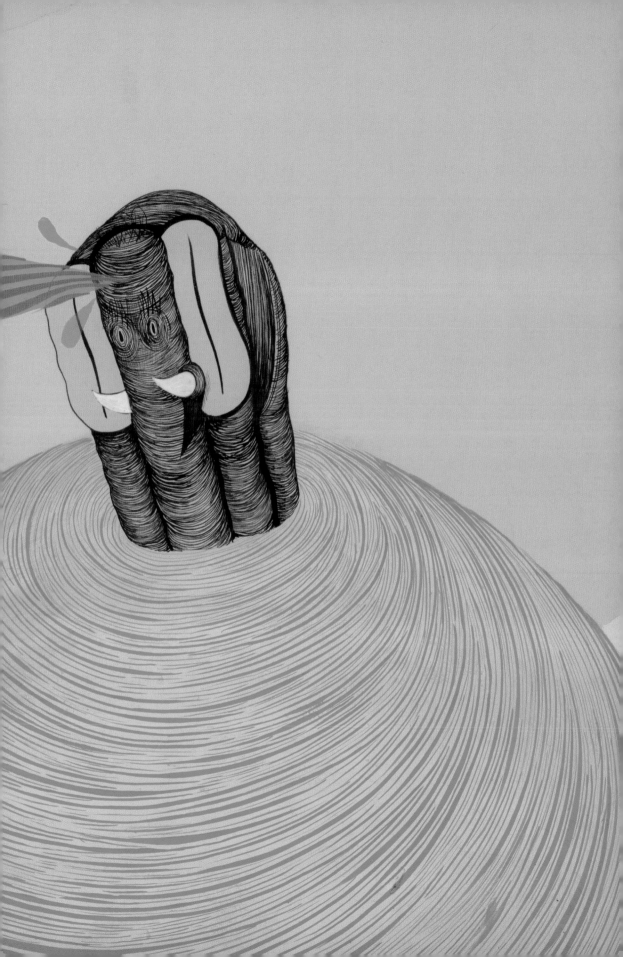

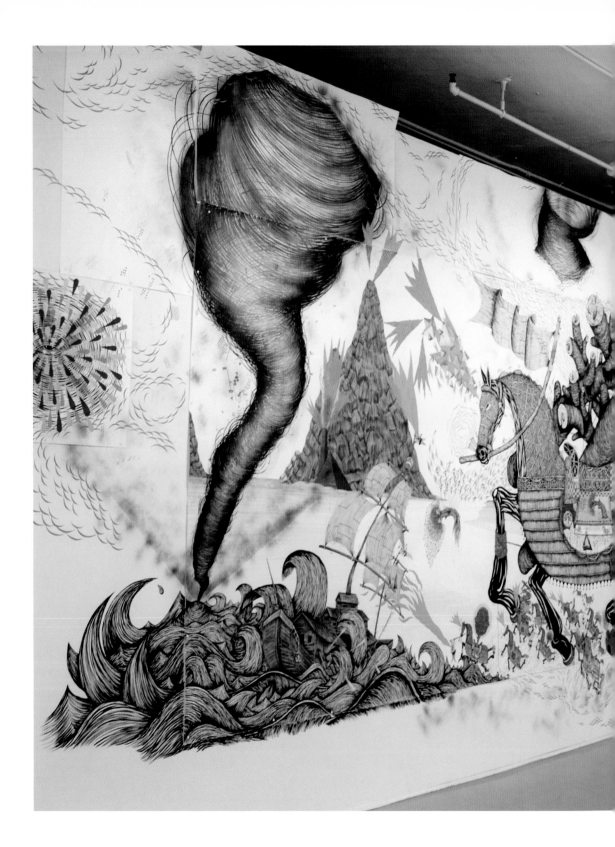

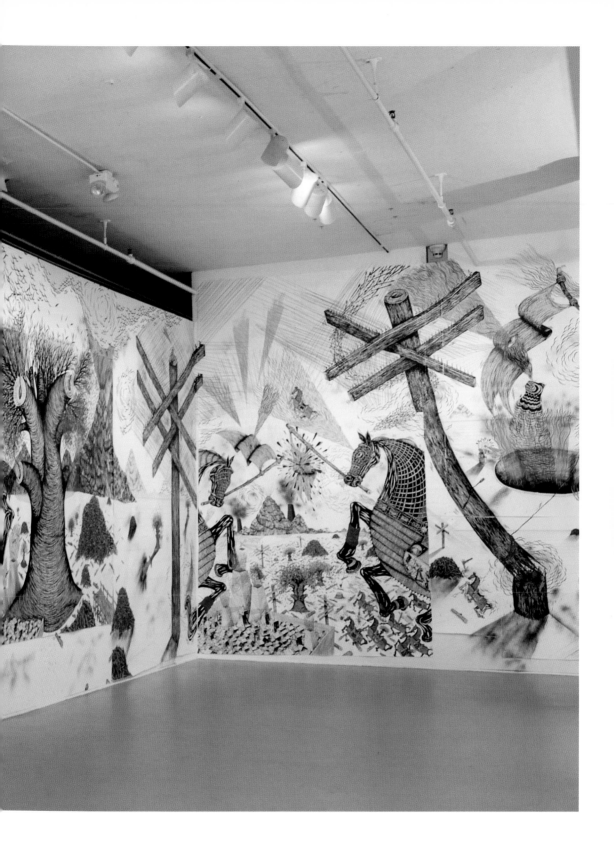

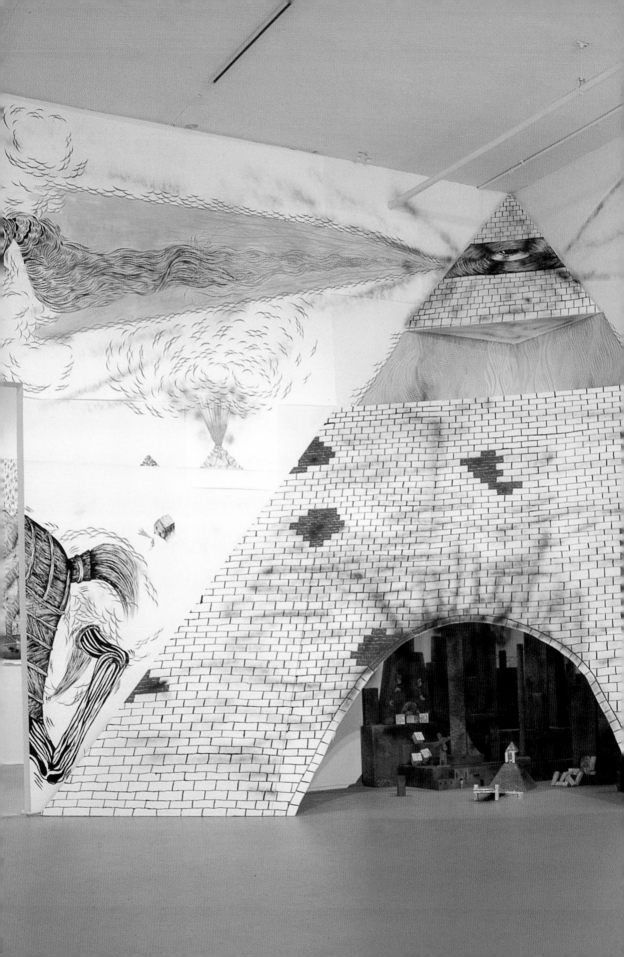

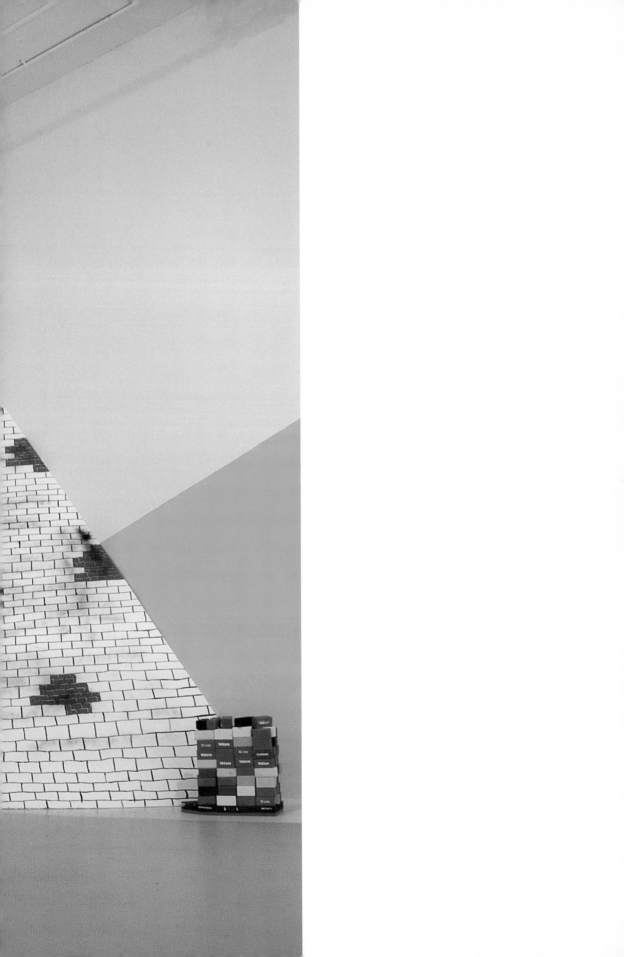

Andrew Schoultz:
Winning in a Loser's Medium

It was in 2000, after a number of years of writing graffiti, that Andrew Schoultz decided that he would begin to paint murals, and he did, in his San Francisco hometown, as well as in cities across the United States—even one in Indonesia. Now after five years of producing some of the most wildly original and labor-intensive murals in recent memory, Andrew has established himself an important place in the slow convergence of graffiti and street art with the longer tradition of murals.

There may be more murals around the world than ever before, but the art world isn't particularly interested. Simple matters of sustainability push the best muralists of today into gallery settings, losing 95% of their public along the way. Despite the best efforts of a decades-old movement of street cultures, the nasty matter of money has only reinforced an ugly truth of the inter-section of business and social service: that people will pay royal sums to 'own,' but a pauper's wage to 'fund.' And a mural is a difficult thing to own.

The sad thing about murals—and I say this personally as someone who would paint only murals, absent the realities of money and sustainability—is that they are a real loser's medium. They are ephemeral, fragile, un-sellable, funded only at the most rudimentary level, and are subject to every caprice of opinion on the part of property owners, communities, and local governments. They are relegated to predominantly marginal neighbor-hoods except when in the form of vapid decoration, and at every step, there is pressure to force the mural theme to be a celebration of local heritage, as well as to have its production and design involve the hands of children to fulfill an educational function. None of these are necessarily bad things, but they aren't examples of the individuality and freedom that are conducive to the making of good art in the Western tradition.

Attitudes towards murals were not always so conde-scending. Many of the most renown of Renaissance artworks were murals, albeit in religious contexts. Up until the mid-1960's, murals were an art form governed by the patronage of states, religions, and the wealthy. Rebellious as their subject matter might have been, the murals of the great Mexican artists of the early 20th

Century—Diego Rivera, David Alfaro Siqueiros, Jose Clemente Orozco—were nearly all funded by governments, universities, and titans of business, hardly a grass-roots movement, however much so their artistic successors might have been.

In 1967 at the corner of 43rd and Langley in the South Side of Chicago, things changed, as the first 'Wall of Respect' was painted in an unsanctioned attempt to make for a better neighborhood. In only a few short years, these 'Walls of Respect' (or 'Pride,' 'Life,' 'Meditation,' etc) would become something of a fixture in African-American neighborhoods throughout the United States, and similarly, locally organized heritage murals would appear in Mexican and Latino neighbor-hoods. These murals were often confrontational and, in a sense, territorial-see a mural of Malcolm X or a sagrada corazón and you know who lives in the neigh-borhood. Naturally, this terrified White people, and to this day, if you see a mural in a White neighborhood (or in any airport, for that matter), you'll probably see a lightly and entirely non-confrontational trompe l'oeil image; a landscape; underwater scene; or an abstraction of colors.

At roughly the same time that the ripple effect of the 'Wall of Respect' spread across the urban United States (the early 1970's,) the graffiti movement of the New York subway system was in its period of rapid development. Where the mural resurgence drew freely from the technical tool chest of traditional arts, graffiti was by and large inventing itself and its techniques from scratch, since neither spray paints nor the kids using them had any history in the arts to speak of. Naturally, it was a hasty art form. Graffiti grew up on subway trains, and painting a 12'x60' subway car, over the course of a night (or a weekend, if you really knew the train lay-up schedule) was for many years about as time-consuming as individual pieces of graffiti got. Until the mid to late 1980's, very few pieces of graffiti ever took more than a weekend to complete. There are still plenty of graffiti writers who find it laughable to spend time in the creation of a single piece of graffiti. Many graffiti writers who enjoy near-universal respect and admiration of their peers have never done anything in the street

that took longer than ten minutes to execute. When graffiti started to work its way onto walls as murals, especially legal ones, that no-longer-necessary haste often showed. Graffiti requires an obsession over doing a great deal of work, but not an obsession over the individual works themselves.

It took a good ten years for graffiti writers to really settle down and take weeks or months on the completion of individual murals. When the FX crew brought writers together from Philly, Puerto Rico, and Germany all together to do up walls in the Bronx in the 1990's—especially about 1996 and 1997—they really opened up the eyes of the graffiti world as to what could be done with talent and time. They took some of the slowest spray-painting techniques, previously used only in detailing, and spread them across entire productions.

At the same time, certain graffiti writers were beginning to take the daring step of incorporating new media into their work. Graffiti had been so faithfully wedded to the spray can that it certainly came as a surprise to see the first street work that used ink, latex paint, wheatpasting, and so on. Some graffiti writers with experience in some traditional fine art techniques began to use them in both legal and illegal graffiti work. San Francisco's Barry McGee/Twist, as well as New York's Revs and Cost partnership were pivotal in this process, as they had the personal conviction, as well as the graffiti work ethic, to withstand the inevitable whining that came from the peanut gallery about their work not being "real" graffiti for whatever reason. Graffiti writers love the idea of rebellion, but as a whole, they really didn't know what to do the first time that they saw one of their peers use a paintbrush along with a spray can.

Andrew Schoultz has kept his murals and his graffiti largely separate, linked only by their work ethic and their public presence. He is a fairly regular, quality graffiti writer, and this is intended as a compliment. There is a traditional and time-tested "right" way to do graffiti, and Andrew is pretty good at all of these. He's not a graffiti rock star on the level of a Revok, a Rime, or any of those greats, but he's solid at what

he does. Graffiti in many ways is more like a craft or a sport than an art, and in fact, many of its participants don't consider themselves artists at all. Perfection is not the goal, but rather quality workmanship and steady, level play.

Andrew has taken this ethic of long hours into his fine art, realizing that there's something respectful and lovely about any body of artwork which plainly took a great deal of work to complete. Beyond that, there is something especially respectable about those artists—like Andrew—who work in labor-intensive styles and are wildly prolific in the face of all the hours required for the completion of even one of their works. Dedication is a sexy, intimidating thing, yet there is little to recommend it to young artists, really. All too frequently, the lesson of art school—an environment that 'professionalizes' artists—is to slow one's productivity down to a crawl, and to fill up that new dead space with the special brand of theoretical couching and posture that costs so many thousands. The thing is, the art school approach makes sense: you need to show the work you make, and being prolific will inevitably result in having more work than one can show. Excess inventory is a recipe for failure in any business.

I don't get the sense that Andrew Schoultz really cared to internalize this lesson while at art school, and thank goodness for it. Thankfully, another art form—graffiti—had already gotten to him first, and beaten art professionalism to the ethical punch. Andy was gonna make a lot of artwork: like any number of graffiti writers, he sees art as a big bank account into which every bit of effort is another check, big or small, all for deposit only, biggest account wins.

Caleb Neelon/SONIK

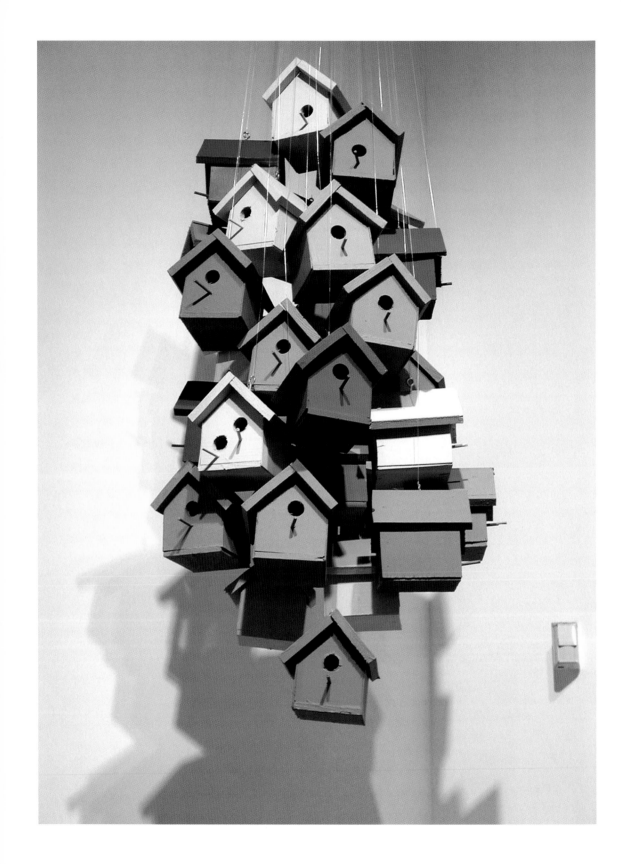

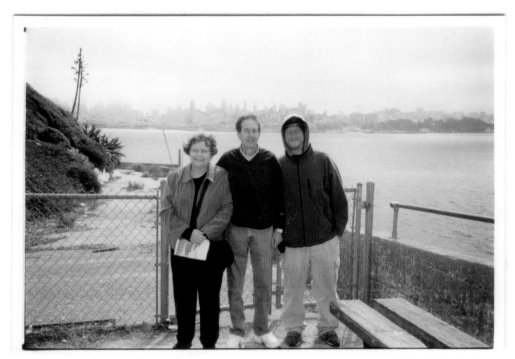

Me & My Folks, Alcatraz, CA, 2003.

Madeline in a Ubud, Indonesia, 2003.

Kung Fu USA with Nano, Arie and Arya, 2003.

Kaba, hanging out on the ladder, SF, 2005.

Skott Cowgill aka D.J. Tragic, SF, 2005

Mark Shark, 4 am, Brooklyn, NY, 2006.

Nano Warsono, 2003.

Kung Fu USA

Arya, Nano, & Denni, Jogja, Indonesia, 200

Tyler Faber aka Terrible photo-ing it up, SF, 2002.

HelloNoisy at the 16th and South Van Ness House, 2002.

Joe, Tom, and Ryan at the Bitchwippaz' premier, Brooklyn, NY, 2006.

Codit, Alicia McCarthy, and Farhan Siki, Jogja, Indonesia, 2003.

Travis, Ryan Wilburn, and me, freshly shaved heads, SF, 1999.

St. Paul, MN, 2002.

Don & Collette Evans, 2003.

Ian Johnson at The Gold Cane, SF, 2005.

SamaSama Project at the Mayors Office, Yogyakarta, Indonesia, 2003.

Kevin Chen, making it happen at The Intersection For The Arts, 2005.

Mats?!, Jeff Roysdon, me, & Antonio at Balazo Gallery, SF 2002

Andy Diaz Hope, New York City, 2005.

Alicia at work, Track 16 Gallery, SantaMonica, CA, 2005.

Aaron Noble at work, Mission Rock Mural Project, 2001

Ando

Samuel Indratma at his home, Jogja, Indonesia, 2003.

Marky P, Helping with the install, 2005.

Mark Mulroney installing, Sun Valley, ID, 2005.

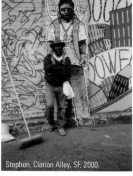
Stephen, Clarion Alley, SF, 2000.

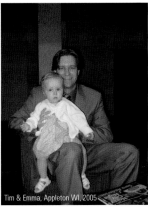
Tim & Emma, Appleton WI, 2005.

Ryan Wallace installing. LA, 2004.

Touched by a Janitor, Clarion Alley Block Party, 2000.

Madi at Critical Mass, 2003.

Caleb

Erik Zo

Thank You

Mary & Bill Schoultz, Madeline Born, Mark Pearsall, Exilition, Aaron Noble, Ian Johnson, Kevin B. Chen, Intersection for the Arts, Collette & Don Evans, Noah Lang, Trillium Press, Laurie Steelink, Track 16 Gallery, Tim & Sue Schoultz, Andres Guerrero, Greg and Mikaela Lamarche, Caleb Neelon, Yuri Psinakis, Ryan Wallace, Casey, Joseph Hart, Jeff, Eric, Tom Mahr, Eric Foster, Erik Zo, Derek Song, Jameson Alexander, Arkitip, Kenton Parker, Alva Greenberg, Alva Gallery, Boston Center for the Arts, Laura Donaldson, Adra Raine, Mccaig-Welles Gallery, Raid Projects, Space Gallery in Maine, Skot Cowgill, Jeff Peterson, Alicia McCarthy, Marky P., Jeff Roysdon, MATS?!, C.A.M.P, Megan Wilson, Taylor Decordoba, Nero Magazine, Lenny at Arrow magazine, Kristen Accola, Lori Freidman, Sara Nightingale, Jonathan Levine Gallery & Staff, Bill Beccio, Mark Mulroney, Western Edition, FTC, Ando, Joe Misurelli, Boris Delepine, Ross Mirkirimi, Eduardo Pineda, Ray Patlan, Morgan-Lehman Gallery, Galerie-Borchardt,

Tyler Faber, Gregory Dicum, Jennifer Gately, Alan Bamberger, Felicia Fahey, Adam Platti, Justin Giarla at Shooting Gallery,
Joey Piziali, Eric Nakamura, Freddi C., BMG, Travis Jenson, Nick Rem, Craig Costello, Rogelio at 111 Minna,
Zahar Kourey, Kung Fu USA, The Enablers, Heather Schultes, Peace, Trust, Evail, Awe 2, Teo, Eruptoe, Diet, Dense 35,
OKOK Gallery, Kemik, Jeana Yoo, Andy Diaz Hope, Robot, Laurel Roth, Zara Thustra, Antonio Roman Alcala,
Evan Porter Larson, Oh So Little..., Apotik Komik, Nano Warsano, Arie Dyanto, Samuel Indratma, Arya, Via Via Cafe,
Rainbow Grocery, Precita Eyes Mural Art Center, Will Yackulic, Brion Nudah Rosch, Oliver Halsman Rosenberg,
Jim Prigoff, Alvin Gregorio, Culture Cache, Luggage Store Gallery & 509 cultural Center, Ricardo Richey, Nome Edonna,
John Breiner, Willenbring Meyers Family, Jake Keeler, Evan Cerasoli,
& Absolutely Anyone I Have Forgotten...

Contributors

Aaron Noble

Aaron Noble is a cofounder of the Clarion Alley Mural Project (CAMP) in San Francisco, which he directed from 1997 to 2001. He has done permanent outdoor murals in San Francisco, Los Angeles, London, Indonesia, Taiwan and Beijing, and temporary wall paintings at the UCLA Hammer museum in Los Angeles, White Columns in New York and the Davis Museum at Wellesley College, among others. He is represented by Pavel Zoubok Gallery in New York and is a member of Booklyn Artists Alliance.

Caleb Neelon

Born in 1976 in Boston and based in neighboring Cambridge, Caleb is an artist, writer, and educator. He is an editor at Swindle magazine and co-author of Thames and Hudson's Graffiti Brasil and its forthcoming title, Street World. Caleb's artwork has appeared in galleries across the United States and on walls in Kathmandu, Reykjavik, Bermuda, Calcutta, São Paulo, and across Europe. He dislikes winter weather. Caleb Neelon's website: *theartwheredreamscometrue.com*

Kevin B. Chen

Kevin B. Chen has been involved in the San Francisco Bay Area arts community for over 12 years. Since 1998, he has been the Program Director at Intersection for the Arts, San Francisco's oldest alternative non-profit multidisciplinary arts organization. He is a graduate of Columbia University, and has served on selection panels for Creative Capital Foundation, San Francisco Arts Commission Public Art Program, City of San Jose Cultural Affairs Office, Arts Council Silicon Valley, WORKS/San Jose, and the Headlands Center for the Arts. Photo: David Huang

Travis Jensen

Travis Jensen is 27 years old and lives in San Francisco, California. He is the author of *Left-Handed Stories* and co-editor and publisher of *No Comply—Skateboarding Speaks on Authority*. Travis' third book, *Welcome to San Franpsycho*, is scheduled for release in October 2007.

Mark Pearsall

Originally from Downers Grove, Illinois, educated at the University of Illinois Chicago, School of Art & Design. Mark moved to San Francisco in 2003 and created Exilition Design & Typography, an independent firm geared towards galleries, artists, and non-profits. Mark has created information graphics for Intersection for the Arts, skateboard graphics for Western Edition, and has worked on a variety of catalogs with Andrew Schoultz.

Jamie Alexander

Jamie Alexander is a California native who spends too much money on art. He prefers the Bay Area to most places, except when he wants to get his feet wet. Then he prefers somewhere tropical. Jamie is co-owner of Paper Museum Press with Derek Song.

Contributing Photographers

Chris Natrop, Joshua White, Leslie Bauer, Brandon Bauer, A.J.S., Peter Tenebaum, Adam Platti, Caleb Neelon, Ronnie Wibano, Nano Warsano, Trillium Press.